DAWGS
GONE WILD

DAWGS
GONE WILD
The Scandalous '70s of UGA Football

PATRICK GARBIN

Steve "Shag" Davis, primary contributor

THE
History
PRESS

Published by The History Press
Charleston, SC
www.historypress.net

Front cover, top left: Helen Castronis collection; *top center*: Historic Images; *top right*: Henck and Kelley collection; *bottom*: dr. jteee collection.
Back cover, top: D.J. Pascale collection; *middle*: Helen Castronis collection; *bottom*: Gittings Studio, Atlanta.

First published 2017

Manufactured in the United States

ISBN 9781625858672

Library of Congress Control Number: 2017940933

To my four favorite people in the world—Dad, Mom, Trip and Rebecca—thank you for your unconditional love and support.

Contents

Acknowledgements

For this personal, uplifting and satisfying, yet often challenging book project concerning the turbulent but inspiring UGA football program of the 1970s, there are a number of individuals I need to identify for the support they have given me.

Notably, during my four years of conducting numerous interviews and hours of research, this book project was viewed by some in the publishing industry as perhaps a little too "controversial." I would like to extend my appreciation to The History Press for considering a book that was seemingly contentious, and for seeing it for what it was meant to be: an accurate and essentially untold account of an era of Georgia football—one that hasn't and will never be replicated—and a tribute to its players, coaches and staff. I want to especially recognize editors Amanda Irle and Rick Delaney for their tremendous guidance and extraordinary patience throughout the entire process.

I also would like to recognize the number of sources who agreed to be interviewed and/or supplied photographs for this book. Special gratitude goes to Harvey and Carolyn Hendrix, Janice Henck, Kathy Wicks Kelley, Doug Moore and Gene Robbins, or "Blue." Without their assistance and support, this project would've likely not materialized. (And, without Blue, "Dawgs" would never have materialized. The Bulldog Nation is forever grateful for your initiation of what has to be the coolest abbreviated nickname in college athletics.)

I was unfortunately dealt an unexpected family hardship around the time I was offered the contract for this project. Because of the project

itself, which provided a therapy of sorts, and the continuous love and encouragement I received from my four ultimate supporters, to whom this book is dedicated, I overcame my grief and became a better person as a result.

Last but certainly not least, I want to acknowledge Shag for revealing to me what is primarily his extraordinary story from decades ago (although I remain astonished that one individual can experience so much in such a short period of time). With Shag, not only was I given the opportunity to share this story, but I also gained a good friend in the process.

1

Somebody Should Write a Book About Us!

Following my second year at the University of Georgia, I returned home in good spirits for the summer of 1974 to my native Cambridge, Maryland. I had been considered two years before as one of the top quarterback prospects coming out of high school—and one of the top eleven prospects regardless of position according to *Coach & Athlete* magazine. But my college football career amounted to an injury to my throwing arm that forced me to play wide receiver as a freshman on the junior varsity squad and expulsion from the 1973 team because of disciplinary issues—that's it. Some All-American quarterback I turned out to be—a disappointment. Still, I had dedicated myself for the upcoming fall and, by all indications, had worked my way up to be the Bulldogs' starting split end as a redshirt sophomore.

Located on the west coast of Maryland's Eastern Shore, Cambridge is approximately thirty miles from Salisbury. Nearly every day during that summer, I'd drive to Salisbury State College to run sprints, lift weights and run pass routes with some of the school's football players. After a particularly hot and hard workout, Salisbury State's starting quarterback, Greg, a friend of mine from Cambridge, and I decided to blow off some steam.

I had informed Greg of some of the wild things I had been a part of at Georgia. In turn, he indicated how he and some of his teammates, especially a particular lineman, Larry, could be just as wild. In hindsight, I guess we decided to test that theory by first icing down three cases of beer in a large cooler. Then, five of us—Greg, Larry, two other Salisbury State players and I—jumped into Greg's Cutlass convertible. With the top down, we drove

toward the beach at Ocean City, roughly thirty minutes away on the east coast of the Eastern Shore.

Something told me our afternoon might possibly end with a run-in with authorities when Greg claimed he knew a shortcut to U.S. Route 50 toward Ocean City. He suddenly jerked his car off the road and into a cornfield. For the full length of the field, spanning at least a couple hundred yards, he mowed down corn until coming out the other side—sure enough, a shortcut to the highway.

Each of us had pounded several beers by the time we reached the outskirts of Ocean City, where we noticed a billboard advertising a bar in a strip mall. It read—and, get this—"Chug a pitcher of our beer, it's FREE!" Well, we thought, this was something we could definitely participate in. So, we eventually bellied up to the advertised bar, and Larry, who had already consumed at least a half dozen beers, decided to go first. But as fast as he chugged the pitcher down, he just as quickly filled it back up with vomit. In an instant, our waitress blurted, "That doesn't count! You're gonna have to pay for it!" We soon left the bar a little ticked off for, basically, having to pay to watch Larry puke. However, soon after we got back in the car, we forgot about our wasted money when we noticed a gas island in front of the strip mall featuring a few "Pump Bunnies."

At the time, because of the oil crisis, some gas stations, in order to lure customers, employed Pump Bunnies—good-looking women dressed in string bikinis who pumped gas. We decided to play a little prank by totally disrobing and sitting in the car to the point where they would be able to see inside the vehicle upon approaching it. After we pulled up, two of the women started walking toward us. When they were only a few feet away, Larry suddenly stood up in the back. "Would you like for me to check your oil for ya?" he asked them. "I brought my dipstick with me." Larry then started doing what was called the "Wombat in Heat," in which one does pelvic thrusts while nude, slapping his midsection and making a "Pop, pop, pop" sound. As the girls started screaming and we began laughing hysterically, Greg put the car in gear. We got back onto the highway with still nothing on—nothing on but the radio.

The main drag of Ocean City runs parallel to the coast and is intersected by ascending numbered streets (First Street, Second Street, Third Street and so on). When we reached the intersection of First Street, there were people everywhere. We stopped at a light, and someone in the back of our car asked a woman with a couple of kids if she knew where First Street was located. Mindful that we were at First, her puzzled look soon turned into

absolute shock as two guys in the back jumped up and did the Wombat in Heat. The "pop, pop, pop" continued at the intersection of Second Street, where a lady screamed; at Third, where a mother stood bewildered while she covered her child's eyes; and finally at Fourth, where an elderly man attempted to go after us after his wife caught a glimpse of a few of us performing the Wombat.

After spotting the hotels that lined the street, someone in the car suggested we take our troublemaking off the main drag. So, we pulled into a hotel—still, with nothing on but the radio—got through the gate and walked up to a large pool crowded with vacationers of all ages. Many of them froze in bafflement as the five of us lined up across one end of the pool, did the Wombat in Heat, jumped into the pool, swam down to the other end and then swam back. Reaching the edge of the pool from where we had started, we climbed out of the water. Finally, we all bent over, shooting everyone a full moon in the midst of a sun-filled afternoon. The five of us would pull this same routine at another hotel pool. We never did make it to the beach that day.

Realizing the police might be called, if they hadn't been already, we decided to get out of Ocean City. We headed west to Salisbury to see if we could cause some trouble there. Along the way, whether we drove past another automobile or were passed by one, the other vehicle was usually dealt a dual dose of the Wombat and a full moon. I'll never forget the look on some of those people's faces—shock, panic, confusion and disgust.

Although there were no cell phones at the time, the CB radio craze had erupted. It turns out that someone had radioed the police, who apparently put out an APB on my Salisbury State friends and me for our antics. Suddenly, a state trooper traveling in the opposite direction pulled off the side of the highway, cut through the grass median and began pursuing our car before eventually pulling us over. In what seemed like no time, there were approximately eight police cars pulled off the road behind us. Finally, one of the state troopers approached the car. As he observed five drunk and nude young men in a vehicle with numerous empty beer cans and at least another unopened case, we witnessed yet another bewildered look. Apparently, our shenanigans were done for the day.

While the Cutlass was driven back to Ocean City by a policeman, we—by then, fully clothed—were toted in the back of a couple of the patrol cars to the town's police station. There, after identifying ourselves, we were grilled before the interrogation temporarily ceased. After discussing something beyond earshot, a couple of the officers reconvened with us.

One of them asked Greg, Larry and the other two players, "Don't you guys play football at Salisbury State?" The four affirmed this. The same officer then addressed me.

Now, let me preface this by saying, granted, my collegiate football career had yet to materialize. But, having been one of the very few individuals from the Eastern Shore to ever sign a football scholarship with a major-college program, I had routinely appeared in the local newspapers in the preceding few years.

"And, aren't you Steve Davis, who plays football at Georgia?" he asked. I nodded.

Suddenly and unexpectedly, there was another moment of bewilderment—not experienced by innocent bystanders or authorities but, instead, by the five of us. A policeman announced, "Okay, you're free to go."

As we got up to leave the police station—still drunk—the same officer approached me and added, "You, especially, don't need to be doing this shit."

Without anything else being said, we all got back into the Cutlass containing the empty cans of beer and, much to our pleasant surprise, the unopened case that remained on ice. We pounded down the beer while we headed toward Salisbury, attempting to finish it before we reached town. All of us were hysterical and inspired, but not because we were back to our Wombat in Heat–and-mooning routine. We agreed to refrain from such antics—temporarily. It had been demonstrated that, whether at a small local school or a large university nearly seven hundred miles away, with a little bit of luck, you could get away with just about anything as a fairly recognized football player.

Oh, how the times have changed since I attended college as a student-athlete in the 1970s—the feel-good decade, the sexy '70s, the "Me Decade." On the contrary, nowadays, most collegiate athletes are capable of getting away with absolutely nothing.

Over the last two decades, a number of major college football programs have been distinguished by NCAA violations, newsworthy arrests, sex scandals, incidents of domestic violence, widespread drug and alcohol use—you name it. The media as a whole has led us to believe that some of these programs have spun out of control, including those in which the inmates seem to run the asylum.

Within the last few years, college football is in a "sad state," according to a major sports media outlet. "Every day, it seems, a new headline smacks us silly and leaves many wondering when, or if, the madness will ever stop, from recruiting abuses to pay for play."

Still, such appalling behavior has only reached the apparent level of "madness" because of the excess press coverage and social media presence in sports. The fact is that the overall behavior of student-athletes forty years ago is similar to that of today's players—likely even worse. At least, that was the case for some student-athletes in the mid-1970s, when we weren't under the watchful eye of online message boards, Twitter, Facebook and the like.

"If a player got out of line or did something really bad back then, we'd call him in the office and would handle it internally," a Georgia assistant coach during the 1970s informed me recently. "No one had to know about it, especially not the damn media." Accordingly, perhaps one of the main reasons the off-field affairs of a major college football program of the 1970s should be chronicled is that today's programs, comparatively speaking, are receiving somewhat of an unfair assessment.

One assistant coach during my time as a Bulldogs player, John Kasay, remains one of the most extraordinary men I've ever known. He played for Georgia in the mid-1960s and then was on the coaching staff in some form starting around 1970 and as late as 2012. While I was playing, he also served as the resident counselor, whereby he literally lived in the athletic dorm with his family among the athletes. In his many years with Georgia football, Coach Kasay was very well respected and became close with numerous players. If there was ever someone who could compare off-field player behavior of different eras, it is him.

Addressing a group of players from the 1970s during a team reunion only a few years ago, Coach Kasay proclaimed, "Compared to today, you guys were unbelievable! If y'all were playing nowadays, when the stadium announcer hollered, 'Here come the Bulldogs!' maybe three of you guys would run onto the field, since the rest of you would have already been kicked off the team!"

It was then, surrounded by laughter, that I heard an unidentified former teammate holler back at Kasay, "Somebody should write a book about us!" A book having to do with the wild times some of my teammates and I experienced while playing football at Georgia? I eventually thought it was a hell of an idea! So did a number of others.

Still, you might wonder, who the hell am I—"Shag" Davis? Considering I started only fourteen games in college and made just twice that number of career receptions, why am I fitting to be the primary contributor for such a book project? Well, in all honesty, I wholeheartedly believe that you'd be hard pressed to find many student-athletes who had as much

of a unique experience as I had in college (an experience that's certainly nothing to be proud of).

Most of those who knew me at Georgia would have been taken aback by my upbringing on the Eastern Shore. I came from a rather prominent and respectable family. Perhaps notably, my grandfather held what was considered a rather powerful position as the commissioner of personnel for the State of Maryland. His son, my father, graduated from Yale University with President George H.W. Bush and served the U.S. attorney general, Robert F. Kennedy, as a one-man conduit, circulating highly sensitive information during the Cambridge race riots of the 1960s. As a child, I was exposed to a number of high-profile individuals, like Attorney General Kennedy's older brother, John, whom I met and shook hands with not long before he was shot and killed in Dallas, Texas.

As an early teen, I, along with a few family members, were escorted to meet Yogi Berra. At the time, he was a coach with the New York Mets. There we stood in the team's locker room, waiting for the legendary baseball figure to finish showering after the team had completed a doubleheader. Yogi eventually emerged, but he had evidently bypassed the dressing room after his shower. As he stood in front of us stark naked, carrying on a casual conversation, my family was assuredly traumatized. I, on the other hand, was shocked that someone could be covered with as much body hair—you couldn't even make out his private parts. Moreover, I instantly believed that if the great Yogi Berra could be openly nude in front of strangers while exhibiting a short, dumpy physique with enough hair to weave the entire carpeting of a large house, there must be little wrong with it.

From shaking hands with the president of the United States, to hanging out in the locker room at Shea Stadium, to getting police escorts to Memorial Stadium to attend Baltimore Colts' football games, I was somewhat privileged as a child because of who my family was and who my family knew. Yet, I was so different than everyone in my family—a black sheep of sorts.

Around Cambridge, a friend and I were widely considered troublemakers who terrorized the residents. You name the mischievous act, there's a good chance my friend and I succeeded in doing it. Perhaps our favorite exploit— often undertaken while wearing ski masks so we couldn't be identified—was throwing whatever was handy (rocks, fruit, snowballs) at, well, whatever we could target, including people, cars and houses. When the police were called, we often started hurling things at them, as well. I truly believe one of the primary reasons I developed a strong throwing arm with considerable accuracy was because of the several years I spent throwing objects at passing cars.

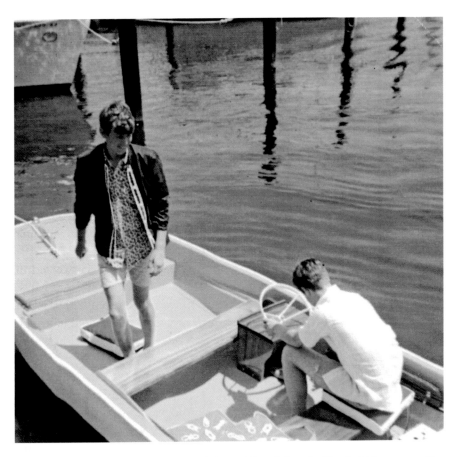

Name the mischievous act, there's a good chance Shag (*left*) and a friend of his succeeded in doing it while growing up in Cambridge, Maryland. *Bob Davis collection.*

Looking back, I think we were bored. Cambridge, whose population then was about what it is now—around twelve thousand residents—was basically only as big as every other town within an hour's drive. At the time, I felt like there was nothing to do in Cambridge except play sports and raise hell. And I was pretty good at doing both. Fortunately, I was a good enough high school quarterback to be recruited by roughly eighty college programs from all over the country. I wanted to attend school far from Cambridge (which is ironic, since I wound up living a good portion of my adult life there), preferably in the Deep South, where the weather was warmer and the football appeared to be more competitive.

The University of Georgia (UGA) had the reputation of being a party school. It featured a football program belonging to the reputable

Southeastern Conference (SEC) and was on the verge of becoming a place where being nude in front of strangers by way of streaking was more commonplace than anywhere else. UGA seemed to be the perfect fit for me.

On entering the university and being part of its football program beginning in August 1972, several members of my incoming class and I picked up where we had left off in high school: the sex, drugs, alcohol and high jinks. But it was heightened—considerably. Outside of the football program, collectively nicknamed "Wildman," a couple of teammates and I might have gone too far with our misconduct. During the spring of 1974, according to the student newspaper, the *Red and Black*, "Yes, the 'Wildman'… has caused quite a commotion in Reed [community] this year, and it has been nothing short of a miracle that the tumble-down red brick structure has remained intact."

As a member of the football team, I witnessed and participated in freshman initiation ceremonies that would now be considered quite appalling. But, as it was said back then, "boys will be boys." On the contrary, what was not child's play was an undercurrent of organized crime associated with Georgia football. However, such association perhaps existed only in the slightest and just involved a few players. I was considered a "Northerner"—a "Yankee." But I pretty much got along with and related to most of my teammates. By virtue of my origins, I had unique insight into the race relations and geographic prejudice of a newly integrated program. Only one year prior to my incoming class, Georgia had signed its initial group of black players while making its first considerable effort in years to lure prospects from outside the South. On the field, although certainly no All-American, nor even an all-conference player, I feel like I had a respectable (although slightly disappointing) career at Georgia. I played a role in some memorable games for a couple of distinguished teams—which is how I came in contact with the book's author to begin with.

UGA football writer and historian Patrick Garbin first reached out to me in 2012, mentioning that he wanted to include me in a book he was writing. The book would feature a wide array of former standout Georgia players—some of them deemed among the greatest ever at the school, some perhaps hardly remembered, if at all. I was uncertain about the application of "standout" to me, but the "hardly remembered, if at all" part was spot-on. Seriously, I was truly honored that Patrick had contacted me.

It turned out that Patrick had written several books on Georgia football, and his articles and blog entries were all over the Internet. I began reading and admiring his work, much of which was historical content based on

archived media accounts. We soon became quick, long-distance friends and, at some point, I shared something with Patrick I had learned as a Bulldog: the media often doesn't know the *entire* story—especially back when I played football and before the existence of social media.

My new friend and I began speaking on a regular basis, and from time to time, I would reveal additional details from my UGA days associated with articles he had written. Among my disclosures were the following: the whole story of the infamous bomb threat in 1974, when the team was en route by plane to play Kentucky in Lexington; accounts of the racial tension and anti-northern prejudice that prevailed on the team; and details of how close Vince Dooley—UGA's revered head coach from 1964 to 1988 and the school's athletic director until 2004—was from his contract not getting extended in the mid-1970s.

In addition to expanding on some reports, I informed Patrick of a few accounts that hardly anybody is familiar with outside maybe a handful of Georgia football players from my time. I found that such sensitive and somewhat scandalous knowledge is rather difficult for me to detail aloud, even though the incidents occurred more than forty years ago. These controversies, which are detailed in the book, include players' involvement with the late Jim Barnett—"the godfather" of professional wrestling—and his proposal of exchanging money for sexual acts. There was also the death of my teammate and friend Hugh Hendrix, who passed away just prior to his senior season from a rare blood infection. The cause of his death has remained a medical mystery for more than four decades. For each of these disturbing episodes, I eventually developed an idea—a theory that, in time, had become a near or absolute certainty of mine.

The week of a Georgia football lettermen's reunion, the first I had attended in at least six or seven years, I traveled from Cambridge to finally meet and stay with Patrick at his home outside of Athens. At the beginning of the week, first on my agenda was to talk with Hugh's parents. I had heard that they were living in Georgia and doing quite well. At the end of the week, Patrick and I decided to initiate what had been suggested only a day or two before from the teammate of mine: write a book about the experiences while playing football for the University of Georgia in the mid-1970s, including the 1975 and 1976 seasons featuring the celebrated "Junkyard Dogs." Presented is just that, primarily my own account. Still, what started out as a two-man project would be transformed over the course of four years into a major undertaking with dozens of contributors.

I want to emphasize that this is a nonfiction book—a true story. Yet, and understandably so, certain people's names have been changed or omitted, while some identities have been altered, to protect the reputations of individuals. A portion of the inserted dialogue is purely approximate, as it occurred more than four decades ago. But, besides changed/omitted names and identities, and some dialogue that might not be *exactly* what was said, everything else is completely truthful and accurate, based mostly on what I encountered, as well as the experiences of other contributors. And, when applicable, what is written is supported with extensive research.

The Georgia football program of the mid-1970s is presented as having at least a suggestion of lawlessness, debauchery, scandal, racial tension, geographic prejudice and organized crime. However, I want to make it *very* clear that many of my teammates did not participate in the "wild" behavior described. There were plenty of guys who abided by the rules, including those who probably were completely unaware that such misconduct was even going on.

I also want to emphasize that Coach Dooley surely had no idea of most of the wild things that went on. But, to his credit, when he caught wind of any wrongdoings, he immediately nipped them in the bud. Times were different back then; a good number of rowdy characters came through the program. Being wild was the "in" thing to do at that time and, likely, the norm for college football programs in the 1970s. However, few other programs had been recently racially integrated like ours had been, and nearly as few had the prevailing pressure to win. It is amazing that Coach Dooley was able to field a team to begin with, especially those as good as the 1975 and 1976 squads—teams that reached major bowls after losing a combined three regular-season games. Dooley not only achieved on-field success, but he also did so while dealing with some tough things along the way and all the while straightening out many boys. He straightened me out, enabled me to earn my college degree and helped me become a man. As I've mentioned to him several times over the years, I owe Coach Dooley a lot.

I also owe a lot to my former teammates, including delivering a story that isn't meant to disparage or denounce anyone by any means. Instead, this story is meant to serve as a truthful, accurate and entertaining account of what took place within the Georgia football program during our time—a tribute, of sorts.

I especially want to pay tribute to friends and teammates on the '76 SEC title team who passed away too early—and too soon for me to tell them how much they meant to me.

Tony Flanagan, the "Flim-Flan Man"—I called him "Flan the Man"—was one of the best high school athletes to come out of the Atlanta area. A couple of years younger than me, he played basketball at Georgia for two seasons before finally coming out for football. Playing in a few games in 1976, Tony became the first black Bulldogs quarterback to play at the varsity level. We often played pickup basketball together. He was a good friend.

The hardest I was ever hit by an opposing player did not occur in an actual game, but during an intrasquad scrimmage at Sanford Stadium by safety Mark Mitchell. Mark, who stood less than six feet tall and weighed only around 170 pounds, nailed me so hard that I was seeing stars and was nearly knocked out cold. He was the epitome of what the members of Georgia's "Junkyard Dogs" defense represented: undersized and inexperienced, but feisty, quick and determined. In 1976, his one season as a starter, Mark was our primary punt returner and one of the team's leaders in interceptions. More than being a fantastic football player, he was a wonderful person and Christian.

Running back Kevin McLee, who was from Pennsylvania, wasn't Georgia's first black player, but he was the first one from the North. Therefore, one might think that "Philly Red" experienced a really tough time adjusting to the program, but such was not the case. Kevin got along with everybody on the team, and he was one of my closest friends. In 1976, he became only the second Georgia player to rush for 1,000 yards in a single season. The next year, he became the school's all-time leading rusher. Nearly thirty years after playing for the Bulldogs in the 1977 Sugar Bowl, Kevin attended the 2006 Sugar Bowl to watch his son Kevin "Boo" McLee. Boo was a standout defender for West Virginia, which, ironically, was facing Georgia in the game. Kevin Sr. supported his son by sitting in the West Virginia section, but he did so while wearing a Bulldogs hat. Sadly, approximately just a year and a half later, he passed away at only fifty-two years of age.

Jeff Sanders, a starting defensive guard on the '76 championship team, weighed only about 220 pounds. But I would argue that he was as tough as any player pound for pound that *ever* played at Georgia. Fittingly, he would eventually obtain the rank of captain in the U.S. Marines. "Jethro" was one of my best friends when we played. He had a great sense of humor, and everybody respected him. A man's man if I ever knew one, Jethro passed away in 2013.

And, of course, there's Hugh Hendrix, who wasn't a member of the 1976 championship team in body, but undoubtedly was in spirit.

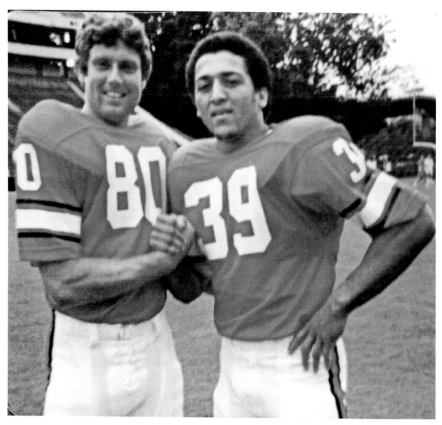

Above: Shag with Kevin McLee (*right*) at Georgia's Picture Day in 1976. That season, McLee became only the second Bulldog player to rush for 1,000 yards in a single season. *Helen Castronis collection.*

Left: At the team hotel in Atlanta, defensive tackle Jeff Sanders dressed in Georgia's travel uniform before the Bulldogs played Georgia Tech at Grant Field in 1975. *Henck and Kelley collection.*

At the beginning of the week of the aforementioned Georgia football lettermen's reunion, Patrick and I, along with two of Hugh's friends from high school, Janice and Kathy, traveled to Carrollton, Georgia, to visit with Hugh's parents. We then went to see Hugh's gravesite. A lot of good resulted from the trip. For one, I had not spoken to Harvey or Carolyn Hendrix, nor visited Hugh's grave, since his funeral and burial thirty-six years before. During the visit, Harvey, eighty-five years old at the time, said something I'll never forget and will always cherish.

Referring to a Georgia football player who had recently been permanently dismissed from the program for serious misconduct, Harvey asserted, "You [as a major-college football player] are admired by tens of thousands, and capable of receiving just as many opportunities in life.... Many of you take advantage of the numerous doors that can open for you. But, some of you blow it!"

I thought of myself—how I had nearly blown my opportunity as a Georgia football player because of my misconduct. I thought of the kindhearted and straitlaced Hugh—how he didn't get the chance to take advantage of all the doors that assuredly would have opened for him.

Finally, it took about a year and a half, but even more good would result from our visit with the Hendrixes. The next day, Patrick initiated a persistent pursuit to reinstate the Hugh Hendrix Memorial Award. The honor, beginning the year of Hugh's passing, was annually given to the Bulldogs player who "most strained his potential." The award was curiously interrupted in the late 1980s / early 1990s. After an unrelenting quest, and with the help of some individuals in UGA's athletic department—namely, the Georgia head football coach's special assistant, Mike Cavan (a young assistant coach when I played)—Patrick's efforts resulted in the Hugh Hendrix Memorial Award being reinstated. As of the writing of this book, the award had been handed out without fail to multiple players annually for four straight years. In doing so, the Georgia football program has rightfully kept the memory of Hugh Hendrix alive.

On the ride from Hugh's gravesite, I informed everyone in the car how close I had come to making an attempt of keeping Hugh fresh on the minds of my teammates just prior to the start of the 1977 Sugar Bowl. Minutes from running onto the field of New Orleans' Superdome to face the undefeated Pittsburgh Panthers for a shot at a national championship, there was a slight pause during the pregame pep talk. I suddenly felt compelled to say something about Hugh. We had dedicated the season to him back during the summer. As a senior playing in my final game for the Bulldogs, I

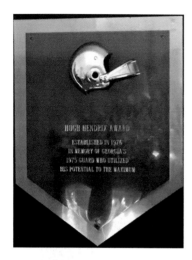

The original Hugh Hendrix
Memorial Award: "In memory of
Georgia's 1975 guard who utilized
his potential to the maximum."
Henck and Kelley collection.

thought it would be fitting to stand up and give some sort of brief talk—a "Let's win this for Hugh" speech before we all went out and played one of the biggest games in Georgia football history. For whatever reason, and I cannot explain it, I simply couldn't do it. I remained sitting, and no words were uttered from my mouth. At the time, I assumed nerves had gotten the best of me.

Am I ever glad I remained seated. Our embarrassing performance in no way should have been associated with the ultimate teammate.

More than forty years later, it's still difficult for me to discuss our 27–3 loss to Pittsburgh. In actuality, the score probably should have been much more lopsided than that. Offensively, we never could get on track. Of course, it didn't help that with nearly every snap of the ball there seemed to be fourteen Pitt defenders on the field at one time, and half of those were in our backfield in an instant. For a squad that epitomized the phrase *team oriented*, it was probably the worst overall team effort I had been a part of as a football player. Not taking anything away from the Panthers; they were an extraordinary, well-rounded team, definitely deserving of the national title. But the 1976 Georgia team was outstanding, as well.

For the Sugar Bowl, we had what seemed to be a perfect game plan for the Panthers, and we were ready for them—perhaps more prepared than we had been all season for any opponent. Yet, we went out and, as a team, played dismally. I've always felt like something just wasn't right with us that afternoon in the Superdome. Something was amiss.

"Do you have any idea how I could watch a replay of the Sugar Bowl?" I asked Patrick on our ride back to Athens. I hadn't seen any footage from the game since I played in it on January 1, 1977. I didn't even know if it was feasible to watch a replay of it.

"We could watch it as soon as we get back," Patrick said. "I have the game on DVD." He then laughed, asking me why on earth I would want to relive such a horrible memory.

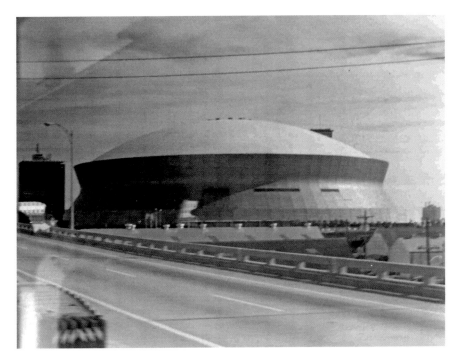

The Superdome in New Orleans is seen from a Georgia team bus just days prior to the 1977 Sugar Bowl. *D.J. Pascale collection.*

I reminded Patrick of Jim Barnett's manipulation and Hugh's passing—experiences of mine I once tried to forget about. Instead, I developed a theory associated with each reality. In time, each theory was transformed into what I believe to be absolutely factual.

"There's something having to do with the Sugar Bowl that is similar to those experiences: What once was a theory of mine about that game eventually has become a near-certainty," I added. "Still, I'd like to watch a replay to see if the idea I've had is completely valid."

—Steve "Shag" Davis

2

Me and You and a Dawg Named Blue

On New Year's Eve of 1976 in New Orleans, the clock was mere minutes away from striking midnight. A buzz filled the air outside the Hyatt Regency located in the downtown central business district of the city. But inside the hotel, specifically a room occupied by two University of Georgia football players, all was calm.

Ben Zambiasi and roommate Steve Davis, better known as "Shag"—the nickname he was given during his freshman initiation four years earlier—laid in their beds quietly whispering back and forth, reminiscing about their team's outstanding regular season, scathed only by a four-point road loss to Ole Miss. Despite the defeat, the Bulldogs captured the program's first SEC title in eight years, earning the right to face the University of Pittsburgh in the following day's Sugar Bowl for a shot at a national championship. The Pittsburgh Panthers had a perfect 11-0 record and were ranked number one in both major polls—the Associated Press (AP) and the United Press International (UPI). Maybe above all, they featured senior tailback Tony Dorsett, recipient of the Heisman Trophy as the most outstanding player in college football.

Ironically, Georgia had a recent history of facing the Panthers and Dorsett. In the spring of 1970, like most major-college football teams, the Bulldogs elected to add an eleventh game to their regular-season schedule beginning with the 1971 campaign. Georgia scheduled season-opening opponents for the next eleven years. The games were intriguing matchups with intersectional opponents, yet all foreseeable victories played at home

The Hyatt Regency in New Orleans in late December 1976, as Georgia arrived to play in the Sugar Bowl. *D.J. Pascale collection.*

in Athens. Included was Pittsburgh, a lowly program at the time, which was scheduled to open Georgia's 1973 and 1975 seasons. In nine years, the Panthers had averaged just over two wins per season and had fired three head coaches. There was then a "major" change in Pittsburgh football with the hiring of Johnny Majors. The new head coach promptly signed a top-notch recruiting class, including the highly touted Dorsett.

After only two seasons, Pittsburgh was no longer an inferior program, and Dorsett was arguably the best running back in the country. Entering the Georgia-Pittsburgh game of 1975, regarding the prospect of facing Dorsett, "we were scared," Zambiasi claimed a couple of weeks prior to the Sugar Bowl. "But not for long."

As was the case with the Georgia defense against the Panthers in 1973 (a 7–7 tie), Zambiasi and the rest of the "Junkyard Dogs" held Dorsett relatively in check the second time the teams squared off, despite losing 19-9. Meeting Pittsburgh for the third time in four years, Georgia assuredly would be ready for the Panthers—and not scared of Dorsett.

The fact that Ben Zambiasi was, at any point, actually scared of someone was hard to believe. The standout junior linebacker from Macon, Georgia, only stood about six feet tall and weighed just over two hundred pounds, but he was quick, tough and extremely fierce. On the day of home games, the team boarded buses for Sanford Stadium from the school's basketball arena, which housed the main locker room and meeting rooms. Noticeably, every time Zambiasi exited the Georgia Coliseum to board a bus, he had the most intense, tunnel-vision look on his face—he was totally focused on what he had to do.

After playing sparingly as a true freshman in 1974, Zambiasi started at Will (weak-side) linebacker as a sophomore, leading the team in tackles while earning All-SEC recognition. In August 1976, he was selected by the *Family Weekly* publication as a preseason first team All-American (along with Dorsett), and he did not disappoint that season, again leading Georgia in tackles.

By 1976, Zambiasi's intensity and his ability to get psyched up had become so immense, it was contagious—even influencing Georgia's senior placekicker, Allan Leavitt. Seemingly the stereotypical ordinary, everyday kicker, the reserved Leavitt looked to become more "wild" and was inspired by Zambiasi. After making just two of ten field-goal attempts as a junior in 1975, Leavitt made eleven of sixteen tries his senior season, while 65 percent of his kickoffs were nonreturnable. His success was partially attributed to getting "a little wildness in me just for those few seconds before kicking the ball," according to Leavitt, who earned All-American honors in 1976.

Zambiasi had come a long way. As a freshman in 1974, he nearly quit the team because he believed he was getting pushed around and picked on by upper-class teammates both on and off the practice field. For instance, on a road trip that season, he was up a little past curfew but innocently in his room watching television. Suddenly, he got a call from an assistant coach, declaring he better turn his lights off and get to bed. Zambiasi raced out of his chair, turned off the lights and television and dove into bed, only then to hear clamorous laughing from the next room. Turns out, the young freshman had been called not by an assistant coach, but by David Wolfe, a senior linebacker.

Fast forward two years, and it was a more determined and self-assured Zambiasi who was picking on freshmen. While in Lexington to face Kentucky, the junior linebacker called the hotel room of Jeff Pyburn, a freshman running back. Pretending to be a reporter, Zambiasi interviewed

the newcomer while teammates in the background tried to cover up their laughing. Pyburn was not told the truth behind the fake interview until days later.

Lying in their beds in the Hyatt Regency, Shag reminded Zambiasi of his trick on Pyburn earlier that season. Nonetheless, the two agreed there would be no prank calls made the night before the biggest game of their lives.

A much-publicized, but slightly exaggerated, side story to the Sugar Bowl was how Georgia head coach Vince Dooley implemented an 11:00 p.m. curfew for the team all week leading up to the game. Majors, on the other hand, had supposedly issued no curfew for the Panthers. In reality, Pittsburgh had no curfew for its first two nights in New Orleans, December 26 and 27, but the players had to be in by 10:00 p.m. on New Year's Eve. The Bulldogs essentially had an 11:00 p.m. curfew all week except soon after their arrival on December 27, when the team was treated to a night out at a bar. Described as a "drunk-o-rama," the activity was an attempt to purge the players of any temptations to break curfew and overindulge the rest of the week. Still, as they did on occasion back home in Athens, some Georgia players may have broken curfew once or twice while in New Orleans.

While out past 11:00 p.m. one night, Shag and a few teammates ran into some Pittsburgh players at Pat O'Brien's, home of the world-famous Hurricane drink. The Bulldogs players approached the Panthers, and Shag began introducing himself. He had hardly uttered a word when he was interrupted by six-foot, six-inch sack-master Randy Holloway.

"I know who you are—Steve Davis," Holloway asserted. The honorable-mention All-American defensive tackle then promptly named the other two Georgia offensive players in the group. That was the extent of the encounter with the opposing players at the bar.

Between two and three o'clock in the morning, the Georgia players left the bar. After happening upon a Pittsburgh player who was so focused on the upcoming game, he apparently knew every Bulldog player solely by face recognition that he possibly might encounter in a few days, a recognizable Panthers coach staggered about half a block down the street. The coach was so drunk that he had to be held up by his company to avoid falling in the street.

On New Year's Eve, Shag and Zambiasi agreed that likely every player and staff member for both teams, even the drunk Pittsburgh coach from a couple nights before on St. Peter Street, were abiding by curfew that night. Whether sleeping or game-planning, everyone was getting ready for a contest that kicked off at 11:30 a.m. local time—the earliest of the four major bowls on January 1.

It was reported that the Bulldogs hadn't approached any of their previous seventeen bowl appearances in a "more serious mood." While the Panthers had not practiced on December 31, Georgia did so, running through some light drills at Tulane Stadium, located a few miles from the Superdome and the Hyatt Regency. It was said that the Bulldogs would have had a full practice if Coach Dooley hadn't wanted to get back to the hotel by 1:30 that afternoon to watch the Peach Bowl, in which his brother Bill, the head coach of North Carolina, was facing Kentucky.

"I don't think any team ever wanted to win a game more," claimed senior Ray Goff on December 31 regarding the Sugar Bowl. Goff was Georgia's starting quarterback and the SEC Player of the Year in 1976. "I know we've never worked harder to get ready for a game at Georgia, and I know we're ready to play."

As it finally turned midnight and the two roommates heard New Orleans jubilantly welcome the new year of 1977, Shag joked that he could think of just one "member" of the Georgia team out celebrating in the city: the likable Blue—the pair's roommate and the lone Bulldog with no curfew the entire week.

Gene "Blue" Robbins of Cambridge, Maryland, initially became a fixture in a football program in 1971, when Shag talked Cambridge High School's head coach, Gorton McWilliams, into allowing Blue to ride with the team on the eighty-five-mile bus trip north to play at Elkton. Blue was not a manager, trainer or cheerleader—just a friend of Shag's who, in some way, simply wanted to be part of the team. Although Shag would eventually leave to attend school and play football at the University of Georgia, Blue was always around the Cambridge Raiders for games during the next couple of years, helping out in some way on the sideline.

In the spring of 1975, Blue enlisted in the U.S. Navy and was stationed in Charleston, South Carolina. Soon, he had a craving to again follow a football program. Trading off naval duties to free up his weekends, Blue began to pursue the Georgia Bulldogs that fall. At first, he was simply known as "Shag's buddy" or "Shag's friend." And, as it was said, "since Shag's alright, this guy must be alright." But Blue had a knack for being able to warm up to all kinds of people and becoming fast friends. During the 1975 season, he became close with Georgia's hardworking and well-respected head student trainer, Stan. By the end of the year, Blue had also become good friends with a young Georgia assistant coach—so much so that he sat with the coach's wife at the Georgia Tech game after showing up in Atlanta without a ticket. By the 1976 season, he was having dinner with the coach

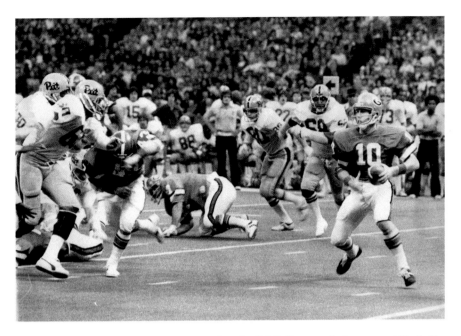

During the 1977 Sugar Bowl, quarterback Ray Goff (10) discovered what seemed like half of Pittsburgh's defense instantly and often in Georgia's backfield. *Historic Images*.

and his family at their home in Athens. Soon, Blue was seen around the team so much that no one questioned whether he was associated with the program or not. During games in 1976, particularly ones at home, he was always on the sideline, yet he never—not once—had a sideline pass.

Blue would accompany the players and board one of the team buses. Usually following a big Georgia victory, a couple of wealthy team boosters might walk by the buses handing out a few fifty-dollar bills to recognizable players who had performed well in the game. Still, a particular player, even a starter, might go an entire three years as a varsity member without ever being offered one of these "fifty-dollar handshakes." In his three seasons, Shag received just one such gratuity—the same number pocketed by the recognizable Blue, who received a fifty-dollar bill from a booster following the Bulldogs' victory over Georgia Tech in 1976.

On Sundays following games, after eating brunch, the players headed over to the Georgia Coliseum, where they split up into their team meetings. And each time, Blue was there waiting in the parking lot to say goodbye before he got into his striking white Ford Pinto station wagon with wood paneling and departed for Charleston. Usually, upon leaving, he blurted

out the Bulldogs' familiar battle cry, "Go Dogs!" However, when articulated
by Blue, the cheer sounded much different. With his mid-Atlantic accent
coupled with an exaggerated attempt at a southern drawl, it sounded more
like, "Go D-aaawwwgggs!"

"Steve, who is that?" Coach Dooley asked Shag one Sunday early in the
1976 season just as Blue got into his Pinto to leave. "I see that guy *everywhere!*"

Shag replied, "Coach, that's your biggest fan." From that point on, it
seemed even Georgia's head coach accepted Blue's presence, likely believing
he was a good influence on the once-troubled Shag.

"Blue was like dog shit after the snow melts—everywhere," said a member
of the 1976 team. "I'm surprised he didn't get his ankles taped by the
trainers."

The year before, after the Bulldogs played Arkansas in the Cotton Bowl,
Blue had somehow worked his way onto a chartered flight from Dallas
to Atlanta carrying a group of Georgia enthusiasts, including the team's
cheerleaders, reputable boosters and UGA president Fred Davison. But,
a year later, Blue was not to be seen—somewhat surprisingly so—on the
chattered Delta flight out of Atlanta bound for New Orleans.

Arriving at the New Orleans airport, the team was met by unusually chilly
temperatures dipping into the mid-forties and a Georgia contingent that
included a Dixieland band and a local pet bulldog, Winnifred. The bulldog
posed with Shag, Zambiasi and two attractive Sugar Bowl hostesses for a
photo that made the front page of the next day's sports section of the *Times-
Picayune*. Afterward, the Georgia players and staff boarded five or six buses
on the airport's tarmac and headed toward the Hyatt Regency.

From the airport to the hotel was quite a drive—nearly thirty minutes.
Accordingly, a ride that began somewhat boisterously, at least on the bus
where Coach Dooley was seated up front, faded halfway en route into
one of moderate chatter. Suddenly, a faint honking was heard outside
the bus window, followed by Dooley blurting out, "There he is again! I
see that guy *everywhere!*"

Seemingly appearing out of nowhere was Blue in his Pinto, driving
alongside the buses with his window down, honking hysterically. Taped
to the car was a curious handmade sign with just two simple words: "Go
Dawgs." Some of the players and staff members no doubt wondered at the
peculiar spelling of "Dogs." However, Shag and a few others knew exactly
why: that's how Blue had always humorously pronounced the word since
associating with the team. But it was the first time anyone on the buses had
seen Georgia's abbreviated nickname spelled "D-A-W-G-S."

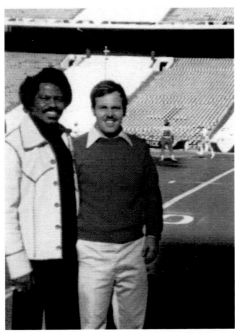

Left: Gene Robbins, or "Blue," was seemingly "everywhere" when it came to the Georgia football team in 1975 and 1976, including posing with James Brown while the Bulldogs practiced for the 1976 Cotton Bowl. *Gene Robbins*.

Below: At the Atlanta airport on December 27, 1976, some members of the Georgia team gather before boarding a Delta chartered jet bound for New Orleans. *D.J. Pascale collection*.

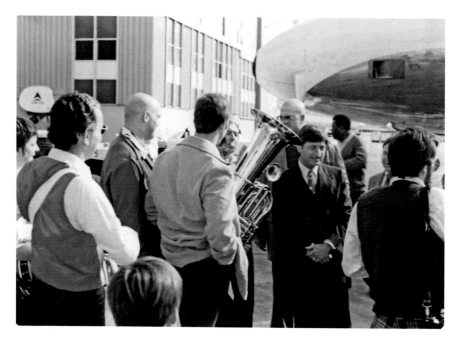

Upon landing in New Orleans, head coach Vince Dooley (suit and tie) and his players were met by a Georgia contingent, including a Dixieland Band. *D.J. Pascale collection.*

Initially planning to spend his entire Christmas break in Cambridge, Blue had arrived home a couple of days before the holiday. When asked by his parents what he wanted for Christmas, it dawned on Blue that the chances of getting a ticket to the Sugar Bowl were slim to none (and slim had just left town). But, he could at least hang out with the team in New Orleans. So, he naturally replied, "Cash!"

Gaining access to the team's itinerary, Blue knew exactly when the Bulldogs would be landing in New Orleans and departing in buses on December 27. He calculated his drive perfectly whereby he had time to make and affix his "Go Dawgs" sign and then catch a few hours of sleep in his car, parked across the street from the airport. Blue was awakened by a parade of buses pulling onto an access road going toward I-10. He knew it had to be the Georgia procession. As before, Blue was once again a "member" of the Bulldogs, eventually teaming up with Shag and Zambiasi to room together.

Soon after Georgia's arrival on Monday, the head coaches met with the media for the initial Sugar Bowl press conference prior to the game. Interestingly, both acknowledged that their respective football teams were

Some Georgia players pose on one of the several buses that delivered the team from the New Orleans airport to its hotel headquarters. *D.J. Pascale collection.*

similar. But, Dooley was quick to mention, "There is one difference. They have Superman," he said in reference to Dorsett.

If Georgia's outstanding defense did have a fault, it was that it could, on occasion, be susceptible to the run. Nevertheless, it was apparent that in order to beat Pittsburgh, Dorsett had to be stopped—or at least contained. Therefore, reputable defensive coordinator Erk Russell had devised a game plan focused on containing Dorsett, likely forcing Pittsburgh to pass more than it intended. Although quarterbacked by able junior Matt Cavanaugh, the Panthers had little passing prowess. As a team, it averaged only around thirteen pass attempts per game; Cavanaugh had thrown for just 854 yards all season, 339 of those coming in a single game.

Georgia's run-oriented Veer offense had begun its campaign by opening up somewhat—at least, more so than the year before, in 1975. However, seemingly reverting back after the loss at Ole Miss, the Bulldogs returned to their three-yards-and-a-cloud-of-dust offense for the regular season's final six games. Still, during the last half of the year, the Georgia coaches were

cognizant of the fact that if they ever encountered a formidable defense, like Pittsburgh's, running the ball 90 percent of the time probably would not be effective.

Besides Holloway at tackle, the Panthers' exceptional front seven featured Don Parrish at the other tackle, linebacker Jim Cramer and guard Al Romano—all of whom had received some sort of All-American recognition. During the regular season, Pittsburgh had faced four respectable ground attacks—Notre Dame, Georgia Tech, Duke and Penn State—holding them to an average of only 129 rushing yards and 2.7 yards per rush.

It was decided that in order to move the ball with any success against Pittsburgh, the Bulldogs would need to open up their passing game. They were very capable of doing so, unlike most other run-oriented offenses. Goff, Georgia's "running" quarterback, was actually an excellent passer. A "passing" quarterback in high school, he had been the Bulldogs' first *Parade* All-American signee. And there was Matt Robinson, a fellow senior who spelled Goff at times during games. Robinson had an extraordinary touch on his throws and was the team's passing leader for the season.

Because of the likelihood of Georgia passing with some frequency, Shag was even more excited for the big game. In addition, offensive coordinator Bill Pace had indicated to the wide receiver that they would likely attempt some trick plays involving him. It was planned for Shag to run end-arounds from a tight end position, where he would either keep the ball himself, pitch it or even throw it. For the former standout dual-threat quarterback, it appeared to be a great way to cap a collegiate career that, to that point, had included only a handful of rushing attempts—none of which resulted in a significant gain—and one pass attempt, which had fallen incomplete.

Regardless of any expected trick plays from Georgia, a slight adjustment to its offense or its somewhat publicized defensive game plan to slow Dorsett, the game's point spread never wavered after bookmakers in Las Vegas established the Bulldogs as, well, underdogs by two and a half to three points. Although, some bookies in New Orleans actually moved the line against Georgia because the Panthers had given some locals the impression they were frivolous and undisciplined. For some of the so-called expert forecasters predicting a Bulldog victory—a few by as many as ten to seventeen points—Georgia's biggest advantage over Pittsburgh had nothing to do with each team's personnel, but the personnel each team had faced.

Besides being accustomed to the Panthers, the Bulldogs were considered in 1976 to have traveled a more difficult road—confronted a tougher schedule. Pittsburgh played just two ranked opponents all season while

generally opposing what was considered inferior eastern independent squads. Georgia had also faced two ranked opponents—but just as part of its *nonconference* slate—along with six teams from the SEC, considered probably the most competitive football conference in the country.

The claim that the Bulldogs' schedule had been demanding was further strengthened on December 20 at the Liberty Bowl in Memphis, Tennessee. The SEC's Alabama, ranked sixteenth and with a record of 8-3, seemed inferior to seventh-ranked UCLA (9-1-1). The Bruins were more than a field-goal favorite. Yet, UCLA was routed, 36–6, by the same Crimson Tide squad that had been easily handled by Georgia, 21–0, in early October.

It was also because of the Bulldogs' difficult schedule that they believed that, despite losing a regular-season game, a win over Pittsburgh should garner them a national title. But not everyone agreed.

Leading up to January 1, there was much debate concerning which of as many as *five* teams should claim the national championship if it won their bowl game. Besides top-ranked Pittsburgh, one-loss Michigan and Southern California were ranked in both major polls ahead of Georgia, at second and third, respectively. The two teams were meeting in the Rose Bowl, which was to kick off around the time the Sugar Bowl would presumably end. Both Michigan and Southern California declared that the Rose Bowl winner should be recognized as the national champion—not only if Georgia won the Sugar Bowl, but if the undefeated Panthers prevailed, as well. Pittsburgh's easier schedule was one of the reasons for this claim. Both Michigan and Southern California also believed that if the other team actually played the Panthers, the Wolverines and Trojans would win.

"That's the most ridiculous farce ever perpetrated," exclaimed Coach Majors regarding the assertion that the Rose Bowl should be the only postseason game considered in deciding the national champion. "If Georgia beats us, they'd have more of a claim than Michigan or Southern Cal."

Dooley agreed with his counterpart. "This game will give us our opportunity to be No. 1," the head coach said. "If we play the best and win, then I think we'd be the best."

Still, there was another team that possibly had a legitimate claim of being champion. Although Georgia was ranked fourth in the country in the UPI poll, it was fifth in the AP poll, trailing fourth-ranked Maryland (11-0). The Terrapins were scheduled to play Southwest Conference champion Houston in the Cotton Bowl, in a game considered a toss-up. That contest was scheduled to kick off approximately an hour and a half following the Sugar Bowl's start.

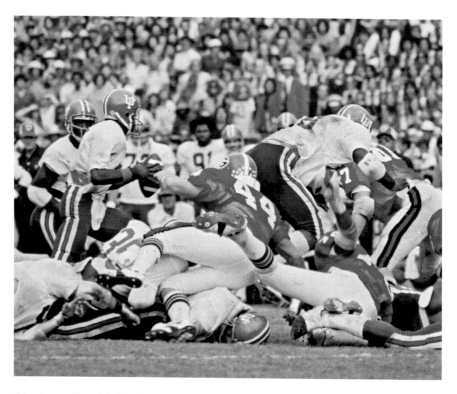

A leader on Georgia's "Junkyard Dogs" defensive units of 1975 and 1976, the extremely focused and tenacious Ben Zambiasi (44), is still considered one of the greatest linebackers ever to play for the Bulldogs. *dr. jteeee collection.*

With his eyes heavy, Shag, close to falling asleep, mentioned to Zambiasi how heavily Maryland had recruited him several years before. Seemingly, there had been pressure on him to attend the state university, and the Terrapins utilized a class-act assistant coach and an all-around great guy to try to lure Shag. In the end, he not only wanted to leave the state to play football but, simply, Maryland had been deplorable for years. Like Pittsburgh before Johnny Majors, the Terrapins had gone almost an entire decade without a winning season before Jerry Claiborne became head coach in 1972. And Shag wanted no part of a losing program. Yet there the Terps were: undefeated and capable of possibly keeping Georgia from capturing a number-one ranking the following day.

"But, didn't you almost sign with the Miami Hurricanes?" Zambiasi piped up in reference to Shag having committed to the University of Miami (Florida) before flipping to Georgia. "Talk about a losing program."

"Yeah, but the situation at Miami was—it was just different than at Maryland," Shag curiously answered.

Shag had decided on Georgia nearly five years before, and Zambiasi made the same decision roughly three years prior to that night in New Orleans. For them and for every other Bulldogs signee, where to attend school and play football was one of the most important decisions in a high school prospect's life. It could be an exhausting process. But, for some, it could certainly be an eventful and lively one, as well.

3

Blazing the Recruiting Trail

Growing up on the Choptank River near the Chesapeake Bay, Shag Davis was the epitome of a "water rat." As someone who could not get enough of swimming, skiing and boating, he loved the water more than anything besides perhaps playing sports, causing trouble and the Baltimore Colts. If Shag could somehow incorporate his love for the water with one of his other passions, like causing trouble, there was no better experience for him in all the world.

Before they were teenagers, Shag and a couple of friends entertained themselves from one of their boats by pulling simple pranks on fishermen along the Choptank River Bridge. These relatively harmless tricks soon progressed to devilish deeds—from throwing empty beer bottles at passing Mack Trucks on the bridge to acts that were much more of a spectacle.

Shag and his friends especially liked to water-ski, and they would often compete to see who was best at generating the big spray—the trademark of the sport. One evening near sundown, Shag and a pal skied toward a nearby surf-and-turf restaurant. Diners of the restaurant usually packed its deck overlooking the water, especially when the sun was setting. The boys decided to enhance the patrons' night out dining and watching the sun set by revealing the signature of water skiing. The boys would supply the diners a little more surf, so to speak, with their surf and turf. And pulling a prank while naked was always an added bonus.

With his friend driving the boat and Shag being pulled behind it wearing nothing but a ski belt, the boys innocently passed the restaurant's deck to

draw attention to themselves. Circling the boat around and steering it to go by the deck a second time, much to the boys' pleasure, they observed that their mischievous scheme had begun to work. At least two dozen diners were standing on the edge of the deck, looking out to see if what they had just spotted was indeed a nude water skier. In an instant, the boat buzzed by the deck, with Shag within five or six feet of its edge. He turned his skis hard and even jammed the back of one of his feet into the water to create a bigger spray. The onlookers soon faced a gigantic water wall of at least ten, maybe fifteen feet, soaking them with such force that a few were knocked down onto the deck.

During that summer, Shag and his friend repeated the same prank at the same restaurant two more times before sensing that their fortuitous run of escaping consequences would soon expire. They took their troublemaking from the water to the land.

At the time, actor Robert Mitchum had a home across the river from Cambridge in Trappe, Maryland. The movie star often hung out at the bar of the Cambridge Yacht Club. Besides acting, Mitchum was also musically talented. But it was widely known—at least around the club—that he could not bear to hear his own singing voice. By that time, he had released the theme song to his movie *Thunder Road*, "The Ballad of Thunder Road," which made the *Billboard* Hot 100 chart. In addition, the song had made its way into the jukebox at the Cambridge Yacht Club.

One afternoon at the club, the boys spotted Mitchum sitting at the bar. Shag put a nickel in the nearby jukebox, selected "The Ballad of Thunder Road" and watched in humor as the song played. Mitchum, the epitome of the "heavy" in films, turned toward the boys and glared at them while sipping on a drink, appearing highly incensed as the two youngsters snickered at the Hollywood actor.

About a week later, Shag and his friend saw Mitchum again at the bar and repeated the devilish deed. A few days later, he was there again, and for the third time, "The Ballad of Thunder Road" was played by the boys. For Shag, the third time wouldn't end quite as well as the previous two run-ins with Mitchum.

Seemingly without even looking to see who had played the song, the actor leaped from his barstool and began chasing the boys outside before catching Shag by the seat of his pants. With one hand on the collar of his shirt and the other on the back of his trousers, Mitchum tossed Shag into the yacht club basin. He then said aloud in a low voice, "I hope you like the water," whereby he calmly walked back into the club and returned

Shag (*middle row, right*) grew up on the water and near the beach. It is often such seemingly trivial matters that a football prospect considers when choosing where to attend school and play football. *Bob Davis collection.*

to his seat at the bar as "The Ballad of Thunder Road" still played in the background.

As previously stated, Shag indeed liked the water. It is often something seemingly trivial as this that a highly touted football prospect considers when having to choose among numerous football programs—all of which evidently have great facilities, beautiful coeds, enticing student life and an opportunity to see early playing time.

If a particular school is willing to provide "extras"—cash, gifts, services—it has an effect on some recruits in deciding where to attend. And some schools did indeed offer extras to Shag!

If Shag was to sign with one particular team, it guaranteed the prep All-American free flights for his parents so they could come from Maryland to watch him play. A recruiter at a different school offered him an automobile. A graduate assistant at another program mentioned that his signing would not only provide a new car for Shag, but one for the graduate assistant, as well. And if the Cambridge standout was in need of a sufficient ACT test score in order to enroll at a particular college, a coach at the school was willing to arrange it. All the coach needed was Shag's driver's license, to loan to another student, who would take the test for him.

Since the very beginning of recruitment in collegiate athletics, parents' influence on their child, the prospect, has been a major factor in countless cases. For instance, Keith Harris of Atlanta, Georgia, who would eventually be recognized as one of the Bulldogs' top linebackers during the decade of the 1970s, signed with Georgia in 1971 primarily because his father informed him that he would have a better chance with job opportunities after graduating college if he attended and played football at an in-state school. Horace King, an African American running back from Athens, Georgia, initially wanted to attend school outside the Southeast because of the racial tension in the region at the time. However, King's mother was a major influence on her son, informing him she would likely not be able to see him play football if he attended school far away. In the end, King chose Georgia over Michigan State and Kansas State. In doing so, he became part of the same freshman class as Harris and one of the first five black players to earn a scholarship and play football at the university.

On the contrary, Shag, like a handful of his collegiate teammates, did not listen to his parents whatsoever when deciding where to attend school. Because of his son's disciplinary issues while growing up, Shag's father, Bob Davis, wanted him to attend a small school, perhaps even a local military college at first. But Shag yearned for the exact opposite: a large, four-

year university located far away. One of the first of such schools to show significant interest in him was located about as far south as it could be: the University of Miami.

Prior to the last couple of decades or so, evaluating a high school player could be a rather difficult task for any recruiter, especially when the player resided a great distance from the school. In fact, prospects were often signed simply based on a high school head coach's opinion of the player and some grainy game footage. So when recruiters started showing up at Shag's games, coupled with the fact that just one football player from his high school had ever earned a football scholarship to a major college

Like many high school kids choosing where to attend college, Shag decided on his own, desiring essentially the exact opposite than what his parents preferred. *Bob Davis collection.*

(Jed Walter in 1964 to NC State), his recruitment became a rather big, publicized ordeal in and around Cambridge. When a recruiter representing a school as far away as Miami visited Shag's small town, it was one of the first times—if not the very first—that the Eastern Shore had experienced anything like it.

Also, unlike today, some college programs got away with having part-time "scouts" on their payroll. These persons, not members of the coaching staff, were able to evaluate prospects who resided in their area. This allowed assistant coaches to focus on local recruits. Such was the case with Harry Bowers at the University of Miami, a football program that needed all the scouting it could get after enduring several consecutive non-winning seasons. Bowers, who lived in Washington, D.C., was good friends with the Hurricanes' head coach, Fran Curci.

Curci, an energetic thirty-four-year old who had been a quarterback at Miami before having success as the head coach at the University of Tampa, was in his first year with the Hurricanes in 1971. He was trying to turn a struggling program around in a number of ways, including utilizing his scouts in regions of the country that weren't easily accessible to him and his staff.

Bowers was asked to scout Shag in person during the latter part of his senior year when Cambridge hosted James M. Bennett High School of Salisbury. The Miami scout came away with a raving review as Shag completed fourteen of twenty-four passes for 294 yards and four touchdowns in a 40–16 victory over the Clippers. Following the game, James M. Bennett's head coach, Tom Bailey, said of Shag, "He's the greatest [high school quarterback] I've ever seen. I was talking to one scout from the University of Miami [Bowers] and he said that if they had Davis he would be starting their next game."

Shag was told by multiple schools that he would see playing time immediately as a true freshman, maybe even start. Many highly touted prospects for 1972 were given the same promise. In January of that year, the NCAA voted to allow freshmen at major colleges to play football and basketball for the first time since the Korean War. Most college football coaches opposed the ruling; the American Football Coaches Association had earlier voted against supporting freshman eligibility. However, programs that lacked depth and, more so, were struggling financially, they figured they could cut back on the total number of scholarships by using freshmen. This would save money; many coaches didn't mind the new ruling. For some, who also took advantage of the ruling for recruiting

Considering the fact that the NCAA allowed freshmen to play varsity football in 1972, Shag, like many college prospects that year, was enticed to certain schools because of the idea of immediately playing on the varsity level. *Bob Davis collection.*

purposes, they not only did not mind the NCAA's decision, they were delighted over it.

"I think it's great," Miami's Curci replied when the head coach was asked about the approval of freshman eligibility. "It's a step forward as far as costs are concerned. Most important, it didn't seem fair to waste young players who are capable of playing."

Envisioning himself the starting quarterback at Miami as a true freshman, Shag traveled to the school for what was considered his fourth "official visit" to a different college as a high school senior. And, on his arrival at the terminal of the Miami International Airport, what a visit it apparently promised to be. Waiting for Shag were five very attractive coeds belonging to the program's recruiting hostess group—the "Hurricane Honeys." Each girl was dressed in a tight top and miniskirt worn over a string bikini. The five Hurricane Honeys and Shag crammed into a car and drove to a secluded beach. There, a number of recruits were treated to an afternoon of coolers of beer and food and games of beach volleyball, all the while mingling with a throng of Honeys.

For a few of the recruits, including Shag, it was the first time they had ever seen a palm tree in person. For perhaps all of the prospects, it was the first time they had experienced a recruiting trip quite like it.

That night, all of the recruits had dinner with Curci at a nice restaurant. The head coach stressed to the young men a viewpoint that really made an impression. Although Miami had struggled in recent years, the program was undoubtedly going to turn around. As a member of the Hurricanes, while aiming to be among college football's best, the recruits had the opportunity to *beat* the best. It was pointed out that over the next four seasons, besides the University of Florida and Florida State annually, Miami's schedule included perennial powers Notre Dame, Alabama, Houston, Texas, Oklahoma, Auburn and Nebraska—some played more than once.

Roughly a decade prior to the inception of National Signing Day, there was no designated day when nearly every college football prospect was expected to sign a binding National Letter of Intent with a school to attend and play football. Instead, most recruits signed a grant-in-aid scholarship essentially whenever they felt it necessary. Even then, unlike the letter of intent, the signing of the grant obligated the school to the student-athlete, but not necessarily the student-athlete to the school.

Accordingly, after Shag's official visit to Miami, the Hurricanes staff—namely, Curci and assistant coach and head recruiter Bill Proulx—kept extremely close tabs by phone on one of the top eleven prospects in the nation according to the Football Writers Association of America. Assuredly, the bigger-name programs would attempt to lure Shag away from one that had struggled—both on the field and financially—during what could become a long, drawn-out recruiting process lasting possibly into the summer.

On occasion, Bowers made the eighty-five-mile trip from Washington, D.C., to visit Shag in Cambridge and often phoned him, as well. Bowers, who was approximately fifty years old, evidently worked full time in the U.S. Department of Justice building as the top assistant to none other than J. Edgar Hoover, the director of the Federal Bureau of Investigation. Apparently, Bowers would carry out just about any task for Hoover—from arranging his meetings, to laying out his formal clothes every morning at work after he left home, generally dressed casually. A fascinating man who invariably had an intriguing story to tell regarding Hoover and the FBI, Bowers made quite an impression on the seventeen-year-old. He once phoned Shag just to inform him that Elvis Presley had visited that day. Apparently, Hoover took "the King of Rock and Roll" down to the building's basement and allowed him to use a tommy gun for target practice. Just a few minutes after the call from Bowers, Shag was phoned by Ted Hendricks—a call undoubtedly arranged by Bowers. Hendricks, the "Mad Stork," had been a renowned All-American linebacker at Miami before having success at the professional level for the Baltimore Colts. During the phone call, he urged Shag to sign and play for the Hurricanes and help lead the program to prominence.

For Shag, the University of Miami appeared to have it all: the water, the beach, the girls and the distance from home. Besides the University of Alabama, which informed Shag he would likely be moved to defensive back, every other school had promised he would remain under center. Nonetheless, the Hurricanes were the only major-college team that indicated he would start immediately at quarterback as a true freshman.

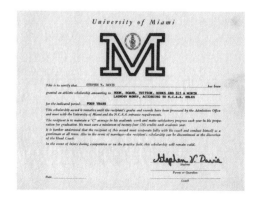

Shag's signed grant-in-aid scholarship to the University of Miami, which obligated the school to the student-athlete, but not the student-athlete to the school. *Bob Davis collection.*

In addition, like essentially all highly touted prospects, Shag was a fierce competitor. Therefore, the fact that he would be facing the nation's toughest competition playing for an up-and-coming program intrigued him. Finally, the compelling Harry Bowers had been thoroughly involved in the prep standout's recruitment—a mentor of sorts—like no other recruiter who had pursued him.

In mid-April, Shag phoned Bowers to announce that his mind was made up. He wanted to attend Miami, and he had just signed his grant-in-aid, which, according to the scholarship, amounted to room, board, tuition and "$15 a month laundry money, according to N.C.A.A. rules." Shag and Bowers agreed on Saturday, May 6 at 5:00 p.m. at the Davis home in Cambridge for the official signing of his National Letter of Intent.

"This recruiting thing was about to drive me crazy," Bob Davis said to the media soon after the signing had been arranged. "I mean it was nice knowing so many schools were interested in your kid, but the phone never stopped ringing."

"I'm glad it's over," said Cambridge head coach Gorton McWilliams. "Steve can play for any college in the country."

Shag, too, was relieved it was over—the weight of the world had been lifted from his shoulders. The quarterback, who apparently could've played for any college in the country, finally ended a long recruiting process that had essentially started a year and a half before. The process was similar to that experienced by many highly touted prospects from yesteryear, but one very different from the present-day procedure.

Like today, football recruits in the early 1970s were allowed five official visits during their senior year of high school. However, whereas a prospect could not make official visits as a junior as of 2017, forty years ago, one could—at least Shag did, three times.

As a result of the local publicity Shag received during his sophomore season in high school as an extremely quick wide receiver and the team's backup quarterback, the University of Maryland began to heavily recruit him the following year. The junior starting quarterback made an official visit to the school in College Park.

After Coach McWilliams had reached out to Penn State, touting the two blue-chip juniors he had on his team—Shag and lineman Bobby Robinson—head coach Joe Paterno began showing interest in the pair. That year, the two boys made an official visit to the Nittany Lions' program at State College, Pennsylvania.

Finally, and it was unclear how the school even became aware of Shag, Tennessee Tech University, located in the small town of Cookeville, also began to recruit him heavily as a junior. Belonging to the lower-tiered Ohio Valley Conference as part of what was then known as the NCAA's Small College Division, the Golden Eagles had little to tout compared to major-college teams. What Tennessee Tech did have to offer to top recruits was the opportunity to play immediately—and play a lot. Thinking a visit to the university might help appease his father's desire for his son to attend a small school, Shag decided to make an official visit there. (The program also offered him something he had never experienced before—a flight on an airplane by himself.)

Once in Cookeville, Shag Davis went through the standard routine of a prospect's visit to a college. He was assigned a freshman scholarship player who gave him a tour of the campus and the football facilities while introducing him to other players. That night, it was the host's responsibility to take the prospect out on the town, showing him a sampling of the school's nightlife.

In Cookeville that night, Shag sat at a country bar outside of campus along with some freshmen players and other recruits. Inside the bar, the host spotted a couple of girls he knew and introduced them to Shag as they joined them at a table. Several beers later, the four of them were exiting the back door of the establishment into a field. As Shag and his host were making out with two girls, another freshman player suddenly emerged from the bar's exit. Swinging the back door open, he shouted, "Look out! Those girls' boyfriends just got here, and they have guns!" Seconds later, two guys carrying shotguns came out the back of the bar. Shag stood up in the field and began maneuvering in the opposite direction of the gun-toting boyfriends when—whether directed at him and his host or in the air in a threatening manner—gunfire abruptly filled the air, inciting Shag into an all-out sprint through the field.

Despite experiencing being shot at, Shag's trip to Tennessee Tech—which, ironically was once known as the University of Dixie—was a significant stop during his recruiting process. It helped confirm a belief of his—a reason for the increased migration south of northern prospects at the time.

By 1971, although the hippie subculture was on the wane, it still was very much present in northern parts of the country. Where Shag was from, it seemingly was "cool" to be a hippie and not so much an athlete, or a "jock." However, evidently in the South, prep and collegiate athletes had been admired for ages, and likely always would be.

By the end of Shag's senior season, requests made by schools for his game film eventually became so excessive that McWilliams started mailing film only to schools he thought the all-everything quarterback would be interested in, which were largely located in the South. To the remaining inquiries, Cambridge's head coach mailed out a novel idea he had created—a recruiting brochure endorsing Shag. Among the superlatives the brochure highlighted were the following: Shag could throw a football seventy yards; he was an excellent runner and blocker; he was "a winner and a game ballplayer"; in addition to quarterback, he could play wide receiver "for any college in the country"; and his six-foot, two-inch, 185-pound frame could run the 40-yard dash in 4.5 seconds. (The time was slightly exaggerated. Shag had been timed with a handheld stopwatch and by a representative of the school. A good portion—if not most—40-yard times presented by high schools during that time were exaggerated.) The brochure also included Shag's career statistics at Cambridge, which included more than 3,000 passing yards and more than 500 rushing yards, most of which were achieved in his final year. Of his forty career touchdown passes, twenty-five were thrown as a senior in just nine games. The brochure concluded by claiming that Shag was "the best prospect in the country."

Prior to the University of Miami, Shag made an official visit to the University of Arkansas, where head coach Frank Broyles drove him around in his car while talking with him for over an hour. He next visited the University of South Carolina, whose interest was initiated when the guidance counselor at Cambridge High School, a South Carolina graduate, contacted the Gamecocks' football program. All the while, the home-state University of Maryland continued to persist.

Although Maryland had struggled, new head coach (and eventual College Football Hall of Fame member) Jerry Claiborne had assembled a good staff, which included a thirty-five-year-old linebackers coach (and eventual

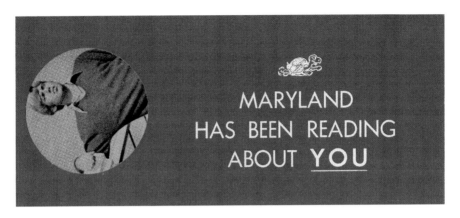

A piece of Maryland football's recruiting material sent to Shag in 1972. *Bob Davis collection.*

prominent college and NFL head coach), Bobby Ross, who was put in charge of the Terrapins' recruitment of Shag. Making at least a dozen visits to the prospect's home during his senior year, Ross became more like an older brother to Shag than a coach attempting to lure him. The two worked out together, and Ross gave him advice on what to expect in college. Even when it was clear that Shag would not be attending Maryland, Ross remained supportive and continued to write him letters.

Notre Dame—at the time, the most celebrated college football program in the country—had been very interested in Shag. However, when it appeared there likely would be a problem with his entry into the university because of insufficient grades and college board scores, the Fighting Irish essentially stopped recruiting the star quarterback. When the esteemed M. Hayes Kennedy, the director of manufacturing for RJR Foods in Cambridge and an active alumnus of Notre Dame, got wind of his alma mater's diminishing interest in a player who was, according to Kennedy, "the best high school quarterback I have ever seen, and I have seen plenty," he rushed to contact the Notre Dame football program. Addressing offensive backfield coach Tom Pagna, Kennedy stressed that Shag's poor grades and testing weren't a result of his bad study habits or academic ability, but "due more to the atmosphere at Cambridge High." Soon after Kennedy's correspondence, Notre Dame regained interest.

Although Shag preferred to attend a southern school, Notre Dame was, well, Notre Dame, and he simply could not resist taking an official visit to the university when invited. After being picked up from the airport by Coach Pagna, Shag was brought to his host for the weekend—Robby, a

big lineman who likely got paired with the recruit because he, too, was from Maryland.

Shag was taken on a tour of the most beautiful campus and best football facilities he had seen to that point. He was so overwhelmed with Notre Dame's grandeur that he literally felt as if he needed to pinch himself to wake up from what seemed like a dream. Robby then introduced Shag to some Fighting Irish players, including a fellow freshman, Tom, who had been the starting quarterback for the school's freshman team.

After Shag met Tom, Robby suddenly stopped and turned to him.

"Look, I'm going to put it to you straight," Robby began. "From what I hear, you are Notre Dame's number-one prospect for the year."

Robby then indicated that Shag would likely not see any varsity action as a true freshman because Notre Dame was probably not going to take full advantage of the NCAA's new ruling on freshman eligibility. However, he would most certainly be starting at quarterback as a sophomore in 1973.

"What about Tom?" Shag asked.

"You don't have to worry about him," Robby said. "Word is that he will not be able to cut it as a quarterback at the varsity level."

Notre Dame might have had the most beautiful campus and the most impressive football facilities, but in terms of a party atmosphere—at least, at the dorm party Robby took Shag to that night—the school essentially had none. At the time, the university was not a fully coeducational institution—accessibility to females was limited, usually restricted to those from the all-female St. Mary's College located across the street. During the dorm party, where the male-to-female ratio was a disappointing seven or eight to one, the atmosphere apparently became so lifeless that a drunk Fighting Irish football player—a standout lineman—decided to liven up the mood. After removing a fire extinguisher from its glass casing in the hallway, he started to hose down partygoers.

After talking with Ara Parseghian the next morning for more than a half hour, all the while wondering if the Notre Dame head coach knew he was still drunk from the night before, Shag met up with Robby. Shag had started to feel somewhat uncertain about signing with Notre Dame, mostly because of its shortage of girls and its limited party atmosphere—so limited that people getting sprayed with a fire extinguisher was evidently the school's essence of entertainment. While walking together on campus, Robby suddenly stopped and turned to Shag.

"Look, I'm going to put it to you straight," Robby began. "I'm sure you got offers from other schools."

Shag nodded in agreement.

"If I were you, I wouldn't come here," Robby said. "Personally, I don't like it—there are no girls and the atmosphere is too stiff. In fact, I'm transferring as soon as I can."

With that, Shag decided that signing with Notre Dame was no longer an option. His "host" had ultimately been the reason for his change of heart. As for Robby, he would indeed eventually transfer—to the University of Maryland. As for Tom Clements—the quarterback who would "not be able to cut it" as a varsity quarterback—he was Notre Dame's starting signal-caller the next season and the two after that, leading the Fighting Irish to a national championship in 1973. He earned first team All-American honors as a senior in 1974.

A few months following Shag's visit to Notre Dame, just after he and the Hurricanes agreed to the May 6 signing date, the father of the Miami-bound quarterback received a phone call from the football program at the University of Georgia. To that point, the Bulldogs had recruited Shag, but only slightly, and not until February of that year. John Donaldson, Georgia's head freshman coach, mailed a canned letter simply asking for a recruiting questionnaire to be filled out and returned.

On the other end of the phone was Don, a graduate assistant at Georgia. Although seemingly somewhat of a blowhard, he was up front and honest with Bob. Evidently, the Bulldogs had just lost out on a particular blue-chip quarterback. The player appeared to be ready to sign, but he then spurned the team for another school. Georgia had already secured five quarterbacks in its incoming class for 1972; however, none of them were highly touted. The Bulldogs, who were coming off an outstanding 11-1 season, returned Andy Johnson and James Ray. The pair was considered perhaps the best one-two quarterback duo in college football; however, they would be a junior and senior, respectively, in 1972, and that much closer to moving on from the team. Don indicated that he was aware that Shag had one official visit remaining. The graduate assistant then closed by asking, "With that being said, how would your son like to take his last visit to a big-time program that certainly could use a Super Eleven All-American quarterback?"

Bob informed Don that his son had already decided on Miami, but there would be no harm in putting him on the phone just to talk. Likewise, Shag soon informed him that he had already signed a grant-in-aid—a verbal commitment of sorts—and the official signing date of his letter of intent was less than three weeks away. In response, with a strong Northeast accent that

surely stuck out like a sore thumb down south in Georgia, Don was abruptly up front with Shag, as he had been with his father.

"That would be a huge mistake!" Don said to Shag over the phone. "Miami's football program is in deep financial trouble and probably will be defunct in a couple of years. If you sign a scholarship to go there, you likely won't make it through four years playing football."

Don's defamation got Shag thinking that, maybe, deciding on Miami might not be his best choice. As for the UGA football program, he hardly knew anything about it—he'd never even been to the state—but he admired the graduate assistant's apparent honesty. And, Shag thought, why not use all of his official visits, even if he had already scheduled a signing date.

Just days later, Shag flew into Atlanta, where he was picked up by Don and driven the roughly hour and a half east to Athens. "The Classic City," as it is nicknamed, was more like a town—a college town in every sense of the term—consisting of forty thousand or so residents and surrounded for miles by rural areas.

Thinking he would first tour the campus and the football facilities, Shag was instead taken to where three houses were located near a river on Elm Street.

"What is this place?" Shag inquired.

"This place has decent rates," Don said, without really answering the question. "But, I only have about fifteen dollars, so I'm not real sure how far you'll get."

Shag had been driven to the infamous Effie's, "an alleged house of ill repute." For nearly a half century—and for evidently a "decent" fee—many a UGA male student had experienced his first sexual encounter at Effie's. On occasion—at least, by way of Don—potential football signees were taken there to help lure them to Georgia. At the time, city officials mostly looked the other way concerning the goings-on inside the three bordellos. Occasionally, the houses were raided by police and fined, but the fines were soon paid, and Effie's would reopen for business.

The fifteen dollars got Shag about fifteen minutes in a room with a nice lady who went by "Kitty." Afterward, Don finally took him on a tour of the Georgia campus and its athletic facilities. Shag was overly impressed with the beauty and prominence of the campus, which he believed rivaled—if not surpassed—that of Notre Dame. And the girls! Never before had he ever seen so many good-looking women at one place in such a short period of time.

In late April, Don traveled to Cambridge to visit with Shag and his family, followed by a meeting with Coach McWilliams for the first time. A

week later, on Friday, May 5—just twenty-four hours before representatives from Miami would be arriving for the official signing—Don returned to Cambridge, where he observed game film of Shag for the first time. From there, he and McWilliams went to the Davis home.

Don, who was equipped with a letter of intent for Georgia, along with McWilliams, Shag's parents and, of course, the recruit himself, discussed into early Saturday morning the collegiate future of a young man who would not be turning eighteen until five weeks later. Shag struggled with the fact that he favored Georgia, yet he had given Miami and Harry Bowers, a friend, his commitment to be a Hurricane. Ultimately, Bob mentioned that if Miami was not going to be his choice, its representatives needed to be notified before they boarded a plane for the scheduled 5:00 p.m. signing at that very house. He then said, "Remember, Steve, it's your decision, and not anyone else's." Don added, "And remember, Steve, what I told you about Miami."

Finally, at 9:30 a.m. on May 6, in front of a small group that included a couple of journalists, Shag ended his recruiting process by signing with the Georgia Bulldogs. An elated Don—who, again, had only seen Shag

Spurning the Miami Hurricanes, Shag signed a letter of intent to become a Georgia Bulldog on May 6, 1972. *Bob Davis collection.*

featured in a single game film observed just the day before—stated to a newspaper writer, "In my own personal opinion, [he's] the finest high school quarterback I've ever seen.…I think our program will be good for him, and I think in turn he will be good for our program."

For the Georgia football program, as for any other college's, many different elements are considered by its potential signees—even a student's fondness for being in and on the water. However, there generally is only one determining factor that ultimately leads to such a significant decision.

The members of the group of prospects who eventually would be seniors at Georgia along with Shag in 1976 had their reasons. Quarterback Ray Goff ultimately decided to become a Bulldog because, in his mind, the school he originally favored, the University of Tennessee, had been pressuring him to sign prematurely. Georgia's other standout quarterback that season, Matt Robinson, had decided to be a Bulldog because the program offered him a dual scholarship, and he initially also wanted to play college baseball. Gene Washington, a lightning-fast wide receiver, initially had no plans to attend college as a student-athlete, despite being recognized at one point as one of the fastest men in the world. Instead, he had plans to start a house-building business with two friends. However, when a couple of Georgia football assistant coaches visited him and his parents two weeks after graduation, they talked Washington's father into his son needing a college education—and, of course, he could play football for the Bulldogs while receiving that education.

As for Shag, his tipping point in choosing Georgia, whose recruiting process for him lasted all of three weeks, over Miami—his original choice, which heavily recruited him for six months—ultimately, yet simply, was a graduate assistant's remark of how his original choice "would be a huge mistake."

4

A Rude Awakening

Before the days of 900 numbers for recruiting enthusiasts to phone, and certainly before the current Internet recruiting sites, finding an accurate account of what schools were attempting to lure a particular prospect, and what places he was interested in attending, could be a challenge. In Shag Davis's case, more plainly, his signing with the Georgia Bulldogs caused outright confusion for those following his recruiting process.

Shag's signing with the University of Miami had been such a foregone conclusion that Cambridge's the *Daily Banner* delivered its early edition on the morning of the signing—just prior to when he actually signed—with the headline "Davis Decides—It's Miami!" For its evening edition, as if the newspaper was confused regarding what had been decided, an article was printed announcing that Shag had signed a letter of intent, but there was no mention of the school.

Those in the media were not alone in being bewildered. Soon after Shag phoned Miami recruiter Harry Bowers and assistant coach Bill Proulx, notifying them of his change of mind just prior to them boarding planes to come to Cambridge, he received a call from Fran Curci. The Hurricanes head coach was also perplexed over the change of heart.

The fiery Curci's confusion soon became anger as he lashed out at Shag. In a way, the youngster didn't blame the head coach for his displeasure. Of course, for a college prospect, it's one thing to hear you might not see playing time because of a lack of opportunity, but it's another to hear you might not see playing time because there is a good chance the school will

Above: An Athens newspaper headlines the Bulldogs' signing of Shag. Athens Banner-Herald.

Left: It was such a foregone conclusion that Shag would sign with the University of Miami that a local newspaper actually printed as much. The Daily Banner.

eventually drop your sport. Ironically, after Miami concluded its 1972 season just seven and a half months later, Curci left the Hurricanes to become the head coach at the University of Kentucky—like Georgia, a member of the Southeastern Conference. Years later, Curci reflected on his decision to leave his alma mater after only two seasons as its head coach: "The Miami board of trustees voted twice to drop football....I'm saying, 'I'm going to get the hell out of here.'"

In part because of the local and national publicity he had received, Shag actually assumed he could just show up at Georgia for fall camp a few months later and immediately be a star player—at least as a member of the freshman team. For the entire summer, he hung out and partied with friends and did not work out a single time. Shag also lost a lot of weight, but mostly strength, and the highly acclaimed quarterback who was listed on Georgia's freshman roster at 185 pounds showed up on campus in late August weighing only around 165 to 170 pounds.

A year before the NCAA placed the first limitations on football scholarships in order to free up money for women's athletics following the

implementation of Title IX, the Bulldogs' 1972 freshman class consisted of a whopping forty-one signees. More than half of the freshmen were from the state of Georgia. Around a dozen players hailed from elsewhere in the Southeast, leaving a half dozen "Yankees"—an often-used derogatory label given to any player who was from anywhere north of the Carolinas.

In 1970, Georgia head coach Vince Dooley had made a conscious effort for the football program for the first time since during the 1950s to start signing multiple prospects from the North. He also began actively recruiting African American players, signing John King, a six-foot, four-inch, 220-pound bruising fullback from Alabama. Georgia's first black scholarship football player, King left the program for the University of Minnesota after being a Bulldog for only a handful of months. Georgia responded by signing five African American recruits for the 1971 season.

Still, despite the efforts of racial and geographical integration by Dooley and his staff, the 1972 Bulldog squad was hardly diverse. The freshman class consisted of just one African American recruit, wide receiver Gene Washington, a last-minute signee who wound up not being a member of the team until 1973, after spending a couple of terms at a military preparatory college.

As far as the six freshmen "Yankees," end Joe Tereshinski Jr. from Washington, D.C., and running back Andy Reid from Ohio were sons/legacies of standout Bulldog players during the 1940s. Quarterback Neal Boring of Upland, California, also had a parental connection of sorts to the state of Georgia. His father had played baseball in the mid-1950s for the lauded minor league Atlanta Crackers, the "Yankees of the Minors." That left three others—a trio of outright Yankees: a couple of signees from the Midwest and Shag.

No matter the makeup of his 1972 team, it was a near-certainty that the forty-year-old Dooley would guide the Bulldogs to another rewarding season. On his arrival to Georgia in 1964, the head coach transformed a program that had experienced only five winning campaigns the previous fifteen years into one that had a better than .700 winning percentage through his first eight seasons. At a time when there were maybe a dozen bowl games—less than one-third of today's total—Dooley had taken six Georgia teams to the postseason following a thirteen-season stretch during which the school made just one bowl appearance. Much of the same—if not even better—was expected in 1972. By late August, well-known college football analyst Beano Cook of ABC-TV sports and *Football Facts* magazine had predicted the Bulldogs to win the national championship.

Off the field, Dooley could be difficult to get to know on a personal level, especially for an incoming player. Although never cold or aloof, the head coach often seemed detached and preferred to stay out of the limelight. Prior to his coaching career, Dooley had served in the U.S. Marine Corps, ending his service with the rank of captain. Accordingly, more than fifteen years after serving in the marines, he exuded a military-like persona that could be intimidating. There were freshmen who literally thought he was unapproachable, almost as if they were not supposed to speak to him. Considering its head football coach, it was fitting that Georgia's athletic dormitory, McWhorter Hall—or, the initial facet of the university's football program newcomers were introduced to upon arrival in the summer—was essentially run like a military camp.

Named after Georgia football's first All-American, Bob McWhorter, McWhorter Hall was a relatively new and state-of-the-art college dormitory for its time. The three-story building was like a motel where rooms were entered from the outside. Each room was occupied by two players, and four rooms made up a suite, each consisting of two showers, two toilets and three sinks. The dorm featured a very nice dining hall and a recreation room equipped with a television and a couple of pool tables. Still, as contemporary as McWhorter Hall was, it was governed by a strict set of rules—more rigid than what most of the members of the 1972 freshman class had endured while living with their parents.

As it turned out, although Shag was probably the most highly touted of Georgia's freshmen, he wasn't the only newcomer who had been distinguished as among the country's best prep players the year before. As most of the more than forty signees arrived at McWhorter Hall the day freshmen were to report, included were high school All-Americans Les Stinson, an end from Metter, Georgia; Will Legg, a center from Athens, Alabama; and Columbus, Georgia's Donald Byrd, who had been recognized by *Kick-Off* magazine as one of the nation's top running back prospects.

Nearly all of the freshmen were paired up with one another, leaving only a few coupled with older players. Shag was paired with redshirt freshman Richard Appleby, who had been one of Georgia's five African American signees the year before. Appleby, a tight end, had been a top prospect from Clarke Central, a local high school in Athens, before sitting out the 1971 season to improve his grades. Although initially puzzled why he was rooming with a player a year ahead of him, Shag arrogantly and mistakenly believed the pairing was likely due to the idea the duo would

become one of Georgia's top pass-catch combinations. That was until, just a few days after roommates were assigned, Shag was visited by "Kojak."

Given the nickname for his likeness to the television character played by Telly Savalas, Kojak was officially titled Georgia football's "Counselor to Athletes." However, he was more like McWhorter Hall's disciplinarian, watching over the dormitory's residents like a hawk. Taking no guff from anyone, Kojak was really good at his job and rather intimidating. Shag was thus surprised during his visit when the dorm dictator seemed rather apologetic.

"Steve, we're really sorry," Kojak stated. "We didn't mean to put you in a room with a black guy. That was a mistake on our part."

Unbeknownst to Shag, Georgia football was still in the early stages of integrating its program. Nevertheless, he informed Kojak that he had no problem living with Richard. A good portion of Shag's football team at Cambridge High School was black, and he had been the only white player on the varsity basketball team his senior year. He had several good friends who were black. In addition, Richard seemed like a good guy and good roommate in the short time he had known him.

"No, no, that wasn't supposed to happen," Kojak countered. "We're going to move you in with someone different."

Shag's new roommate was about as different from Richard as one could be—and beyond just race. Standing six feet, four inches tall and weighing 245 pounds, hailing from Macon, Georgia, lineman Steve Wilson was not only as strong as an ox—carrying a six-pack stomach, he was also an absolute physical specimen.

Wilson was one of several freshmen who appeared to Shag like freaks of nature. There was "Flat Ass," a six-foot, six-inch, 260-pound lineman from Alabama nicknamed for his humongous, slumping stature that made him appear as if he didn't have a backside. One of the state's top lineman prospects, Steve Murdock from Lindale, Georgia, stood six feet, four inches and weighed 240 pounds. Finally, exhibiting the broadest set of shoulders Shag had ever seen on any human being, Cooper Gunby from Thomson, Georgia—six feet, two inches and 235 pounds—was not even a lineman, but a linebacker.

It is likely that none of the "Yankees" in Georgia's 1972 signing class had played with or against such large and strong players. Hailing from the Delmarva Peninsula—the area occupied by most of Delaware, the Eastern Shore of Maryland and the Eastern Shore of Virginia—Shag certainly had never faced or played with as much physicality. For instance, the average

weight of the freshmen linemen the University of Maryland signed in 1972 was less than 215 pounds.

At Woodruff Field, named after reputable George Woodruff, a former Georgia player and head coach, and where the Bulldogs conducted their practices, the freshmen underwent speed drills for their first few practice sessions. Shag's weight dropped even more—to as low as 160 pounds. When practice eventually began in full pads, the Maryland native was quickly reminded of the one time as a senior in high school when he was not the leading player on the field—and far from it.

Quarterbacking Cambridge in 1971, Shag was filled with confidence and cockiness. During a 72–8 blowout over Colonel Richardson High School, his backup faked an injury late in the second quarter, forcing Shag back into action so he could tie the single-game school record for touchdown passes (five). What's more, Shag achieved the passing record on a play in which the head coach had called to run the ball. During a few games, merely to fuel his humor, Shag informed opposing defenders at the line of scrimmage of the actual play the offense was to run. The record-breaking quarterback amassed his yardage and touchdowns primarily playing for only about two and a half quarters per game; he was pulled early because the Raiders by then were routing their opposition. However, against Elkton High School—a team full of big and fast farm boys—it was a completely different story for the normally self-assured Shag.

Elkton handed Cambridge its only loss of the season in an otherwise perfect 8-1 campaign. The defeat not only cost Cambridge the Bayside Conference title but, in a time when only the winner of the conference made the playoffs, the one-sided loss also deprived the school of a postseason appearance. The Elks' huge defensive line shut down Shag and the Raider offense, wore them down physically, in a 38–14 defeat.

Shag likened practicing in full pads at Woodruff Field to the night a year before when he faced Elkton, except instead of encountering big, quick farm boys, he was up against large, fast southern boys. Such was the case every day during fall camp and twice daily during two-a-days. For those who were not prepared—mentally and/or physically—for the daily grind on the field, coupled with the constant harassment from upperclassmen, it could become too much for a young man to bear, especially if one did not quite fit in socially.

One morning during the summer, as Georgia's freshmen gathered to take the field for practice, a coach shouted, "Where's Anderson?!?" referring to a signee from Indiana and directed at his roommate.

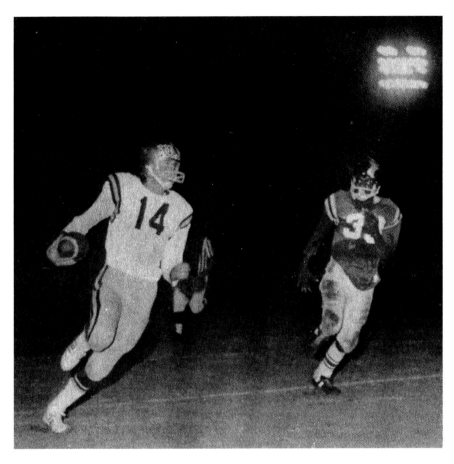

On his arrival to Georgia, Shag realized that practicing against his Bulldog teammates was a far cry from when he starred while playing against Delmarva prep teams. *Bob Davis collection.*

"It was the damndest thing…" Anderson's roommate began.

The freshmen then heard of how the night before, around midnight, the roommate suddenly awoke to see Anderson leaving their dorm room holding a couple of suitcases and literally tiptoeing as he crossed the threshold. Once the door shut, the roommate moved to the window to see Anderson briskly walking toward a taxi cab. As it turned out, the disgruntled freshman could no longer stand Georgia's fall camp and took a redeye flight to Chicago for home. When the roommate finished the story, the freshmen collectively howled with laughter. The coaching staff must have found humor in it, as well. From that point on, for the rest of fall camp, whenever a player was struggling on the practice field, a coach could be heard hollering something

on the order of, "You wimping out?!? You want to pack your bags, tiptoe out of the room at midnight and catch the redeye back home?!?"

One afternoon at practice, when Shag took the snap from center on an option play and faked to the fullback, a big defensive lineman slammed directly into his left knee, knocking him down. Shag instantly knew something was wrong with his knee. However, he did not want to appear to his teammates and coaches as lacking toughness—he did not want to be taunted about catching "the redeye back home" to Maryland. He remained on the field. The next play called was a quarterback sweep—perhaps the worst play to call for a quarterback with an apparent injured knee. Shag took the snap and started to roll to his right when he instantly felt his knee wobbling, as though it wasn't fully attached to his lower leg. Unable to withstand the pain, he stopped the play just before he was about to run head-on into a charging linebacker.

Shag was taken to the hospital, where it was discovered that his knee had suffered severely stretched ligaments. His leg was fitted with a full-length cast. His ability to play football had become rather restricted. Nevertheless, Shag's off-the-field self-indulgence only persisted—and escalated.

Just a month or so before, the Twenty-Sixth Amendment had decreased the legal drinking age in the state of Georgia from twenty-one to eighteen. As a result, the students at the university, which had been recognized in November 1971 as "exclusively a party school" by the *Red and Black*, became, on the whole, even wilder.

On the first of the few days the team had off during fall camp, one of the freshman quarterbacks decided to throw a party for the entire incoming class at his sister's off-campus apartment. This debauchery-filled night was an eye-opening experience for several of the young men, including Shag, who had always believed there were few people who could be as wild as he was.

Shag discovered how much beer could be consumed by many of the southern boys; in turn, he also saw how untamed and reckless they could become. At the same time, he experienced how friendly and neighborly some of them would remain—true southern hospitality. And speaking of southern hospitality, while also discovering how difficult it was to urinate while wearing a full-length cast while drunk, the first time Shag started to relieve himself at the party, he was suddenly startled when the nearby shower curtain was pulled open. Lying in the bathtub was a naked couple—a freshman teammate of his with a beautiful southern belle.

"You look like you could use some help. Let me hold that for you," the girl said in a distinct southern accent while reaching out and grabbing

Shag's penis. After he awkwardly finished urinating, she added, "Now, hold on. If I'm going to fully assist you, let me help you finish up" as she jiggled his shaft a few times.

A house party such as this was normally restricted to the weekends. Unlike today in Athens, where bar hopping is popular throughout the week, nightlife at local bars in the 1970s generally occurred on weekdays. For instance, Wednesday night was commonly known as "drink and drown night." Downtown Athens at the time was basically a retail center and not a place featuring a music scene with a party-like atmosphere. In 1972, the town's most popular bars—at least the ones often frequented by many of the Georgia football players—included Between the Hedges, Allen's, the Fifth Quarter, T.K. Harty's Saloon (more fitting for an older crowd) and the Dog House. Only the latter was located downtown.

The first night out at a bar for several freshman players took place at Allen's, a staple of Athens for nearly a half century located on Prince Avenue and known for its hamburgers and cheap beer. As the group was entering Allen's, one of them—a six-foot, five-inch, 220-pound player from south Georgia—stopped several others just prior to their walking in. Notably, in just a short period, the large player had already established himself among the class as an absolute wild man, a legitimate nut.

As he had apparently done before while in high school, the "wild horse," as he was characterized by one of his teammates, informed the players that he was going to introduce the girls inside Allen's to his "pet white-eared elephant." He then commenced by pulling out the insides of his pants pockets, resembling two dangling white elephant ears, followed by unzipping his pants and pulling out his penis, suggesting a dangling elephant trunk. Entering the bar, he proceeded to tap at least ten girls on the shoulder. As the girls—complete strangers—turned around, he inquired, "Would you like to meet my pet white-eared elephant?" while motioning toward its "trunk." The girls screamed, and the friends with them screamed. Soon, Allen's was transformed into a shriek-filled bar where any girl who hadn't already made a run for the door gathered in a corner, as far away from the "pet elephant" as she could.

The same wild teammate broke his leg sometime later and was fitted for a cast. After a couple of months, when the team doctor, the esteemed Dr. Marion Hubert—in his mid-seventies at the time—was removing the cast, a bag of marijuana that had been tucked inside of it fell to the floor. With all sincerity, the player asserted, "I've been wondering what I did with that!"

Although seriously injured at practice during his freshman season, Shag discovered that he could "thrive" in college aside from football by partying. *Bob Davis collection.*

More so than its bar scene, Athens was known in the early 1970s for the renowned musical acts it attracted. In just a little over a year after Georgia's 1972 signing class arrived on campus, America, B.B. King, Elton John and Marshall Tucker were among the reputable bands that performed in the college town.

The day of a Manassas concert, the manager of Stephen Stills approached head equipment manager Harry Weaver. Meanwhile, a few freshmen players gathered around, impressed that an individual representing the former member of Buffalo Springfield and Crosby, Stills, Nash & Young had graced their locker room. Weaver, who had been a member of the program for about a dozen years and would continue until retiring two decades later, had been recognized as "the man who makes Georgia's athletic teams go." Generously, he would help jump-start the Georgia Southern football program about a decade later by donating a portion of the Bulldogs' equipment to what was then a club team. Still, Weaver took his job very seriously and was not impressed in the least with the presence of Stills's long-haired manager.

It was explained to Weaver that Stills was a big football fan and preferred to wear a football jersey on stage representing the school where he was performing.

"Can we borrow a University of Georgia jersey for Stephen to wear for tonight's concert?" Stills's manager asked.

"Hell, no, you can't have a jersey! Get outta here!" Weaver answered.

Embarrassed and surprised, the manager glanced at Shag with a look of "Wait, did he really just say that?" Shag, who had just put on his No. 11 jersey, pulled it off and said Stills could wear his jersey that night. The manager was very pleased and indicated that the singer would likely want to party following the concert, so Shag and a few other teammates should stop by their hotel room afterward. The players were honored but had no choice but to decline the offer, especially in front of Weaver, in light of McWhorter Hall's strict curfew.

Stills's manager walked off with jersey in hand. Weaver blurted to Shag, "That'll be four dollars you son of a bitch—unless you don't want to wear a jersey to practice!"

Partying and concert-going made it rather difficult for a significant number of Bulldog players to abide by McWhorter Hall's 11:00 p.m. in-season curfew, 10:00 p.m. the night before games. Another dorm rule prohibited alcohol in the rooms, although virtually everyone was of age to drink. Residents could not have any facial hair whatsoever, and earlobes had to be seen through one's hair, which couldn't reach in the back too far down over the collar. If there was a violation of all of the above, there especially would be hell to pay—even for those violators who were only visitors.

Around the time Manassas played at the Georgia Coliseum, the Allman Brothers Band did so as well, marking what remains the only time the prominent band has ever headlined a show in Athens. Shag's brother and some of his friends from their small college in Maryland drove down to attend the concert, followed by spending a night on the town before crashing at McWhorter Hall. Catching wind that a group of "hippie" boys from up North had spent the night drunk in Shag's room, a dorm disciplinarian bearing a master key paid the group a visit early the next morning.

"Shag!" bellowed a booming voice standing above the player passed out on his bed. It was Kojak. "Who the hell are these Goddamn long-haired hippies in your room?!?" he yelled. "Get these people out of here!"

As Shag's friends started to wake up, Kojak spotted a half-filled fifth of whiskey one of the boys had set on a desk behind the bed. He grabbed the bottle, opened the door to the outside and, as all the boys sat in disbelief, poured out what remained of the whiskey over the railing.

"They got ten minutes to completely get out of here, Shag!" Kojak added. "We don't need these lowlives hanging around McWhorter Hall!"

Between the stern but fair Dooley, the lurking enforcer, Kojak, and the assistant coach who resided in the dorm as its authoritarian, it perhaps was a wonder how the tenants of McWhorter Hall could get away with any shenanigans whatsoever. Granted, there often was mischievous or childish behavior typical of boys or young men: a player getting grabbed and picked up by a couple of drunk teammates late at night and dangled over the dorm's railing by his ankles; hiding a dead fish between the box springs of a bed, whereby the putrid smell could persist for weeks before being discovered; or, worse, the good ole "shit in the shoebox" trick, in which a shoebox was filled with excrement and then hidden well, like in the ventilation system of a neighbor's room. However, as far as any absolute immoral chaos or disorder,

such was not evident—at least, not to Shag, and not until after he had lived a few months in the dormitory.

Another guideline of McWhorter Hall was mandatory breakfast. On one particular morning, Shag was cutting it close as to whether he was going to make it in time for the meal. Still, his slow run toward the dining hall was suddenly interrupted when he heard commotion coming from inside a teammate's room. Shag quickly swung open the door to see what all the fuss was about. There before him was a sight unlike any he had ever witnessed or could have imagined. A player from his class was standing naked over an unknown older man who was lying on his back and propped up on his elbows while he was fellating the player. A few teammates stood in the corner of the room and were, in a way, cheering on the player. It was not a moment of sexual pleasure for the player, and certainly not a passionate occasion, but more like a mocking game of ridicule and dominance over the older man, apparently a homosexual, while deriving amusement from teammates.

Almost sick to his stomach, Shag quickly shut the door and continued running toward the dining hall with one thought in mind, and it no longer had to do with getting to breakfast on time. In reality, in terms of being "wild," he was somewhat tame compared to other players in Georgia football's freshman class of 1972. For the "Yankee" from Maryland, that was probably not a bad thing.

5

Brutes Will Be Brutes

After arriving on campus, one of the first experiences many freshmen players had outside of McWhorter Hall was being taken by an upperclassman to see "Black Jesus." A number of newcomers had gotten wind before leaving for Athens of the strenuous and humiliating initiation process that awaited them. Therefore, being driven to see a man—and one named "Black Jesus" just after the program had been integrated—was an alarming notion for some.

What a relief it was for most newcomers to hear that there would be no actual interaction with Black Jesus, only observation of the man as the players sat in an automobile. While driving on the outskirts of a predominantly African American apartment complex near where Alps Road and Hawthorne Avenue cross Broad Street today, the upperclassmen claimed that Black Jesus was a penitent from a strict religious sect who climbed up on a cross, where he attached himself at sundown every night. He would hang there all night until climbing down at sunup the next day.

"And, there he is…" an upperclassman whispered to Shag while pointing off in the distance as he parked his car. And sure enough, roughly one hundred feet away, a cross was definitely visible. Attached to it was what seemed to be a black man who, although only in the slightest, appeared to be moving.

It took some freshmen a while, some as many as a few months, before they discovered the truth regarding Black Jesus—such as when the figure was observed during the day. As per local folklore, he was indeed black in color,

This photograph, believed to have been taken in 1973, shows "Black Jesus." The optical phenomenon was part of local folklore and often one of the first encounters for Georgia freshmen football players. *Al Garbin.*

but he was merely a statue that had become charred years before when the church it was part of caught fire and burned. As far as the figure appearing to move, it was an optical phenomenon. The statue seemed lifelike when lit by the moon.

For those newcomers who assumed that tasks like merely observing Black Jesus would be the extent of being initiated from freshman status, they were soon in for a sudden, unwelcome and discouraging realization.

When the older players moved into McWhorter Hall for the start of fall camp, the freshmen had to stop what they were doing and carry the elders' bags to their rooms. At dinner, newcomers had virtually no place in line for food; upperclassmen could butt ahead of them at any time. And whenever a freshman heard a ringing glass—an older player clanging his drink with a utensil—he had to immediately run to the sound. The freshman would then essentially become a waiter or, more accurately, a servant. Waiting on the older players lasted for the majority of one's freshman year. As far as the freshmen's eating experience, some upperclassmen literally went out of their way to prevent that from happening in the dining hall—even if it meant waiting around late in case a freshman decided to eat just prior to its closing. Still, being harassed while denied food was only the tip of the iceberg of what was in store for the incoming class.

On one of their first nights, the freshmen were instructed to report out in front of McWhorter Hall for "Rat Court." Arriving at the immense parking lot that faced the dormitory, the neophytes looked up to see several dozen harassing teammates hanging over the balconies. The freshmen were told to take off all of their clothes except their underwear and line up in a line shoulder-to-shoulder facing the dorm and with their backs to the parking lot. As the freshmen stood silent at near attention, the sound of a siren soon pierced the air.

The freshmen turned around to the noise. Some actually believed the local or campus police had showed up to put a stop to what promised to be a horrific experience. Instead, much to their chagrin, a 1950s police car driven by an upperclassman with its siren blaring, lights flashing and engine revving escorted a black limousine around the parking lot. The limo's windows were rolled down, and noticeable in the back were three individuals dressed in Ku Klux Klan attire. A figure on one side with huge bulging biceps waved a Confederate flag out the window, while the one on the other side, exhibiting biceps nearly as big, held a sawed-off shotgun. Although dressed similarly, the hood and robe of the middle passenger was colorful, unlike the all-white attire worn by the other two.

As the two cars continued driving around in circles, the hooded figure with the shotgun began shooting into the air. The roughly forty members of Georgia football's 1972 incoming class stared in amazement, confusion and dismay. One freshman whispered to no one in particular, "This is like something you'd see straight out of the fucking movies." The experience was about to become even more entertaining.

The two cars pulled up to the line of freshmen and, from the limo, out stepped the three apparent members of the KKK. The one in the colorful outfit appeared to be the "Grand Dragon." At second glance, it was obvious that the three individuals were upperclass football players. Shag recognized two of them immediately, including the Grand Dragon, the largest of all the players.

One by one, each freshman was asked a series of questions, including his name, where he was from, what position he played, how fast he could run the 40-yard dash, how much he could bench press and, finally, if he was "bad" or not. The first newcomer replied, "Yes," he was "bad." This prompted the players on the balconies—the "peanut gallery"—to call out, "Wooo, wooo, wooo." After the freshman quickly responded instead with "no," this incited the peanut gallery to cry, "Booo, booo, booo."

With a black magic marker, the hooded players drew circles around each freshman's nipples and bellybutton for what turned out to be target practice for the peanut gallery. The newcomers were pelted with eggs, mud balls, water balloons—and it got worse. For some time, the peanut gallery had been urinating and defecating into buckets, and these were soon slung at the newcomers, splattering urine and feces onto them. They were then instructed to roll around in a nearby grassy area. Further punishment usually awaited, as many of the freshmen were bent over and beaten with a belt.

Going along the line of frightened and dazed newcomers, the trio of upperclassmen eventually reached Shag.

"Oh, you're the All-American quarterback!" one of them started. "We hear you can throw a football 60 yards." Shag instantly became somewhat relaxed, knowing he could throw a football 60 yards without even warming up. "With *both* arms!" the player added.

Shag was no longer relieved. With his right (throwing) arm, he heaved a perfect spiral that traveled 65 yards or so, prompting some "woos" from the peanut gallery. However, with his left arm, Shag lobbed an ugly, wobbly pass that covered 20 yards at most, causing the players on the balconies to shower him with "boos."

"Where is the Mason-Dixon line?" asked another of the three players. As Shag started explaining that he thought it was somewhere in Maryland, he was interrupted.

"Wrong!" exclaimed the upperclassman. "It's where southerners go to shit, and northerners go to eat."

Appearing to be highly agitated, the same player asked, "How do you spell 'Georgia Tech'?"

Shag started, "G-E-O-R…"

"Wrong already!" hollered another one of the three upperclassmen. "It's capital S-h-i-t, and you dot the 'i' with a pile of shit and cross the 't' with a stream of piss." And, with that, Shag was doused with buckets of urine and feces, pelted with eggs, mud and water balloons and then bent over and beaten on his backside with a belt.

Next, it was time for Shag to be given a nickname. For those freshmen receiving a moniker, their new name ranged from the fairly innocent to the downright degrading. The father of fellow newcomer Andy Reid, Floyd Reid, a standout Georgia halfback in the 1940s, had been nicknamed "Breezy" for his speed. Andy was given the same name. A player from the Chicago area had been asked to give the name of one of his friends from high school. When he replied that he had an Asian friend back home named "Nish," the three hooded upperclassmen and the peanut gallery first bellowed with laughter before bestowing the freshman the same name. A newcomer who had a large, circular birthmark was given the nickname "Full Moon." A lineman who had some sort of deformity in his left arm was nicknamed "Lefty," whereas another freshman who had an abnormality with his right arm was labeled "Slot Machine." As for Shag, he perhaps made the mistake of having a shag haircut, similar to that of Mick Jagger, Rod Stewart and David Cassidy at the time, in an area abound with conservative hairstyles.

"What the fuck is that haircut all about?" asked one of the upperclassmen.

"It's a shag haircut," Shag answered, "It's kind of fashionable where I'm from."

The response by the upperclassmen consisted of some laughter and a smattering of boos; nonetheless, Shag was ultimately given the nickname of the type of hairstyle he had.

Finally, the freshmen had to bow before the three players dressed like Klansmen, including the Grand Dragon seated in the middle. The trio sat in chairs atop the front steps leading to McWhorter Hall while a hangman's noose dangled overhead from the second-floor balcony. Shag thought about the five African American players who had been freshmen the year before.

Surely, they did not have to endure the same racist encounter. As it turned out, they did have a similar experience.

As Clarence Pope, one of the five black players, recalled in an interview years later: "There were guys that were sitting at the front of the steps at McWhorter Hall, and you had a Grand Dragon who had a sheet over his head sitting in a chair with a shotgun. You had other guys sitting with shotguns and a bandolier belt with ammunition in it. From what I hear, this was a welcome that they always did. It was something we [the five black players] didn't like."

Finally, the freshmen were informed that if they didn't already know the school's fight song, *Glory, Glory*—and few did—they'd need to learn it immediately. Tobacco was stuffed into the mouths of some of the "Yankee" newcomers, who were then forced to learn *Dixie*, a popular southern song released during the blackface minstrelsy of the nineteenth century. While attempting to sing both songs, the freshmen were marched around the parking lot in lines resembling a drill team.

Going forward and before the 1972 season started, the incoming class had to endure certain aspects of Rat Court on multiple occasions, especially following one afternoon when the freshmen defeated the varsity in a scrimmage.

Soon after the scrimmage, the highly anticipated season started in mid-September. But the Bulldogs did not play like champions, as had been forecasted. They had a difficult time defeating four-touchdown underdog Baylor in the season opener. The substandard performance was followed with an outing even more shoddy, as Georgia was upset in New Orleans by Tulane, 24–13.

Things got better for the Bulldogs. In game three, they defeated a good North Carolina State team coached by a thirty-five-year-old Lou Holtz. Versatile sophomore Horace King starred for Georgia, becoming the first African American to score a touchdown in the varsity program's history. A newspaper article from the Associated Press the next day declared, "Negro Back Lets Georgia Click, 28–22."

N.C. State was an excellent example of a team utilizing the new NCAA ruling of freshman eligibility. At the time, it was estimated that freshmen players had already made considerable contributions to at least three dozen major programs. But such was not the case at Georgia—not even close.

Although the Bulldogs had dressed out eight of their signees for the Baylor game, only one—Glynn Harrison, a running back from Decatur, Georgia—saw playing time against the Bears, rushing twice for five yards. In

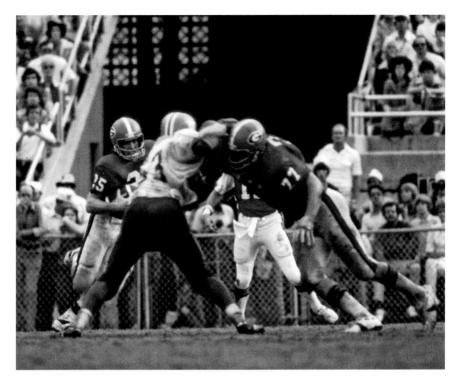

Although freshmen were eligible to play varsity ball in 1972, no newcomers lettered at Georgia, and only freshman running back Glynn Harrison (background with ball) saw the field. *dr. jteeee collection.*

the end, none of the freshmen earned a letter for the season, a disappointing 7-4 campaign for the Bulldogs. For just the third time in head coach Vince Dooley's nine years, Georgia did not play in a bowl game.

At Georgia, freshmen essentially remained suitable to play only for the junior-varsity Bullpups team. Beginning its schedule more than three weeks following the varsity squad, the Bullpups impressively won three of their first four games. Quarterbacked by Ralph Page and Neil Boring, they were just as conservative offensively as the run-oriented style exhibited by the varsity Bulldogs. After being sidelined for two months because of his knee injury, Shag returned to the freshman team. Since Page and Boring had established themselves at quarterback, Shag was moved to wide receiver. Despite missing the first two games rehabbing his injury, he led the Bullpups in receiving for the season—only four catches for sixty-two yards.

The Bullpups' season finale against Georgia Tech's Baby Jackets, the Shrine's Scottish Rite Classic, was the most distinguished freshman game

in the country. The game, which had started in 1933, was always played at Georgia Tech's Grant Field and usually on Thanksgiving Day. Although attendance had steadily declined to just over twenty thousand spectators, the annual affair in the 1950s had drawn close to forty-five thousand, or nearly as many fans as the Georgia–Georgia Tech varsity game would attract a couple of days later.

Yet it was the event before the game that, if for only a short time, was an experience like no other—one that could tame the wildest of the wild. For instance, the "wild horse"—the large freshman player who had introduced his penis to girls as an elephant trunk and later was discovered to have stashed marijuana in the cast on his leg—was said to have drastically improved his behavior so he wouldn't get thrown off the team, and also to experience the Scottish Rite Classic. He was aware that the experience was much more than the game.

The day before Thanksgiving, the Georgia freshmen, followed by Georgia Tech's thirty minutes later, toured Atlanta's Scottish Rite Hospital, which collected all the proceeds from the following day's game. Visiting children with physical or mobility impairments induced feelings that cannot be adequately described—even to this day—by the eighteen- and nineteen-year-old players who experienced as much. The visit resulted in the freshmen being placed on a pedestal as heroes by the children. Many of those heroes then walked out of the hospital with tears in their eyes. Huge linemen literally bawled over an encounter like none they had ever experienced before, or likely have since.

For some Bullpups in 1972, the experience at the hospital included an unforgettable encounter with Athens native David McGill, who was about to turn three years old. Born with an open spine, David had been hospitalized after he fractured both of his hips as a result of his weak legs, leaving little hope of him ever walking. Early in his life, doctors decided he wouldn't live too much longer. But after multiple operations and skin grafts, David was beginning to stand up on his own while working on being able to walk. He had also recently learned to talk—and how.

"What's your name?" David blurted as he stared at the largest player among a group of Bullpups.

"I'm Will Legg," replied the lineman. "Who do you want to win?"

With a sense of diplomacy, David replied, "I want football players to win." It was the same response he later gave when asked the same question by a Baby Jacket player.

Legg and the group moved on to visit with the next child, prompting David to assert, "Come back and talk to me, Will." He then curiously asked,

"Where's your car?" It, too, was the same question he would later ask a player for the Baby Jackets.

David's parents, Paul and Judy, later explained that, despite all that their young son had endured, he never cried—except when he craved to return to his home in Athens. He knew he could only get home if he was given a ride by someone. Thus, everybody who had a car was fair game.

Only a year later, David would become well enough to leave the hospital and attend the 1973 Scottish Rite game. Eventually, the young child who wasn't supposed to live for very long got even better and returned to Athens. He finally found his ride home. In time, David graduated from Clarke Central High School, where he served as a manager for its football team. He became a counselor for Extra-Special People, an honorary member of the Athens Jaycees and, fittingly, a spokesman for the Georgia–Georgia Tech Junior Varsity Thanksgiving Day Game. In 1999, David McGill passed away at the age of twenty-nine.

It is understandable why the Scottish Rite game could have been considered somewhat secondary in light of what had taken place the day before. Still, when the Bullpups and Baby Jackets met on the gridiron, the contest was viewed as monumental, especially for Georgia in 1972, as Georgia Tech entered the game undefeated on the season.

Trailing 14–10 with 7:09 left in the contest, the Bullpups appeared primed for the upset, as they held possession on the opposing 37-yard line. Although Shag's injured knee hadn't fully recovered for him to play the quarterback position, head coach John Donaldson wanted to utilize the prep All-American's strong arm by taking a shot downfield. However, although Shag hadn't attempted a pass all season, the Baby Jackets had prepared for the possibility of him throwing from his wide receiver slot.

Following the game, a sportswriter noticed in Georgia Tech's locker room a green blackboard, scrawled on it what remained of a pregame directive: "Be alert for No. 11 [Shag], he can throw." And, when Shag was handed the ball, he threw a perfect strike to his receiver for what appeared to be a touchdown—until the ball hit the receiver in the chest and fell to the turf. The incompletion was a hint of what Shag's collegiate passing career would become.

Two plays later, a Bullpups' quarterback threw the team's fourth interception of the game. And, irony of ironies, the Baby Jackets then countered with a trick pass of their own when one of their halfbacks passed for a long touchdown, clinching a Georgia Tech victory with just under three minutes remaining.

The season had ended on a losing note. And with it, apparently, all of the freshmen hazing at McWhorter Hall had also ended. Yet for some, there was one final step—or, rather, a final stoop. One by one, a few of the newcomers were blindfolded, guided into a bathroom and instructed to kneel before a toilet. Each freshman was told to reach into the toilet water, where they would feel a long piece of feces. They were to pull the excrement out of the tank and take a bite of it. If one refused, it was threatened that he would be beaten. As one upperclassman informed a hesitant freshman, "Eat shit, or get the shit kicked out of you!"

Blindfolded while holding what certainly felt like a long piece of feces, all kinds of thoughts were swirling in the heads of the freshmen: "Others have taken a bite, so what can it hurt for me to do so also?" For some, there was little thinking at all: "Just bite the damn turd and get this initiation over with!" Either way, how comforted each newcomer was when what was supposed to be a turd turned out to be a banana covered in peanut butter, and that it actually tasted pretty good.

Although relieved, a freshman could not help but also feel deflated and disgraced as he got up from stooping over the toilet, one into which he had just submerged his arm. Still, there was some good that came out of the initiation process: a special, brotherly bond had been formed among the newcomers, knowing they had all survived a brutal freshman year— together. Yet, for a couple of these rising sophomores, a harsh realization would persist into spring practice of 1973.

During the winter, the NCAA made sweeping changes in college football, including limiting scholarships: 30 new scholarships per year, with an overall team total that could not exceed 105. First and foremost, the new rule suggested that fewer chances could be taken in the recruiting process. Programs would have to be more selective in recruiting to reduce the possibility of mistakes, like enrolling too many high school stars who eventually became "flops" at the college level. With scholarship limitations, programs could no longer afford to have too many flops as part of their team. If so, whether instigated by assistant coaches, graduate assistants, trainers/managers or even teammates, there could be an attempt to run certain disappointing players out of the program—try to make them quit. This business-like decision in order to free up scholarships, executed by major college programs all over the country, was evident at Georgia at the beginning of spring practice when a rising sophomore scholarship end walked into the football locker room at the Georgia Coliseum.

Pictured in 1974, Georgia's McWhorter Hall at times was the site of unspeakable and appalling actions and behavior, yet it was where brotherly bonds were repeatedly formed between teammates. *Henck and Kelley collection.*

The player had been injured for most of his freshman campaign and was still somewhat banged up. A looming injury coupled with, on second glance, what seemed to be a lack of potential to eventually contribute to the team were reasons why, after a lengthy search, he could not find his locker. After all, he no longer had one. Believing some mistake had been made, he approached a trainer, asking him to tape him up before practice. However, he and his request were totally ignored, as if he was invisible. As a consequence, someone had decided that the player needed to be driven out of the program and, in short time, succeeded in doing so, freeing up a scholarship.

With the start of spring practice came the paramount question: who was going to back up standout senior Andy Johnson at quarterback? James Ray, Johnson's backup for two seasons, had graduated. A trio of signal callers— Shag, Boring and Page—one of whom was certain to receive ample playing time in 1973 as Johnson's backup, battled it out throughout the spring.

Despite being the only one of the three who had not played quarterback the season before, Shag entered the practice session as the slight favorite to win the number-two job. However, a couple of weeks into practice, he popped his throwing arm out of joint, whereupon his passing suddenly became somewhat inconsistent. It was next reported that the three quarterbacks

were in a dead heat. Finally, by the end of the spring, while Shag's knee had plainly not healed completely, slowing him, especially on the Bulldogs' often-used option plays, Boring was said to hold the slightest of edges over the other two.

Having been told by the Miami Hurricanes that he would be the team's starting quarterback as a true freshman, a dejected Shag cringed at the thought of being a third- or fourth-stringer in his second year at Georgia. At the time, nothing could have made the rising sophomore feel more disheartened—except maybe being informed he faced one more phase of the initiation process before actually becoming a sophomore.

At the conclusion of spring practice, the freshmen were given notice one afternoon that an early barbecue lunch the next day at McWhorter Hall was mandatory. On arrival at the dining hall, they were curiously instructed to eat at least two barbecue sandwiches. Surely, some freshmen thought, there was a reason why they were being forced to eat so much. They would soon find out.

There is the final stage of every other college initiation there has ever been—and then there was Georgia football's "Seagraves Initiation." It was an event so insane and untamed, one might not believe it was legitimate unless they experienced it firsthand.

Equipped with a private lake, Seagraves Farm was located roughly five to ten miles outside of Athens in a rural area. A country road led to a dirt road, which led to a lake in what seemed like the middle of nowhere. When the 1972 freshman class was taken to Seagraves in groups, each was met by the same huge lineman who had been the Grand Dragon for Rat Court. But instead of being dressed in KKK attire, he wasn't dressed at all, lying naked in the back of a pickup truck filled with iced-down beer. Near him, a huge bonfire burned where, close by, roughly one hundred cases of warm beer were piled. Also on site was about the same amount of beer, but iced down. Apparently, all of the beer had been donated by local distributors.

The freshmen were ordered to disrobe. If a hesitant newcomer looked around, he would have noticed many older teammates naked, as well. Instantly, however, whatever comfort the freshmen might have had disappeared when their clothes were thrown into the bonfire. Then, each player, one by one, was grabbed by the back of the hair, his head pulled back. An upperclassman then repeatedly poured hot beer down his throat while others sprayed his nude body with more beer. After several beers were chugged, the older players began chanting "Meat! Meat! Meat!," anticipating, and then witnessing, the freshman regurgitate the two or

more barbecue sandwiches he had eaten earlier. After vomiting, each freshman was allowed to drink one cold beer to get the bad taste out of his mouth.

After each player lost his lunch, so to speak, he was made to perform football drills on an area of sand near the lake. The mass of diving and tumbling nude bodies covered with sand became too awkwardly intimate for some freshmen. However, as soon as one seemed unwilling, he was threatened with a beating.

Interrupting the nude football drills, an upperclassman suddenly threw an empty beer can into the lake and announced, "Okay, the first one of you motherfuckers to bring that can back to me will be done. You'll be finished with the initiation!"

Forty players instantly dove into the lake, resembling what the swim stage of a nude triathlon would look like. Invariably each year, there was a particular freshman—usually one who had swam competitively in high school—who easily reached the can before anyone else. However, he had made a grave mistake.

The dozens of other freshmen, most of whom were much bigger than the one with the can, eventually reached him before he could even make headway back to the shore. He was dunked underwater by his fellow classmates, grabbed and punched everywhere on his body. *Everything* was done so that he would surrender the empty can of beer. And, without fail, he always did. Yet, having to face the rest of a determined and hostile class, everyone soon realized that none of them would be able to return the can to its owner. Eventually, all the freshmen swam back to shore, leaving the can to remain floating on the lake.

Along the edge of the sand, ankle deep in the water, the newcomers were ordered to line up in a single file one foot apart. It was then explained how they were to perform what was referred to as the "elephant walk." Each player was to reach between the legs of the guy in front of him and grab hold of his genitals—and then start walking. For about ten minutes, the line of players walked along the shore, changed directions, walked back and so forth. All the while, what appeared to be a human centipede was verbally harassed while pelted with objects until being told to halt.

Finally, the freshmen had become fully initiated, and nobody at Seagraves was considered a newcomer. At that point, as the extremely large group of eighteen to twenty-two-year-old young men stood around nude, the only thing for most of them to do was get drunk—*extremely* drunk. And for many of those who had already reached that phase, they would drink even more.

Besides the initiation, what made Seagraves so memorable for the players—that is, those who could remember details of the annual event after drinking as much as a case of beer, maybe more, that afternoon—were the occasional run-ins with outsiders.

One year, Shag was visited by a friend from his hometown for a weekend, which just so happened to coincide with the Seagraves initiation. With only a forewarning from Shag that "this is going to be wild," the friend was stunned on his arrival to Seagraves to observe upperclassmen, most of whom where nude, harassing an all-nude freshman class. At some point, a big, burly lineman spotted the friend and demanded that he, too, get nude. When he refused, the lineman sicced a few freshmen on him, whereupon the friend soon relented and got undressed rather than face the alternative of being beaten. For good measure, and without a word, the lineman took the clothes of Shag's friend and tossed them into the bonfire to burn alongside those of the freshmen.

Another year, a couple of girls in their bathing suits decided to spend an afternoon at the lake, but they picked the wrong afternoon and lake to do so. Pulling their car up to Seagraves, they obviously had no clue they were about to crash a party consisting of more than one hundred drunk, nude football players. Unforgettable were the jaw-dropping, terrified looks of the girls as dozens of naked players raced for the displaced automobile. Some onlooking players were actually scared for the girls and were relieved to see them scramble to lock their doors just before some of their teammates attempted to enter the vehicle. Unable to infiltrate the car, the players swarmed and covered it to where it resembled a human beehive. Outside the car, the players repeatedly pressed not only their faces, but also their backsides and genitals, against the windows and windshield while the girls continually screamed inside. Finally, the car was able to maneuver away from the throng of bare players and speed off from the lake and up the dirt road to safety.

Prior to the Seagraves of 1973, the daughter of the owner of a local beer store told some upperclassmen that she had heard about the annual event and wanted to see it for herself. In addition, the girl boldly declared that she wanted to have sex with Georgia football players and wouldn't mind if an audience was on hand to witness it. Hours after she was expected to arrive, the girl and a friend of hers finally showed up at the lake. However, of the players who weren't passed out drunk by that time, none were prepared to have sex—no one could get an erection. Eventually, Wesley Foster, a fourth-year player from south Georgia, emerged and appeared to be nearly, or

halfway, ready. With Foster semi-erect—and his penis seemingly not getting any bigger any time soon—some of his teammates decided to lend him a hand. With no objection from the girl, a wooden splint was made with a small stick and string and was tied to Foster's penis, enabling him to, if you will, get started.

What commenced that evening on the wet Georgia red clay in front of dozens of cheering observers was absolute insanity. Foster, wooden splint and all, rapidly thrust himself in and out of the girl "like a wild man, going one hundred miles per hour," according to an onlooker. All along, the girl howled with delight—even when her head eventually moved from the clay and partially plunged into a mud puddle. All the while, the bystanders cheered—a cheer that was soon transformed into a distinct chant of "Go, Dog! Go! Go, Dog! Go! Go, Dog! Go!"

Following a Seagraves initiation a few years before, the older players had abandoned the nude initiates, forcing them to take the long, humiliating walk back to McWhorter Hall. In time, some freshmen began recognizing just prior to the event that they would probably need a ride home and prearranged for someone to pick them up. For other initiates, they settled for sleeping on the ground near the lake, deciding to worry about getting back to the dorm the next day. Some upperclassmen departed the lake exactly how they had gotten there—by vehicle—and usually with a driver much more intoxicated than before.

In 1975, a group was just about to leave the area surrounding Seagraves when one of the passengers insisted that the driver stop at one of the few nearby houses. He apparently had to make some phone calls. After patiently knocking at the home's front door, and then feeling that the knob was locked, the player opened up an unlocked window and slipped into the house. After being gone for what seemed like an eternity, the player who, as it turned out, did indeed make his calls from the house phone, emerged from the front door carrying a large television set. This prompted a few others from the car to enter the home, whereupon they robbed the place blind.

The morning after an initiation, McWhorter Hall usually resembled a war zone. The dorm was covered with scattered and naked bodies of the freshmen who did not quite make it to their rooms before passing out.

For some upperclassmen, the aftermath of Seagraves was a forgettable time, as well. There was the player who woke up in the front yard of an unfamiliar house miles away from both Seagraves and the dormitory. Another upperclassman was awakened by police in the laundry room of an apartment complex the morning after the event. The police had

been called by a resident after she had stumbled upon the passed-out, nude player, who had no idea where he was or how he got there. One year, an upperclassman woke up at the dorm separated from his car. The vehicle was discovered almost two weeks later parked behind a bar located roughly ten miles from campus and about twice as far from Seagraves.

Finally, there was the aftermath of the burglarized home near the Seagraves property. The next day, players found in their dorm mailbox a notice announcing a very important, mandatory meeting to be held at the Georgia Coliseum that afternoon. At the meeting, curiously, there were no coaches present—only the Oconee County sheriff. He was brief, hardly mentioning the ransacked house. He did indicate that a lot of people, including the sheriff's office, were fully aware of what took place at Seagraves the day before.

"So, for one of you, and probably several others, it should be a no-brainer why I am here today," the sheriff said. Motioning to an adjoining room, he added, "You got twenty-four hours to put in that room everything you took from that house, or everybody will be brought back up here again, and I'll start making arrests."

It's been said that everything stolen was anonymously delivered to the room inside the coliseum in less than ten hours, including a few valuables the owner of the house claimed were not his. As far as Seagraves, the annual rite became so infamous that *Sports Illustrated* published a piece in August 1980 describing it. Still, the article really did not give the chaotic affair its due. Either the magazine drastically toned down its findings, or Seagraves had become a much, much tamer event than what had taken place at the lake during the early to mid-1970s—and who knows how long prior to that.

6

Directions to the Dog House

On the afternoon of April 14, 1973, as both the Red and Black teams took the field at Sanford Stadium for Georgia's annual G-Day spring game, Shag Davis was overly excited and brimming with confidence that he would perform well enough in the intra-squad contest to distinguish himself as the team's number-two quarterback behind the super-talented senior, Andy Johnson. Johnson, who was playing for the school's baseball team at the time, was absent from the game. Competing for the team's top backup role were Shag, the starter for the Red team; Ralph Page, the Red's number-two quarterback; and Neal Boring, the starter for the Black team.

Shag was especially self-assured. Probably the two best backs on the entire team—Jimmy Poulos and Horace King—would be lined up behind him. Also, the Red's starting offensive line featured at least three, maybe four of the five linemen the Bulldogs would likely be starting in the fall.

Just as the game kicked off, a beat writer in the press box spotted along the sideline a senior in high school who had been discussed as possibly playing for the Bulldogs' varsity team in the fall. Wearing his letterman's jacket, highly touted halfback Chuck Farris stood off by himself. Hailing from a town in the Northeast, about one thousand miles from Athens, Farris had signed with Georgia only ten days before.

Grabbing a team graduate assistant, who occasionally served as his source for inside information regarding the program, the writer inquired, "Tell me about this Farris kid….Is he really good enough to contribute to the varsity this year?"

uate assistant paused and then, evidently irritated, curiously
ırsity? Don't be surprised if Farris doesn't make it at all. He'll
probab., ͺ ɛt run off."

There were those players who, under no circumstances, were allowed to
quit—players the coaches did *not* want to run off—like Mike "Moonpie"
Wilson. A six-foot, six-inch, 270-pound lineman, Wilson was part of the
same signing class as Farris and an eventual first team All-American for the
Bulldogs. He admittedly quit the team at least five times during preseason
drills his freshman year because he had enough of playing football, had a
girlfriend back home and decided he'd rather work in construction. Every
time Wilson ran off to his home forty miles away in Gainesville, Georgia,
the esteemed and highly respected assistant Mike Castronis coaxed him back
to Athens.

But, as with most other major programs, the writer was also fully aware
of the exact opposite—Georgia players who were forcibly run off. Whether
for a rising sophomore who had been highly recruited, the multiyear player
on scholarship or even a walk-on player without a scholarship, it was a
proceeding not reserved for any one group. A case in point was found in the
Bulldogs' spring practice, which opened with the highly anticipated debut
of "Football Jones."

A student at the university and a native of Ohio, Jones simply showed
up one off-season and began lifting weights with some Bulldogs' players.
Claiming he had worked out with Ohio State star and eventual two-time
Heisman Trophy winner Archie Griffin back home, Jones said he was
going to walk on in the spring and envisioned himself being offered a
scholarship in no time. He constantly bragged about what a great all-
purpose back he was, especially when it came to returning punts. Jones
was really pumped up, displaying a more muscular physique than anyone
else on the team, so he certainly looked the part. However, when the
bragging walk-on claimed he was going to "be the Archie Griffin of the
SEC," players, and some coaches, could hardly wait for the debut of
"Football Jones"—the nickname was given to him in jest after a popular
song at the time, "Basketball Jones featuring Tyrone Shoelaces," by
Cheech and Chong.

On the first day of spring practice, during punt coverage drills, punter
Bucky Dilts was just about to kick to Jones for his first return until the
overseeing assistant coach suddenly halted practice. "Jones, you stay back,
but everybody else come here!" the coach instructed the twenty-one players
on the field besides Jones. In a near whisper, he continued: "Return team, I

don't want anybody to block for this cocky son of a bitch. Coverage team, I want you to welcome this bragging fucker to the SEC. And Dilts, you kick that ball as high as you can to make sure the coverage team can get down the field....Let's find out how tough this Jones is."

With Jones standing approximately forty yards back from the line of scrimmage, Dilts received the snap and, after hesitating for a moment to allow the coverage team to get farther downfield, lifted a beautiful, high punt. As it descended into the arms of Jones, he virtually had no place to go but for the sideline. Ten unblocked defenders had literally stood still, waiting for him to catch the ball. The returner covered only a few yards horizontally before what was, perhaps for the first time in the history of football, a special teams tackle made collectively by ten different players.

"Dilts, now you go jump on the pile!" hollered the coach. The punter did exactly what he was told, leaping onto the large heap of eleven players, which included Jones at the very bottom. The punter even flailed his legs at the top for good measure. Everyone then unpiled—everyone, that is, except Jones. The bragging, big-mouthed returner lay motionless on the field before he was carried off by a couple of trainers.

By the time practice was over, the players noticed that not only had Jones apparently recovered from any injury, but he also had cleaned out his locker. He had left—quit right then and there on the first day of spring practice. Football Jones's first punt return at Georgia was his last.

In the press box at G-Day, the beat writer perhaps understood how a player like Jones would be run off, but a recent signee from only a week and a half before, who was still in high school? The graduate assistant filled in the writer on the curious case of Chuck Farris.

Like Jones, Farris certainly looked the part. Standing six feet, one inch and weighing 220 pounds, he was two inches taller and a hefty 35 pounds heavier than Georgia's biggest running back from 1972. In high school, Farris was as versatile as they come. Besides being a hard, bruising runner, he could catch the ball out of the backfield. Defensively, he was a standout linebacker, and he even filled in occasionally as the team's placekicker.

There were some concerns with Farris, including trouble he had with calcium deposits in his thighs, which had caused him to miss nine of his school's last eighteen games. Also, in what little game film his assistant coach provided, it appeared Farris was somewhat slow. Still, the same coach claimed the halfback ran a speedy 4.5 in the 40-yard dash. He also apparently had been heavily recruited by the University of Texas, which required quick and athletic backs as part of its wishbone offense.

Red flags first popped up on Farris while his assistant coach and a Georgia graduate assistant were planning the prospect's official visit to the university. The coach wanted to accompany Farris to Athens, which was normal. However, the fact that he also requested for the graduate assistant to give up his apartment for the weekend, while providing the coach "company" in the form of a beautiful coed, was not the norm at all. What's more, as it turned out, the assistant coach was much more than just that to Farris; he was also the recruit's older brother. Nevertheless, based on Farris's versatility evident on game film, his fast time in the 40 and the fact that Georgia wasn't the only major program who had recruited the prospect, he was signed by the Bulldogs at his mother's home in the presence of his assistant coach/brother and the Georgia graduate assistant.

The Bulldog coaching staff was not fully aware of what it had in Farris until he worked out for the team a few days after being granted his scholarship. It only took just over 5.0 seconds to realize as much. Running the 40-yard dash, the "speedster" was indeed clocked at "4.5," but only if the two figures were swapped. Farris ran a 5.4—at the time, maybe slightly faster than Georgia's average offensive lineman. Ingrained forever in the minds of a few witnesses on that afternoon was the Bulldog assistant coach, who had timed Farris, running rather aimlessly along the sideline and staring at his stopwatch in utter disbelief. The coach then looked up and shouted, "That can't be right! Run that guy again!" The newly signed freshman-to-be promptly ran the 40 again and, on his second try, was actually clocked a little slower—5.6 seconds.

Because Farris's 4.5 time was more than just slightly exaggerated, and he obviously hadn't been highly sought after by the Texas Longhorns, what was evidently clear was that the Bulldogs had been duped. Farris was deemed an instant "flop."

"And, he'll likely have to pay for his brother fooling us," the graduate assistant said of Farris to the beat writer. "We don't want to be made out like we don't know what we're doing, especially by a couple of damn Yankees."

Meanwhile, during the spring game, it was Shag who appeared as though he didn't know what he was doing. For the contest, he completed just two of thirteen passes for 46 yards and was intercepted three times. He rushed for only three net yards on twelve carries. In an 18–9 defeat, the Red's offense was woeful, gaining just 137 total yards in sixty plays against a Black defense that was supposed to be its inferior. The losing squad's supposed first-rate offensive line continually blew assignments as Poulos, King and three other running backs combined to average just 3 yards per carry, while Shag was

constantly pressured and sacked several times. There were a half dozen times when his center curiously snapped the ball quarterback's hands.

During the game, the beat writer noted, "It appears as if part of the Red's offensive line is simply just going through the motions on some plays." In passing for 118 yards and a touchdown while rushing for 45 yards in the victory, the Black's Boring was reported as having done just enough to solidify his place entering fall camp as Georgia's number-two quarterback behind Andy Johnson.

Returning home to Cambridge for the summer, Shag's throwing shoulder ached from separating it during the spring, while his knee remained weak from the ligament damage suffered the previous fall camp. Regardless, for the first time in a long while, he was determined to do whatever it took to reclaim Georgia's top backup spot at quarterback—even if it meant receiving some enhancement.

As a freshman, Shag had known of some Bulldog players who took "Black Beauties," a combination of speed and dextroamphetamine, which increases hyperactivity and awareness. He had also heard of certain players who took Dianabol, a mild form of an oral steroid that builds muscle in a short period of time. And there was suspicion that some players experimented with stronger forms of steroids. A combination of the aforementioned performance-enhancing drugs could explain, in part, what seemed at the time an abundance of large but quick, barbaric players at major programs all over the country.

To reach the level of play to face an SEC defense, Shag realized he had a lot of work to do that summer before returning to Athens for fall camp, beginning with strengthening his body. He approached a hometown doctor, a family friend, who agreed to prescribe him Dianabol. Shag was to take the steroid for two weeks, lay off of it for the same period of time and take the drug again for two more weeks. While on Dianabol, he was instructed to work out, including lift weights, and eat plenty of protein. As far as any long-term effects, the doctor said there would be none, because the drug would be taken for such a short period, yet long enough for Shag's injuries to recover.

Shag did exactly what the doctor ordered. After six weeks of dedication and hard work, plus some help from Dianabol, his injuries had healed and his body was much stronger. He was in the best shape of his life. He was ready to return to Georgia and finally play big-time football.

On August 27, nineteen days before Georgia's season opener against the Pittsburgh Panthers, ninety-six players reported for fall camp. During a

required three days of conditioning drills, Shag began to show glimpses of why he had been so highly recruited. In wind sprints, he outraced players that he hadn't beaten the spring before. He established himself as perhaps the fastest quarterback on the team. Throwing the football farther and more accurate than ever, Shag's arm strength had actually increased over the summer. Perhaps more than anything, he felt that he was tougher than before—more hardened.

During fall camp the previous year, when facing the varsity squad, Shag had been introduced by a defensive lineman to the "flipper"—a tightened forearm slammed against the side of his helmet—coupled with the verbal greeting, "Welcome to the SEC, motherfucker!" As a freshman quarterback, every flipper that had been thrown his way seemed to reach its mark, leaving him dazed and seeing stars. A year later, however, Shag seemed to have developed the knack of avoiding the blows to the head and, for those that happened to land, the ability to easily shake them off.

Accordingly, on one particular goal-line scrimmage from the 5-yard line, and facing the first-string defense, Shag took the snap under center, faked to his fullback and easily ran untouched into the end zone. Unaccustomed to reserve players running the ball with ease against his defenders, defensive coordinator Erk Russell immediately hollered, "Okay, offense, line up and run the exact same play! Quarterback, you run through the exact same hole!"

Shag knew the next play would probably result in absolute disaster for him; there would be no touchdown on his second attempt—not even close. And, true to form, running the same play, several defenders shot through the hole, dropping the quarterback for a 4-yard loss. By the time the play ended, most of the defense had piled on, including a senior starting tackle, whose facemask was penned face-to-face with Shag's. Instantly, the large lineman hocked up phlegm, spit it directly in Shag's face and added, "Don't you ever make us look bad again, you Yankee motherfucker."

Despite having to wipe a huge splatter of someone else's saliva from his face while being reminded of the hint of geographical prejudice that persisted within the program, Shag felt more confident than ever. He realized that others—players and coaches—were starting to see that the Yankee quarterback was holding his own against the big, intimidating southern boys. Still, be that as it may, Shag would soon be seeing red.

As fall camp drew to a close, Shag was called to meet with a couple of offensive assistants who gave him the news no healthy and eager player ever wants to hear: he was going to be redshirted. The coaches acted as if the

maneuver was a positive one, indicating that Shag sitting out and saving a year signified that, instead of him playing behind Johnson in 1973, he had the opportunity of being Georgia's starting quarterback from 1974 through 1976. Nevertheless, a redshirt season was normally perceived as being reserved for the injured or for a player who simply wasn't ready. But Shag felt he *was* ready, fully prepared to get out on the gridiron and show what he was capable of. What's more, being redshirted still meant having to practice as much as everyone else, bearing the head-rattling flippers, yet knowing it would be another year before seeing game action.

Shag's frustration and disappointment only mounted when, while observing his teammates from the Sanford Stadium stands, he witnessed Pittsburgh, an eighteen-point underdog, pull off a big upset by tying Georgia, 7–7. The Bulldogs' offense was essentially stagnant the entire contest, due in large part to six-foot, three-inch, 260-pound Gary Burley, a junior-college transfer who was often in the Bulldogs' backfield wreaking havoc during what was his first game for the Panthers. To add insult to injury, Burley sounded off afterward to the media about the Georgia offensive lineman he faced for much of the afternoon.

"Was that [lineman] supposed to be any good?" Burley asked about the Georgia senior who was considered the strongest player on the team and had earned All-SEC honors the year before. "He just kept giving me breaks all afternoon, and I took 'em every time. I've never seen a Georgia team before, but those guys looked overweight to me, and, man, they were already tired in the third quarter." Also relishing the tie with the Bulldogs, Pittsburgh return specialist Robert Haygood—a mere freshman who was from Georgia—later added, "I know they haven't worked as hard as we have. You could tell that when they got so tired."

Hard at work during the next week of practice, Shag and three other restless players, none of whom had played against Pittsburgh for separate reasons, collectively decided they deserved to blow off some steam. To that point, Chambers and Nick, both juniors; Sam, a walk-on; and Shag had taken their frustrations out on the innocent only during concerts held at nearby Poss' Lakeview. At the big-event catering facility, they tipped over porta-potties occupied by unsuspecting victims on a couple of occasions. But for the evening following practice, the players decided to heighten their antics a tad.

Shag informed his friends of the experience he had had as a senior in high school while visiting Notre Dame, when the football player sprayed partygoers with a fire extinguisher. Subsequently, after stealing a fire

extinguisher from the Holiday Inn near downtown, the four jumped in Sam's bright yellow Dodge Coronet 440, jokingly dubbed the "Perfect Getaway Car" for its conspicuous color, and began riding around campus bored, delirious and armed.

Fall quarter classes were only a couple of days away from starting. Although the campus had yet to become filled with students, there were enough of them around for the fire-extinguisher foolishness that was about to take place. Nick was in the passenger seat, the extinguisher on the floor concealed between his closed legs, while his left hand was resting on and ready to pull its lever. His right hand held the nozzle at the end of the device's hose. Soon, the car pulled up to a stoplight, and the players spotted their first victim.

"Excuse me, sir," Nick called out of his window to a man who looked to be a young professor standing at a campus bus stop. "Could you please give me directions to the Dog House?"

The man began giving directions to the beer establishment located downtown when he was interrupted. "Sir, I can't hear you that well," Nick said. "Could you come just a little closer?"

A few moments later, bent over talking with his face just a foot or so from the opened window, the man was interrupted again—not by another request, but by Nick lifting the nozzle and then dousing his victim from point-blank range. As the foamy, wet concoction drenched the man's face with such force that his hair flew back, the Coronet sped off as laughter erupted inside the vehicle.

Some bystanders were hit in the face so hard that they fell back onto the ground. "Hosing people down like elephants at the zoo," as Chambers called it, was always initiated by asking directions to the Dog House. The number of victims was so high that the players were unaware of the count. More important, the four boys were unaware at the time of the contents of their fire extinguisher. What they thought was simply a water-foam mixture also included a dry chemical that could be harmful on contact.

Around two o'clock the next morning, Shag was awoken by local police entering his room at McWhorter Hall. Apparently, a witness had identified a fire extinguisher being sprayed from inside a bright yellow Dodge Coronet, which was traced to the four players.

Shag was arrested in his room, where he was informed that about fifteen people had visited local medical clinics after experiencing blindness from being squirted in the face with a fire extinguisher. "And, you better hope the eyesight for every last one of them returns, or you boys are going to be in

G-E THE ATLANTA CONSTITUTION, Thurs., Sept. 19, 1974

Fire Extinguishers Risky, Davis Finds

By WAYNE MINSHEW
Constitution Sports Writer

ATHENS—University of Georgia split end Steve Davis celebrated an anniversary the other day. It was a relatively quiet celebration, however. Davis simply stayed as far away from fire extinguishers as he possibly could, and there were undoubtedly

Steve

Davis

strong as it used to be. I'd be a very inconsistent passer."

Davis couldn't suppress a grin. "But we don't pass that much anyway, do we?"

No matter. He's on the receiving end of passes now, anyway. Steve Davis has accepted that as a fact of life

According to an Atlanta newspaper, Shag found the spraying of fire extinguishers "risky," among other concerns. Atlanta Constitution.

deep-shit trouble," added a policeman as he led Shag from the room to a patrol car.

After spending the night in jail and getting bailed out the next day, the four boys were fortunate to dodge a series of bullets, any one of which would likely have been their undoing.

Facing the student judiciary—a university tribunal that had a reputation for being biased against football players—the boys opposed a committee whose hands were essentially tied, since the crime had been committed when school was not in session. If fall classes had started, the players could have very well been dismissed from school. Instead, they were placed on a probationary period of one year and instructed to apologize in person to each of their victims who lived on campus. As for the players participating in football, Vince Dooley would have been warranted in taking away their scholarships and kicking them off the team permanently. Instead, the head coach allowed the three scholarship players to remain on scholarship; however, they were dismissed from the team until the following spring practice and forced to move out of McWhorter Hall.

One might think that nearly getting kicked out of school, and ousted from its football program, would put Shag, Nick, Chambers and Sam on their best behavior. On the contrary, despite being mindful that one more false move could be their last, the wild bunch was inclined to become even wilder

as they moved from stringent McWhorter Hall to Reed Hall, a student dormitory where there was little supervision, few rules and no curfew.

In two separate rooms, both near the center of the third and top floor of Reed Hall, which was situated at the head of a quadrangle, the four young men started a late-night routine. At least one, sometimes all four of them, would howl out their window, according to the *Red and Black*, "a great cry, accompanied by a rumbling which would have put Billy Friedkin [director of *The Exorcist*] to shame: WA-WA-WA-WA-WA-WILD-MAN!!!!"

The late-night "Wildman Call," which was as ear-piercing as it was disturbing, bounced off surrounding buildings, echoing over a good portion of the university's North Campus. Occurring around midnight most nights, the call received its first detectable response after a couple of weeks by a male resident who apparently had been interrupted while trying to go to sleep: "Wildman, you're an asshole! I'm trying to get some sleep! I have a test tomorrow!" With that, Shag, Nick, Chambers and Sam together acquired the moniker "Wildman." They became inspired to make their call a nightly ritual.

According to the newspaper article, some residents grew accustomed to the Wildman: "Steve, what the hell was that?" asked a "visibly shaken" visitor to the dorm after hearing the call. "Go to sleep; it's just the Wildman," Steve replied while "turning over." Other residents grew exasperated, shouting "Fuck you, Wildman! When I find out who you are, I'm going to fucking kill you!" Others, like the handful of students on the third floor who discovered the Wildman's true identity, became his followers, nicknaming themselves his "Tribesmen." Sworn to protect and never expose the Wildman, the Tribesmen gave him their own nickname: "Grog, the Monkey Monster."

The Wildman Call persevered and even terrorized the Reed community via a loud PA system with a horn speaker provided by a member of the Tribesmen. The four football players fortunately, but just barely, avoided further trouble.

Although removed from the football program until spring, the players continued to take advantage of their free laundry service. One afternoon when picking up their laundry, they decided to also grab the bundle belonging to a group of others—the assistant coaching staff. When the campus police showed up the next day to search the players' two rooms on "suspicion of stealing something very important from the laundry facility," there was no coaches' laundry to be found. Maybe thirty seconds prior to the police entering the dormitory, Sam had thrown the bundle into a random room down the hall after happening to observe campus police cars with their lights

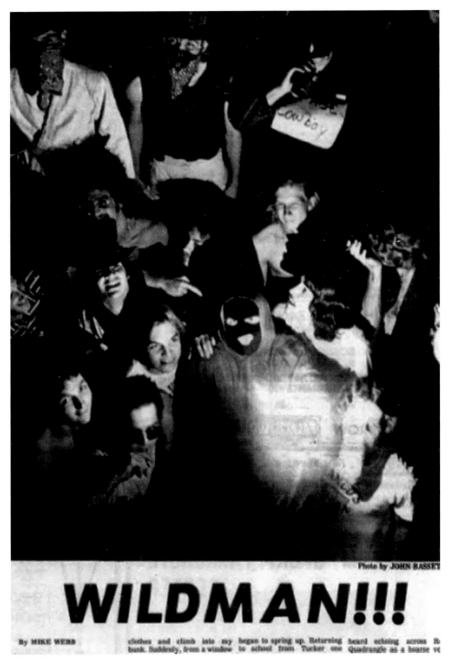

The "Wildman" and his "Tribesmen" of Reed Hall became so infamous, they were featured in UGA's student newspaper. The Red and Black.

on pulling into the dorm's parking lot. Consequently, the officers actually apologized to the players for what they thought was their mistake.

Soon after the laundry incident, Shag was apprehended by campus police after he slammed a combative parking attendant to the ground. He escaped prosecution by bribing the attendant with football tickets.

When the four players realized that eggs from a campus dining hall were much more accessible than a bundle of clothes from the laundry service, they began stealing them by the cartons, whereupon a variety of bystanders became their targets. To lure the Athens Fire Department to Reed Hall, the troublemakers threw Molotov cocktails into a dormitory dumpster, igniting the contents. Soon after the firemen arrived, a barrage of eggs rained down on them from the dorm's third floor. One afternoon, for the sole reason that Nick disapproved of the fact that his anthropology professor had started to conduct his class outdoors, the players hid while the class was in session. They each hoisted a carton of eggs into some overhanging trees. As yolk and eggshells dripped from the trees onto Nick's professor and classmates, the gathering dispersed with screams and curses. The anthropology class was immediately dismissed—it would not be held outside for the remainder of the quarter.

While riding around one evening in Shag's Ford Gran Torino during Greek rush, the four players spotted a huge crowd of girls gathered outside of their sorority house. After the players hoisted several cartons of eggs into some low-hanging trees, the congregation's singing and performing of skits turned into screaming and absolute chaos as egg particles drizzled onto the girls from above. The girls' hysterical reaction humored and inspired the boys, prompting them to continue targeting sororities, and with advanced methods beyond simply egg-throwing.

Entering the Alpha Omicron Pi house one night while wearing ski masks, the players approached a girl in the front room sitting at a small table doing class work. Without a word, they surrounded the girl—Shag and Sam behind her, Nick and Chambers in front—and stood in silence. Surprisingly, the girl sat there without any reaction whatsoever, not even a glance at any of the boys, until she finally piped up.

"What do you dumb assholes want?" the sorority girl asked the group. "Is this part of y'all's fraternity initiation, or something?" There was no answer and, again, everyone was silent—until Shag ran his hands under the girl's arms, grabbed her breasts and, while squeezing them a couple of times, shouted, "Honk! Honk!"

Then, all hell broke loose.

A group of Georgia football players often executed their mischievous and menacing deeds while donning ski masks. *Henck and Kelley collection.*

The sorority girl stood and wheeled around, knocking over the table, which fell onto Nick's legs, spilling him onto the floor. With papers flying everywhere, Chambers attempted to help Nick out from under the table. The girl, holding her pencil with an icepick grip, swung it madly at the other two players. Sam was stabbed by the object in one of his forearms.

Besides a hobbled Nick, and Sam, who had suffered a nearly one-inch gash in his arm, the boys escaped from the sorority house without further injury. However, the girl gave chase long enough to get the tag number off the fleeing Gran Torino. The next morning, Shag was called down to the campus police station. A university officer opened the interrogation by saying, word for word, "We have suspicion that you might have been at a sorority house last night, where you 'honked' a girl's tits."

Knowing that, if the truth was discovered, he would likely be thrown off the team permanently, Shag lied to the policeman, claiming he had been in Atlanta the night before with some teammates. They had taken a friend's car, so the Gran Torino had remained in Athens. "But, you know, now that I think about it, my car keys weren't in the same place where I left them," Shag told the officer. "And I always leave my dorm room unlocked, so someone must have borrowed my car!"

It was obvious that the policeman did not buy Shag's story, but there was no evidence that he was part of any wrongdoing. Well, perhaps there was a *slash* of evidence—one almost an inch deep.

"The girl thought that whoever 'honked' her tits, she slashed his arm real good with a pencil," the officer said. "So, roll up your sleeves and let me look at your arms." Knowing it wasn't he who had suffered the stabbing, Shag was more than glad to abide by the policeman's request.

After the pencil-stabbing incident, the "Wildman" suddenly consisted of only three men. Nick, evidently coming to his senses, distanced himself from the group, citing the fact that his parents had threatened him with returning home and working on their family farm if he was dismissed from school.

A teammate who lived in McWhorter Hall, a Donaldson from the Midwest, visited Shag, Chambers and Sam one afternoon. The conversation soon turned to the visitor's complaining that he had been thrown out of a party for being drunk the night before at the Kappa Theta Alpha sorority house.

"I just wanted to pass out in a particular girl's room," Donaldson said. "What the hell is wrong with that?" The three others wholeheartedly agreed and decided right then and there to seek revenge on the sorority.

Armed with M-80s—powerful, explosive firecrackers—the four players rode to the Kappa Alpha Theta house in Sam's Dodge Coronet, parking across the street in an alleyway. Donaldson ran up to the house, attached a burning, non-filtered cigarette acting as a time fuse to an M-80 and taped the firecracker to a huge front window. He lit the fuse and got away. As Donaldson ran back to the car, the players observed through the rigged window a girl suddenly enter the room beyond the glass. And then—*boom!*—an explosion occurred quite like nothing any of them had ever experienced, or certainly expected from the single M-80. Screaming like she was in a horror movie, the girl's face could plainly be seen through the glassless window opening, the curtains having caught fire. The players pulled out of the alley onto Milledge Avenue, laughing hysterically.

About ten minutes after the window exploded, the Coronet returned to the scene of the crime to see what kind of damage and commotion had been caused. Driving slowly past the house, where as many as ten police cars were parked along the sidewalk and in the street, the players noticed the same girl as before, standing in the front yard talking with several police officers. All of a sudden, the girl spotted the car and pointed at it, clearly mouthing, "There's the car!"

In an instant, a car chase—literally—ensued in west Athens. The players attempted to elude authorities. They knew that, if they were caught, they undoubtedly would, at the very least, be thrown off the team permanently and would likely face much stiffer consequences. Cutting down a couple of side roads did not lose the police; there were just too many of them. Finally, pulling into a parking lot off of Broad Street just before reaching downtown, the boys gave up, bringing the car to a complete stop. The police cars were right behind them, and the officers, who quickly exited their vehicles, surrounded the Coronet. They meant business.

"Get out of the car!" shouted a policeman who, like the others, had drawn his gun. "Then, lean over the hood!" As Shag got out of the car and began

to lean over the hood, he noticed that Chambers and Sam, already leaning against the car, each had M-80s protruding from their back pockets.

Desperate to try anything to avoid being arrested, Donaldson played stupid. "What did we do?" he asked. "We didn't do anything!"

"Then, why did you run?" asked an officer.

"Because we were scared!" Chambers replied.

The police searched the car—thoroughly. However, it appeared that, whatever they were looking for, they did not find. They also didn't seem to care about the bulging M-80s, if they noticed them at all. Finally, after what seemed like at least least fifteen minutes of searching, one of the officers sternly asked, "Okay, where is it—where's the shotgun?"

The players must have looked perplexed, as the same officer continued. "Yeah, the girl at the sorority house said the guys in this car shot out their window with a shotgun."

The players stood baffled, and the police were beginning to look as if perhaps a mistake in identity had been made. Sam chimed in with a brilliant pitch: "Officers, we're Georgia football players. Of course, none of us own a shotgun and, if we did, we certainly wouldn't bring it on campus and shoot it! We were just driving down Milledge when we heard what sounded like a gunshot. After continuing to drive for a few minutes, one of these three guys told me to turn around and head back up Milledge to see what happened—see if we might need to help out in some way. But then, all of the sudden, you guys started to chase us, and I got scared. That's all we know."

After Sam's convincing account, the players—for the second time in a matter of only several months following a wrongdoing of their own—were apologized to and released by law enforcement.

All the while, the boys continued to do the Wildman Call from Reed Hall. And they continued to get away with it, even when the university placed campus security around the dormitory, including a guard who sat in a chair on the third floor, directly across from the room of two of the players. The boys not only avoided getting caught, but they also rigged the PA system and speaker so that the two students living in the room below them on the second floor were soon blamed for being the Wildman.

In the spring of 1974, and as Coach Dooley had promised, the players' temporary suspension was lifted and they were allowed to rejoin the team. Sam, the walk-on, decided to concentrate on his studies and stopped playing football altogether. Shag and Chambers moved out of the student dorm and prepared for spring practice.

At Reed Hall around midnight, all was calm as the Wildman no longer occupied the dormitory to terrorize the community. It was at that time, according to the article in the *Red and Black*, that an inscription appeared on a marble partition in the third-floor bathroom of Reed: "GROG, THE MONKEY MONSTER IS DEAD."

Besides a few more eggings of sorority girls and residents of a nearby neighborhood while wearing their ski masks, Shag and Chambers were rather hesitant to cause any additional trouble after their latest escape from law enforcement—at first. One late morning, the pair was visiting teammates at McWhorter Hall. Sitting outside the dormitory, a delivery man passed them entering the building carrying two fire extinguishers—two freshly refilled extinguishers, the non-blinding type containing essentially pressurized water. Right then, Donaldson indicated that he was bored. Shag and Chambers looked at one another and each smiled, realizing that Donaldson's car, an older Mercury Cougar, had not been traced by authorities—not yet, anyway. The Cougar might not have been the "Perfect Getaway Car," but it was darn near close, and it would certainly do.

With Donaldson driving, Chambers in the passenger seat with a stolen fire extinguisher hidden between his legs and Shag in the back, the Cougar pulled up to a carload of fraternity guys. At that moment, Chambers got the driver's attention. He then asked a familiar question: "Hey, man. Could you please give me directions to the Dog House?"

Just as the driver leaned out his window while extending his arm in a pointing fashion toward downtown, he was hit in the face with the water mixture with such impact that his glasses flew off over his head. As before, the players drove off laughing madly. But, unlike the previous sprayings with an extinguisher, the victim, not temporarily blinded by the concoction, began chasing the culprits.

As the Cougar raced through the streets unable to lose the pursuers, Chambers insisted a few times, "Just stop the car, let's get out and kick their asses!" But Donaldson had a better plan as he drove toward the Georgia Coliseum.

At the time, situated behind Georgia's basketball arena was a partitioned facility of stables that housed animals for rodeos, horse shows and the like. The football players were very familiar with the stables, as they often walked through them en route from McWhorter Hall to the coliseum's locker room and meeting rooms and back. But anyone not accustomed to the stables, which consisted of a complex maze, likely would have trouble negotiating their way through the concrete barriers.

After entering the stables, the Cougar sped around a few corners and began distancing itself from the other car. Suddenly, the players heard the squealing of tires followed by a loud crash. Evidently, the chasing car had come to a complete halt by slamming into a concrete partition. The players knew better than return to the scene of the crime to see what kind of damage had been caused. Instead, they pulled into the parking lot of the athletic dormitory while—what had become routine for the rabble-rousers—laughing wildly.

At Reed Hall, Grog, the Monkey Monster might have died. However, with Shag and Chambers uniting with Donaldson, the Wildman apparently was very much alive and well.

7

Jock Flies and Free Meals

On a Sunday afternoon in 1974, the phone rang in a random room at McWhorter Hall until finally being picked up by a residing football player.

"Can I please speak to Jimmy Poulos?" a female voice on the other end peculiarly asked, requesting Georgia's standout tailback from the previous three seasons. However, not only had she not called the appropriate room, but it was also unclear if Poulos, as a graduating senior, was even living in the athletic dormitory at the time.

"Why do you want to speak to him?" the player asked.

"I want to fuck Jimmy Poulos!" replied the girl, who, although seemingly having never met Poulos, apparently was very enamored with the good-looking Greek football star.

"Well, this is Jimmy!" claimed the player. A sophomore walk-on defensive back, he was far—*very* far—from being Jimmy Poulos. "So, drive on over then! And I'll meet you outside McWhorter Hall in the parking lot."

The girl did indeed drive to McWhorter Hall. The trip took her over an hour and a half, as she lived just outside of Atlanta. After her lengthy trek, she might have very well been disappointed not to find an awaiting Jimmy Poulos in the parking lot. Nevertheless, his replacement of sorts, the sophomore walk-on, did indeed wind up having sex with the girl at McWhorter Hall—as did, it was later disclosed, at least two other players.

The sexual revolution throughout the Western world during the 1970s saw the convergence of several phenomena related to sex, sexuality and

gender, including sexual liberation and the women's liberation movement. At the "party school," the University of Georgia, the sexual revolution especially persisted by 1974. In addition, a nationwide phenomenon of streaking flourished, including at the university. On March 7, more than 1,500 simultaneous streakers on campus set the world record for largest group streak.

The sexual revolution and streaking, combined with testosterone-filled young men in their late teens and early twenties, could be a setting for prevalent sexual intercourse. Add in the fact that there were young females who would do just about anything—like drive eighty miles to have sex with strangers—to associate with Bulldog football players, and certain residential rooms at McWhorter Hall could be transformed into what resembled a wild swinger's club.

Remarkably, dorm authorities had little idea of such sexual proceedings. Although head coach Vince Dooley and Kojak, the resident counselor, were disciplinarians, they obviously did not live in the dormitory. By 1974, that role was filled by the likeable and well-respected John Kasay, who was keen at catching players out past curfew, possessing alcohol and the like. However, when it came to carrying out sexcapades in McWhorter Hall, some residents were skilled and seasoned, keeping the behavior confidential.

Coach Kasay lived at McWhorter Hall with his wife and two young children. His son, five-year-old John David, who kicked at the players when they teased him, would fittingly develop into one of the greatest placekickers of all time, playing for Georgia and then in the NFL for twenty seasons. The Kasay family resided toward the back of the dormitory, as did most of the non-football athletes—primarily golfers and basketball and tennis players. However, all of the football players lived toward the front of McWhorter Hall.

Coach Kasay would often catch residents past curfew by advancing his way late at night toward the front of the dorm, and then hide in the bushes if he didn't literally hide somewhere in the player's room. For breaking curfew, Coach Dooley decided the penalty as far as number of missed games and the like. But Kasay enforced his own punishment: the violator had to report early—*real* early—the next morning for the coach's "Sunrise Service." This entailed repeatedly running the basketball coliseum's steps and lifting weights, all while usually hung over.

The football players who got away with debauchery generally did so by simply engaging in such activities in the back of the dormitory, in rooms belonging to non-football athletes, and where Coach Kasay had little to no

Coach John Kasay (*right*) lived in McWhorter Hall with the players. He was respected, well liked and the master of catching residents of the dorm out past curfew. *D.J. Pascale collection.*

jurisdiction. If Kasay posed a threat, players learned to uncover the details of his travel itinerary for recruiting and scouting trips. These out-of-town outings often occurred on weekends, including Saturday nights following home games when the team did not have curfew. When the cat was away, the mice did indeed play!

Allowed to visit players' dorm rooms during specified hours, girls would occasionally flock to certain rooms at McWhorter Hall. Because they seemed to always be around, "buzzing" everywhere, these girls were given the nickname "Jock Flies." The Jock Flies were of many varieties, including, unthinkably, the sister of a straitlaced out-of-state player. No one seemed to know for sure—or seemed to care, for that matter—if the player was aware of the lewdness in which his own sister was involved.

The sex with the Jock Flies was rampant, often involving two or three athletes with one female in the back of the dormitory. By 1974, reports began to surface of four athletes with one girl, followed by five, and then six. Increasingly, more individuals were involved until numbers reached outright ridiculous totals.

Notably, at one point, it was rumored that a particular girl, nicknamed "Ass Breath," had been with athletes totaling in the double figures. Although never having intercourse with any player, Ass Breath would stimulate a group one by one by tonguing an individual's anus from behind—thus the nickname—while she reached around and gave him a hand job. One instance, after she and a particular athlete had finished, while others waited their turns, the player presumptuously declared, "Now, let's go fuck in my room!" Seemingly offended, Ass Breath replied precisely, "I won't do that! I'm not going to hurt my reputation."

Finally, one afternoon, the group sex at McWhorter Hall had evidently gotten out of control. The door to Donaldson's room swung open, whereupon a player stuck his head in and exclaimed, "Donaldson, you got to check this out, man. There's a big gang bang in the back of the dorm!"

Donaldson hurriedly followed the other player to the back of McWhorter Hall before reaching a single-file line of roughly a dozen athletes waiting outside a room. "What the hell is this?" Donaldson inquired.

"It's a gang bang with some girl in Parker and Garner's [UGA basketball players] room," said "Flat Ass," a rising junior who stood last in line.

Perhaps worthy of mention, through two seasons, although Flat Ass had yet to pan out on the field, he was very well known among his teammates for one distinction: the large, slumping lineman could flatulate on cue. Players often approached him with the simple five-word request, "Fart for me, Flat Ass," and each and every time, without fail, he obliged.

"Seriously, one time I was walking through the training room and saw him sitting in a whirlpool that had yet to be turned on," recalled a teammate of Flat Ass from the same incoming class. "I said, 'Fart for me, Flat Ass!' And no kidding, next thing I knew, I saw the water bubbling up on the surface. The guy could have probably farted to the tune 'Old MacDonald Had a Farm.'"

Besides being able to break wind on cue, Flat Ass apparently was also easily sexually aroused. When it was finally his time—what would be the final turn in the gang bang—the few observing players hanging out in the room got a big kick out of seeing Flat Ass—*again*. You see, the number of turns taken in the orgy that afternoon—a total known only because one of the players actually stood by with a pencil and clipboard and kept tally—amounted to thirty-eight: thirty-four athletes who each had a turn, not including Flat Ass, who had four. And, notably, all four times, although it is unclear if he ever fulfilled the request, one of the observing players shouted, "Fart for me, Flat Ass!" Sometimes with the number of participants close to double figures,

other gang bangs followed, but none of them were as outrageous as what was deemed the "Flat-Ass Four Count."

Eventually, each athlete received a note in his mailbox instructing him to evacuate the dormitory for an entire day. Apparently, McWhorter Hall had become infested with crabs, or pubic lice, presumably because of the magnitude of ongoing sexual acts. As a result, fumigators had been called to delouse the entire athletic dorm. At this point, Coach Dooley apparently had learned why the dormitory had become overrun with crabs. The fuming head coach was evidently at his wits' end. Every player in McWhorter Hall would be punished if there was one more "screw-up"—even if it was rendered by "Screw Job" himself.

A member of the 1973 freshman class, Screw Job had been an all-state linebacker at the highest classification in high school and was versatile enough to be moved to the defensive line on his arrival at Georgia. A starter on the freshman team, Screw Job was expected to contribute at Will linebacker on the varsity squad as a sophomore in 1974—if he could somehow stay out of trouble off the field. He was known to drink—a lot—and if there was a drug he could get his hands on, he would usually partake in it. Seemingly always screwed up on something, Screw Job certainly upheld the nickname given to him during his initiation.

Once, around two o'clock in the morning, Screw Job entered the recreation room at McWhorter Hall, where players often brought girls and continued to party on nights without curfew. Everyone who knew of his reputation immediately shared glances, realizing something bizarre was likely to happen. After challenging an attractive girl to a game of strip nine-ball pool, whereby the loser of each game had to remove an article of clothing, it was apparent that either Screw Job was very much inebriated or horrendous at shooting pool. Much to the chagrin of the onlooking players, while the girl remained totally clothed, Screw Job eventually staggered about stark naked. In defeat, he crawled onto the pool table, laid down while closing his eyes and then uttered what could be considered his infamous last words.

"I'm going to lay down for a bit," Screw Job mumbled. "Don't let me pass out up here." Instead, a few of his teammates reacted to the request by covertly hiding his clothes by stuffing them inside a nearby trashcan.

The next morning, like most Sunday mornings at McWhorter Hall, was Sunday brunch. Chambers's parents had not attended a Sunday brunch at the dormitory since before their son had been temporarily kicked off the team. Nevertheless, Chambers had managed to keep his nose clean— rather, he had escaped from getting caught. His grades were up a little, and

it appeared as though he would finally be able to contribute to the Georgia varsity team. His parents couldn't have been prouder of him.

With his father, younger brother and sister trailing close behind, Chambers walked his mother through the primary entrance of McWhorter Hall, which included the dining hall beyond the recreation room. The mom raved to her son about how proud she was that he finally was taking advantage of earning a scholarship from the University of Georgia's football program, which was such a "class operation," in the mother's words, and "with such a beautiful dormi—"

Halting in her tracks, Chambers's mom literally stopped in midsentence as she observed through a large glass wall that looked into the recreation room, Screw Job, or what appeared like a nude dead body, laid out on top of a pool table. As the mother screamed, the father stood in disbelief, shaking his head. Chambers's younger siblings giggled (as did Chambers, who had been in the room only several hours before as Screw Job passed out).

Two or three more families observed Screw Job's naked body sprawled out on the pool table before he finally awoke. Spotting a few people standing horrified on the other side of the glass wall, he leaped from the table and began to frantically look for his hidden clothes. After a few minutes of unsuccessful searching, Screw Job gave up and ran out a back door, covering his genitals with a couch pillow.

As far as Dooley was concerned, such misbehavior was the final straw for the players residing at McWhorter Hall. Although he surely realized it could possibly hamper recruiting, the head coach instantly ordered a dormitory guideline of "no females"—at all times whatsoever—except one's mother and sisters, and only on game days and for Sunday brunch. As for Screw Job, it was his last straw, as well. Dooley pulled his scholarship and permanently kicked him off the team.

The new guideline especially disturbed Chambers, who, in moving back into McWhorter Hall, had desperately wanted his own room. Since it was apparently decided that he should live with a good influence, he instead was paired with Bobby. A student manager, Bobby was on at least a partial scholarship, presumably only because he had been part of a package deal so that his brother, a highly touted fullback, would sign with Georgia. Chambers actually didn't mind Bobby so much. Still, wanting his own space, he desired to be alone.

Before the new rule, a player having a girl over was the one guarantee his roommate would stay out of the room (unless, naturally, he was invited in for a threesome). However, since girls were no longer allowed, the one

Seen here playing around with mascot Uga III during Picture Day of 1975, the Georgia players had to figure out other ways to entertain themselves once strict guidelines at their dormitory were enforced. *Helen Castronis collection.*

guarantee for Chambers was that Bobby would be in the room—seemingly constantly. And the only chance of any change was the very unlikely event of Bobby deciding to pack his bags and move out.

Working with his partners in crime, Chambers had experience in making the unlikeliest of events plausible. Accordingly, following room check one night near midnight, Shag and Donaldson crept toward Chambers and Bobby's room wearing ski masks and armed with a fire extinguisher. After Shag quietly opened the prearranged unlocked door, Donaldson pointed the extinguisher's nozzle inches from the face of a sleeping Bobby—and, *smack*! A fury of foamy water doused the sleeping manager, shaking him from his sleep. As Bobby quickly lifted his hands to block the stream, his eyes closed tighter, he proceeded to release an eerie cry of an expletive that resonated as "G-aw-aw-aw-aw-aw-d, da-a-a-a-a-mn-it!"

After drenching an entire side of the room, and one of its residents, Shag and Donaldson ceased their spraying and darted for the door. Bobby

got out of bed and gave pursuit before Chambers cut him off several feet from the doorway.

"What the hell is going on here?" Chambers shouted, pretending to come to the aid of Bobby but actually getting in his way of chasing the offenders. "Get out of here!" Chambers yelled.

Over the next month, Bobby was paid a visit just before midnight by the extinguisher-wielding duo on three more occasions. Following the first of these instances, an apologetic Chambers "swore" to his roommate that he thought he had locked the door but must have forgotten. With the door secured prior to the second time, the extinguisher hose was positioned through one of the room's two front windows. The windows didn't open all the way, but just enough at a 45-degree angle, allowing ample space to spray down at Bobby. With the window locked for the third spraying, the hose was fed through the other window near Chambers's side of the room and angled to point crosswise at the sleeping roommate. For each of the three subsequent dousings, the result was just like the first: As Bobby was getting sprayed, he lifted his hands while letting out his death cry of "G-aw-aw-aw-aw-aw-aw-d, da-a-a-a-a-mn-it!" He then attempted to give chase until being cut off short of the door by Chambers, who pretended to have the best of intentions, always asserting something on the order of "Why do you keep fucking with my roommate?" while acting as if he was going to go after the two wrongdoers. "This is ridiculous! This shit has to stop!"

While he was cleaning up the water in the room left by the fourth drenching, and as Chambers buried his head in his pillow to keep his laughter from being heard, Bobby suddenly spoke.

"Chambers, I think I might know who is doing this to me."

Somewhat anxious, waiting with bated breath, Chambers replied, "Really? Who's that?"

"Would you expect maybe the McPhee brothers are up to this?" Bobby asked of a pair of intimidating brothers, linemen on the football team who lived down the hall.

"You know, it just might be them. I could totally see that," Chambers answered while, again, trying to refrain from snickering.

Still, Bobby remained in the room, possibly mindful that, going forward, with the door and both windows locked, there was no conceivable way he could be sprayed at night by the masked assailants. Yet, as is said, where there's a will, there's a way.

For the fifth drenching attempt—one last-ditch effort to force Bobby to move out—Shag and Donaldson approached the roommates who were

connected to Chambers's room by a bathroom. The suitemates agreed to let the two players enter their room late the next night, whereby they could pass through the connecting bathroom. Its door, which always remained unlocked, opened into Chambers and Bobby's room. The suitemates had one condition: they wanted to join in on the spraying shenanigans.

The next day around midnight, the four crept through the adjoining bathroom equipped with two fire extinguishers and each wearing a ski mask. They slowly opened the door to the neighboring room and, much to their surprise, as if he had been waiting for the infringement, Bobby sat straight up in his bed. Revealing only his dark silhouette, he muttered, "What the hell is going on here?"

Bobby promptly found out what was going on, as both extinguishers were unleashed onto him, to which he howled his familiar cry of "G-aw-aw-aw-aw-aw-d, da-a-a-a-a-mn-it!" As Bobby jumped out of bed and gave chase, the four intruders passed through the bathroom and into the adjoining room, closing and locking its door, leaving their pursuer behind.

The following morning, a defeated and deflated Bobby had evidently had enough. He packed up all of his belongings and began moving out of the room. Chambers not only had finally been granted a room to himself, but he was also extended sincere gratitude. On his way out the door, Bobby actually thanked his former roommate for his multiple attempts in trying to apprehend the miscreant players.

One had to feel sorry for Bobby, but he would wind up in a much better living situation. Moving in with a basketball player, the football manager eventually scored dates with girls because of his roommate's status. Bobby was also seen occasionally driving the player's alluring sports car—which in itself was rather ironic.

At the time, Georgia's football program had not suffered a losing campaign since 1963 and routinely reached a postseason bowl game. The school's lowly basketball program, on the other hand, was amid a twenty-eight-year period during which it achieved only four winning seasons. Yet, whereas many Bulldogs football players had a difficult time making ends meet financially, a few of the players on the basketball team suddenly and suspiciously began driving nice sports cars.

In 1978, the NCAA reprimanded the university for small personal loans and financial gifts given to basketball players during the mid-1970s. These gifts were given by a former, unnamed assistant coach who also loaned a car to a player for the athlete's personal use. Still, that was the extent of what were at the time minor violations. Yet, for Georgia football players,

there evidently were only very minor material and monetary perks. These certainly did not include what has long been rumored as gifts for some big-time college football players, like suitcases of cash, houses for relatives and complimentary automobiles.

Scholarship football players were each given a monthly "extra cleaning allowance" check of ten or fifteen dollars. This was usually cashed as soon as it was allotted and, for most players, spent on anything but "cleaning." In addition, for home and away games, players were given tickets intended to go to family members. Instead, these tickets were often sold to the public, primarily alumni. If players didn't have the means to sell the tickets themselves, many would give them to the trusty team trainer, Harry "Squab" Jones, or "Squabby," who could usually find a home for them while taking a piece of the proceeds—the "Squab commission."

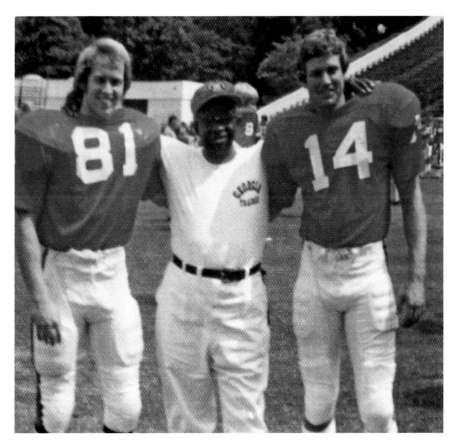

Trainer Harry "Squab" Jones, or "Squabby," poses with wide receivers Dave Christianson (81) and Shag (14) in 1974. *Henck and Kelley collection.*

Every home ticket sold to the public would usually collect its face value of $8, maybe a little more if the game was a sellout or near-sellout. The one exception was when Georgia hosted Alabama in 1976; some players received as much as $100 per ticket, equivalent to about $500 today. In addition, there was the "$50 handshake" following a big victory. But the fistful of dollars, even for star players, came few and far between.

Granted, scholarship players received a free college education, room, board, books and laundry service—opportunities the players wouldn't have benefited from if not for being football standouts in high school. However, probably more than half of the Bulldogs players at the time came from just below a middle-class background or even lower. The average player received little money, if any at all, sent from their home.

To make matters worse, strict NCAA regulations prohibited nearly all scholarship football players from getting a job during the school year, even during the off-season. Once the extra cleaning allowance was spent, and there were no more tickets to sell or fifty-dollar handshakes to receive, most players had little to no spending money.

Even obtaining a meal outside of McWhorter Hall could become problematic, because it meant that players would actually have to pay for food. The food served at the dining hall was adequate on the whole, but one could grow sick of the same things being served, especially the soy burger. Still, using the athletic dormitory as the perfect sanctuary, Shag and a few teammates eventually discovered a free meal in the form of a relatively new concept at the time, pizza delivery.

The first few times Shag and his cohorts carried out the scheme, it was like taking candy from a baby. A Domino's Pizza driver would pull up to the dorm, whereupon someone spotted his car and alerted the other players. One of them would then track down the delivery man inside the dorm and detain him with small talk, allowing the rest of the group to run down to the delivery car, grab every one of its pizzas and sneak them back to their rooms.

The driver eventually wised up. On a return trip to McWhorter Hall, the players found his delivery car locked, but they vowed not to be denied a free meal on the driver's subsequent delivery. The next time he entered the lobby carrying a large pizza, the driver unexpectedly heard a voice from behind.

"Stop! Don't you turn around, you son of a bitch, or you're going to get your ass kicked," Donaldson informed the driver. "Put that pizza on the ground," Shag commanded. "Take two steps forward, and don't turn around, or you'll get your ass beat!"

Wearing ski masks, Shag, Chambers and Donaldson had left their rooms and headed toward the back of the dorm before slipping around to the front and coming up behind the driver. After the threats, the driver did exactly what was ordered. The pizza was hijacked and the boys returned to one of their rooms with dinner.

With girls not being allowed in McWhorter Hall, a handful of players continued to entertain themselves while seizing free food at the same time. They stole pizza, of course. And then there was what would be known as the "Perfect High."

Living in an Athens apartment complex equipped with a sauna, a friend of the players seemed to always have a bag of marijuana on him. After working out or practicing, the players occasionally went over to the apartment, where they got into the sauna for about a half hour. Rather dehydrated, they then each drank three cans of Colt 45 Malt Liquor, followed by taking a few hits off of a joint—talk about a high! In fact, they became so high, they dubbed the experience the "Perfect High," or getting "St-unk." However, they then became reckless, getting into a car to take a joyride around Athens. In hindsight, it was foolish and irresponsible, since any of them or, worse, an innocent bystander could have been harmed.

On one particular night after getting St-unk, the players decided to grab their ski masks before getting into the car. Riding around, they started to get hungry. But they had hardly any money; however, they were able to pool enough together to afford what they figured to be a couple of snacks between three or four of them. As they pulled up to a Golden Pantry convenience store located not too far from campus, Chambers suggested they all put on their ski masks, go into the store and "really freak out the guy behind the counter." At the time, it sounded like a funny thing to do, and certainly harmless. As they entered the store, Shag started heading to the snacks and didn't even notice the cashier at first. But he soon definitely heard him.

"Take whatever you want! I don't care—I just work here!" a black man behind the counter yelled. "You don't have to pay for anything! Just please don't hurt me!"

After the players calmed the cashier down, proclaiming they weren't there to rob the store but were instead just goofing around, they had a lengthy conversation with the man. They then grabbed what snacks they could afford, all while still wearing their ski masks. Just as they were about to pay, the man, who said his name was "Elmo," still insisted that the food was "on the house."

From then on, any time the boys experienced the Perfect High, it was always followed with a "let's go to Elmo's." And each time, wearing the ski masks into the same Golden Pantry, Elmo allowed them to grab free of charge whatever food they could carry.

Getting their hands on a free meal while simultaneously finding some humor and a thrill might have filled the players' bellies, but it did not fill their pockets. For some, the need to acquire the money to buy new clothes, shoes or jewelry, or to take a girl out for some dinner and entertainment, called for drastic measures, including associating with shady and questionable individuals.

8
Biggest Bunch of Thugs

As at most major-college programs in the 1970s, whether during games and practices or off the field, getting close to Georgia football players, coaches and staff members was relatively easy compared to today's highly guarded measures.

Take Blue, for example, Shag's hometown friend whose persistence and knack of warming up to all types of people essentially earned him a position on the team. So much so that, to cap off the 1975 season in Dallas, Texas, when the Georgia players each received a Stetson cowboy hat as part of their gift package from the Cotton Bowl, Blue was mistakenly (yet fittingly) given a hat, as well.

There was the case of Howard Moss, a Georgia football fanatic in his seventies who once ran on the field to interfere with Georgia Tech's halftime show. When police gave chase, he ran toward the Georgia sideline, where, according to a newspaper article, "sanctuary awaited." In the mid-1970s, when the Bulldogs arrived at Jacksonville's Gator Bowl for a walk-through the day before their annual game against Florida, Moss was waiting for them. During the walk-through, he ran around the field and among the team members, stiff-arming imaginary would-be tacklers. Moss, who today would be considered perhaps problematic and a security risk, was at the time acknowledged as a "superfan" and a "Georgia legend."

Whereas Blue and Moss were considered harmless outsiders, the Georgia staff appropriately handled any individual believed to be a possible liability to the program. Such liabilities generally originated with family members,

At one time, the Georgia football program and its players could be rather accessible, as "Blue" (*extreme right*) demonstrated time and time again. *D.J. Pascale collection.*

"Georgia legend" Howard Moss (in quarterback position) poses with some Georgia football players on the Woodruff practice fields. *D.J. Pascale collection.*

like the stepfather of a player who was suspected of giving money to another player, or the mother of a player who was believed to be sleeping with an assistant coach. At the same time, Georgia football was encountering a menace much more threatening than some shady family members. It was around this time that organized crime clearly infiltrated the program—and it did not appear to be going away anytime soon.

For years, organized crime, especially gamblers and bookmakers, was rumored to be entangled with the sport of football—primarily professional football—including conspiracies to "fix" games. Still, for the most part, such allegations were determined to in all likelihood be just that—rumors.

Paul "Bear" Bryant was a legendary college football coach for thirty-eight seasons at five different schools, including the University of Kentucky (1946–53). He reportedly said that betting on football "excludes about nobody in the state" of Kentucky.

Ironically, it was Bryant who, while head coach at the University of Alabama, was alleged by the *Saturday Evening Post* in 1963 to have received from Wally Butts, the athletic director at the University of Georgia, "all the significant secrets Georgia's football team possessed" for the Bulldogs' 1962 season opener against Alabama. Butts, who had been forced out as Georgia's head football coach only a couple of years before, was said to be involved in the possible "fixing" of the Crimson Tide's 35–0 victory over the Bulldogs, which entered the game as a sixteen-point underdog. Allegations included Butts's admitted friendship with a beer dealer from Chicago who gambled what would now be the equivalent of around $400,000 a season on football games, and his supposed displeasure with his replacement as head coach, Johnny Griffith. But any evidence against Butts of assisting in fixing the 1962 Georgia-Alabama game was apparently not strong enough, as a jury later ruled in his favor in a libel suit against the publishing company of the *Saturday Evening Post*.

During one season in the mid-1970s, there were rumors of an investigation of the Kentucky football team by the NCAA for allegedly shaving points. After the Wildcats' season had ended, an article in *Sports Illustrated* declared, "The insinuations seemed plain enough: Kentucky players were fixing games. ("Point shaving" in this case was a euphemism; the team was losing, not cutting its margin of victory.)" Although some considered this an uncovering of viable evidence, the magazine had made its assertion with tongue in cheek, concluding, "If the Kentucky team were [*sic*] dumping games, there would be evidence of a betting coup, either locally or nationally. There is none."

Around that time at the University of Georgia—at least, as far as Shag and his close teammates were aware of in 1972—the sole manner in which college football related to "illegal" gambling was the simple and relatively innocent, yet very popular, parlay card. So widespread was the playing of parlay cards that the State of Michigan considered legalizing them, replacing bookies with state employees as operators.

On the UGA campus each week during football season, parlay cards were sold a number of different ways, including by students on each hall of every male residential dorm on campus. Usually sold for about five dollars each, the cards listed approximately forty to forty-five college and NFL games taking place that weekend and their respective point spreads. From the card, the bettor usually chose three teams—and no less—that he thought would cover their indicated spreads. In order to win, the bettor had to choose all three correctly, whereby he would collect generally at 5-to-1 odds (a five-dollar card paid twenty-five dollars if all three selections were winners). Another option was to make ten selections—again, needing to pick every game accurately. This method could pay 200-to-1 odds.

In theory, since each game's point spread is established to be a fifty/fifty proposition, a bettor would have a 1 in 8 chance of correctly picking three winners (yet received only 5-to-1 odds), and a 1 in 1,024 chance of correctly picking ten winners (yet received only 200-to-1 odds). In hindsight, parlay cards certainly favored their distributor, not the bettors.

The students on campus selling the parlay cards were for the most part involved in the racket only for themselves, hoping to make a little spending money so they wouldn't have to go out and find a real job. However, by 1973, Shag, Chambers, Nick and Sam were introduced by a friend to a distributor of a different sort—we'll call him Mayflower Maxwell.

Mayflower Maxwell usually could be found at, well, the Mayflower Restaurant—a charming breakfast-lunch greasy spoon and staple in downtown Athens. What he did at the restaurant was unclear— if anything at all. Although a man in his forties, to the four football players he was just another guy who sold cards. But to others, Mayflower Maxwell was what was called a "go-between"—someone who sold cards as part of a parlay ring working for and under a top distributor, or a "big guy," the "top brass."

With the start of the 1973 season, Mayflower Maxwell not only sold parlay cards to the four players, he would also sit down with them at the restaurant, chatting with them while offering advice on certain games— which teams he would pick if he was playing the card.

One morning in late September, the players ordered breakfast at the restaurant and then continued what had been their weekly routine. Mayflower Maxwell emerged and sold each a couple of cards, then joined them at their booth. He gave his advice on which teams that weekend he felt would cover the point spread. However, this time, Maxwell followed up his advice by asking the players for their advice.

"What do you boys think of team no. 21 for this Saturday?" Maxwell asked the four players.

A quick glance over the card, searching for team no. 21 revealed:

21. Georgia 22. N.C. State +2*

North Carolina State was a two-point underdog to Georgia. The asterisk indicated that the Bulldogs were the home team. More so, Georgia was no. 21, the team Mayflower Maxwell had inquired about.

After the players stared in confusion without answering, Maxwell continued, "You guys play for Georgia, right?" He then asked the players what injuries their team had suffered—those that perhaps had not been made public. He particularly wanted to know about the Bulldogs' quarterback situation.

The week before against Clemson, star signal-caller Andy Johnson was removed from the game after injuring an ankle and reinjuring his ribs. He was relieved by sophomore Ralph Page, who, playing in his first game as a member of the varsity, led Georgia to a 31–14 victory. A big question on a lot of people's minds, including Mayflower Maxwell's, was whether Johnson had healed enough to start against North Carolina State. And, if so, would Page still see playing time?

The players soon revealed why they really couldn't give Mayflower Maxwell any information, even if they would've liked to.

"Yeah, we're on the team, but we've all been suspended for this season," Nick said. "We don't practice. We don't even live in the athletic dorm."

"Well, do you know enough about the team to tell me if they can beat N.C. State by at least a field goal, or not?" Mayflower Maxwell asked.

"Not a clue," Chamber replied.

In less than a minute, Mayflower Maxwell had left the players' booth and wandered toward the back of the restaurant, disappearing near the kitchen area. Promptly, Sam informed the rest that the inside information Maxwell was seeking likely had nothing to do with his parlay-card operation, but football gambling on a much bigger scale—one probably involving the

"top brass." The players decided that if they were to continue buying and playing parlay cards, it wouldn't involve Mayflower Maxwell. Accordingly, they would not encounter their older acquaintance again—at least, not until several months later, after the football season.

One evening that spring, Shag, Nick and Sam were riding in the latter's bright yellow Dodge Coronet when they decided to drive about four and a half miles outside of downtown Athens to check out a stand-alone building on the Atlanta Highway. The building was supposedly a bar; however, it was known in some circles of the football team to be some sort of gambling house. The foursome's interest had been piqued.

When they pulled into the establishment's dirt parking lot, they spotted cars belonging to a couple of upper-class linemen and decided that they, too, would enter the bar. However, on reaching its front door, they realized that there was no way to enter the building unless granted access from the inside.

Nick banged on the building's steel door. Within seconds, a latch opened and a pair of eyes appeared, just like at a speakeasy door from Prohibition. Suddenly, a voice was heard from behind the door: "Who are you?"

The boys briefly stood silent before Shag finally stated, "Um, we're… we're Georgia football players." The voice instantly shot back, "Fuck you. Get outta here," as the latch closed.

As the players walked away from the building and back into their car, they spotted another vehicle pulling into the parking lot. The driver got out of his car, and the players recognized Mayflower Maxwell. He, unlike the boys, was apparently recognized by the doorman and allowed to enter the bar/gambling house.

At a time when it had been reported that local law enforcement was "continuously on the trail of organized gambling," another older man, in his early thirties and having no apparent association with Mayflower Maxwell as far as the players were aware, began hanging around the Georgia football program. Spotted maybe once or twice on the sideline during games, "the Bookie" as he was simply known, associated with only certain players—primarily the ones larger in stature (and, ironically, those who often played cards).

True to his moniker, the Bookie was known to operate a large gambling operation. It involved parlay cards but extended beyond that, to straight bets—large ones, at that. Such bets were accepted only from "100 percent non-risk elites," or bettors who were not a risk to expose the Bookie and who assuredly would always pay up if they owed him money. Evidently, the Bookie primarily hung around only two types of people: others involved in

organized crime in the Athens area—primarily other gamblers/bookies—and selected former and current UGA football players.

Apparently, the gamblers associated only with Georgia football players they could fully trust and, curiously, those who were starters or, at least, seemed like they'd be starting the following season. The gamblers would buy the players food, alcoholic drinks and rounds of golf.

Shag, who appeared as though he would be starting in 1974, was approached by two linemen teammates only days prior to the beginning of the season. He was asked to go out with them and a friend of theirs who would be picking them up and taking them to Cooper's, a country bar and liquor store on the east side of Athens.

Waiting outside of McWhorter Hall, the three players were picked up in a Cadillac driven by none other than the Bookie. Driving to Cooper's, the Bookie had very little to say to Shag except to offer him a joint, which was passed around before they finally arrived at the bar.

After an hour or so inside Cooper's, one of the two players told Shag to accompany him and the other player, who followed close behind the Bookie. The four of them walked up to a guy sitting at a barstool along a bare brick wall. The Bookie mumbled something to the man. Suddenly, and Shag had no idea what exactly caused it, the wall revolved partially, allowing the group to walk to the other side.

Behind the wall was a hidden gambling house no bigger than a single, one-thousand-square-foot room. It was a full-fledged casino consisting of roulette, slots, poker with actual dealers and the like. At that moment, and perhaps enhanced by having smoked marijuana and drunk alcohol, Shag felt as though he had emerged in an episode of the *The Twilight Zone* television series he had watched as a kid in the early 1960s.

Following what had been, and still remains, the most surreal moment of his life, Shag never again returned to Cooper's, which would be in a dilapidated state roughly twenty-five years later. He also never intermingled again with the Bookie, who eventually would be referred to as "Señor Grande" by the Georgia Bureau of Investigation (GBI).

Although Shag may not have associated with him again, Señor Grande was still observed hanging around certain members of the football team by the start of the 1974 season. It was around this time that two starters confided in Shag that they had each been approached by a different "gambler"—neither of whom appeared to be Señor Grande. Whether or not either of the two gamblers was somehow connected to Señor Grande was uncertain. For the 1974 campaign, each of these gamblers asked the

respective starter to "throw games" in exchange for money and gifts. Both players later vehemently claimed they declined the offers. It was also by then that a few Georgia players, one of whom had accompanied Shag to Cooper's, were called into the office of Vince Dooley. The head coach informed the group that he had heard a rumor that they were hanging out and playing golf with gamblers. If they were doing so, he wanted them to stop immediately.

It was apparent to a number of players that an "undercurrent of organized crime," as it was characterized, primarily concerning illegal gambling, loomed within the Georgia football program by 1974. A few players believe this "undercurrent" had also existed during the 1973 season, and maybe even before. However, for most of the team, such a notion was entirely inconspicuous. For instance, Shag would have thought the idea was absolutely ridiculous—that is, until his encounter with Mayflower Maxwell, followed by the two starters divulging the fact that they were approached by gamblers before the start of the 1974 season.

To begin the 1974 season, although Shag had inherited number 14—the jersey number worn by the recently departed Andy Johnson—he hadn't inherited what he once thought was his destiny: Johnson's role as Georgia's starting quarterback. Shag had moved positions and, with it, had a new position coach.

The previous winter quarter, Shag had taken a wrestling class for one of his physical education requirements. The class was taught by Sam Mrvos, who was better known for his role as an assistant football coach for more than twenty years after being a standout Bulldogs player in the early 1950s. Coach Mrvos, who would work out with the players, was said to be "as strong as an ox, and hairier than a bear"—even hairier, in fact, than Yogi Berra in Shag's eyes. Still, he might have been best known for his part in the weekly delivery of the opposing scouting report.

In his high, lispy voice, Coach Mrvos, in regards to seemingly every opposing player, notoriously and repeatedly declared, "And, the worst thing I can say about [player X] is that he's the best player I've ever seen!" The week of Georgia's season opener against Oregon State, Coach Mrvos claimed, "And, the worst thing I can say about their quarterback, Alvin White, is that he's the best quarterback I've ever seen!" Considering White had quarterbacked the Beavers the year before to a 2-9 record, passing for just five touchdowns and twenty-three interceptions while averaging a lowly 4.1 yards per offensive play, the coach's statement was beyond comical to a reputable Georgia defense.

In his wrestling class, Coach Mrvos had pitted Shag against an opponent who had been an all-state wrestler in high school. The wrestler soon placed Shag into an awkward move, snapping his elbow once and right shoulder a couple of times. Barely able to throw a football 10 yards, Shag's throwing arm was temporarily ruined.

Although somewhat anxious since his time under center had been placed on hold, Shag was confident he could contribute somehow—maybe at his initial position in high school, wide receiver. Just prior to spring practice, he had approached Dooley, asking to be moved to receiver because of his injury. The head coach succeeded in doing this—kind of. When spring practice opened, Shag was listed as the team's *seventh*-string split end. Shag wasn't the only Bulldog offensive player who fought an uphill battle in the off-season.

After two consecutive seasons of displaying an often stagnant offensive attack, Coach Dooley removed a close friend of his from the Bulldogs' offensive coordinator post and hired Bill Pace as his replacement. Pace, fresh off a one-season stint as an assistant coach for the New England Patriots after spending six years as Vanderbilt's head coach, replaced Georgia's "I" offensive formation with the "Veer."

Reportedly, the Veer was primarily implemented by Georgia to improve its short passing game, although the new offensive formation was very much a run-oriented, tripe-option set featuring two running backs. After deciding to run the Veer, Dooley and Pace thoroughly researched the formation to see how it could best benefit the Bulldogs. They discovered that to be effective, the offense needed "a good option quarterback" and "good running backs," or to be "great" in one of the two areas. Unfortunately, Georgia seemingly featured neither entering the 1974 season.

The single offensive unit that appeared capable was the one they seemed to need the least—wide receiver. Receivers Gordon Robbins, Kevin Hartman, Gene Washington, Butch Box and Dave Christianson all had starting experience and/or had seen playing time as a true freshman. There was also Shag, who had worked his way up from seventh-string split end to starting at the position.

Although Georgia's offensive line was considered one of the largest units in the nation, it returned only one starter, all-star candidate Craig Hertwig. At running back, Georgia had lost three of its top four rushers from 1973 and lacked size. Still, with the loss of Johnson and the Bulldogs not returning a seasoned signal-caller for the first time in the Dooley era, the team's biggest question was at quarterback. By early September, Georgia's lone returner with experience under center, Ralph Page, was experiencing a bum ankle.

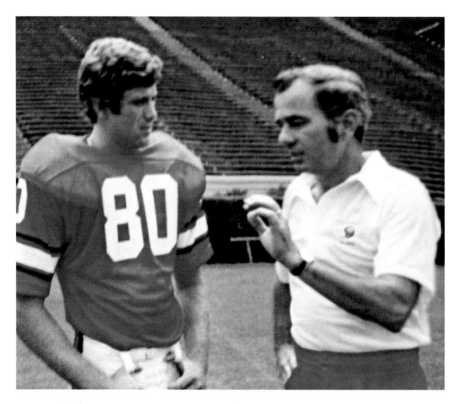

Above: Shag with Bill Pace, who was hired as Georgia's offensive coordinator in 1974. *Helen Castronis collection.*

Left: Pictured with a couple of admirers, All-American tackle Craig Hertwig and his consistent, exceptional play was about the only certainty for an inexperienced Georgia offense entering the 1974 campaign. *Helen Castronis collection.*

True freshman Anthony (Tony) Flanagan, arguably the most sought-after high school signal-caller in the country, had decided to play basketball. This left a trio of first-year varsity members, each talented in their own way, vying for the starting position: Dicky Clark, Matt Robinson and Ray Goff.

According to the *Atlanta Constitution*, a little more than two weeks prior to the Oregon State game, "Defense is supposed to be Georgia's salvation early in the season while the quarterback—who ever [*sic*] he may be—gains experience."

Under the direction of esteemed coordinator Erk Russell, Georgia's defense appeared as stout as it had always been during the decade-long Dooley era. Despite missing half his junior year with an injury, senior defensive tackle Dan Spivey was being touted as an All-American candidate. Sophomore Sylvester Boler appeared in only four of Georgia's eleven regular-season games as a true freshman in 1973, but he was a consensus preseason choice as first team All-SEC. Besides Spivey and Boler, all-star candidates included defensive ends David McKnight and Rusty Russell, linebacker Keith Harris and cornerbacks Steve Taylor and Larry West.

To kick off the season, the Bulldogs' Veer thrived, silencing those who had questioned the offense. In scoring three touchdowns each rushing and passing (after throwing for just six touchdowns the entire 1973 season), Georgia's 464 yards of total offense was its most in a game in five years. If the Bulldogs needed a "good" quarterback to effectively run the Veer, they featured three against Oregon State. With Clark starting the game, and Robinson and Goff entering in relief, Georgia's signal-calling trio combined to gain nearly 150 yards of total offense while accounting for four touchdowns. Shag had a game-high three receptions for 63 yards, including a 35-yard touchdown reception from Robinson. However, as far as the Georgia defense's performance in the 48–35 victory, it was, surprisingly, another story.

After Georgia had allowed an average of just roughly twelve points and 250 yards per game during the previous *decade*, the Beavers' Alvin White engineered an offense that tallied five touchdowns and totaled nearly 400 yards. Torching Georgia both through the air and on the ground, the Oregon State quarterback demonstrated to the Bulldogs' defense that it should have heeded Coach Mrvos's warning. White passed for almost 200 yards and added 65 on the ground.

At practice leading up to the second game of the season in Jackson, Mississippi—a nighttime affair against Mississippi State—Dooley focused on the defensive side of the ball. In addition, he brought in a record player

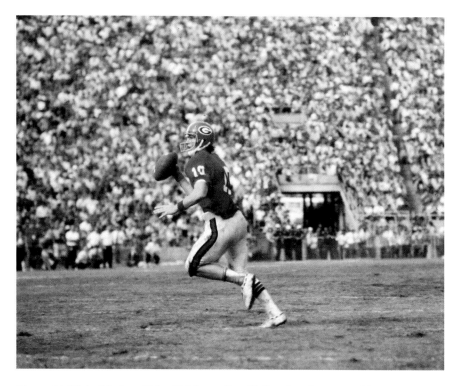

Along with Dicky Clark and Matt Robinson, Ray Goff—all sophomores without any varsity experience—entered the 1974 season in a three-way battle for the Bulldogs' starting quarterback position. *dr. jteeee collection.*

and an amplifier to mimic State's tradition of ringing cowbells to distract opposing offenses. With a game under their belts, the head coach believed his Bulldogs would perform much better than they did versus Oregon State. Instead, the result was Georgia getting "out-everythinged," according to Dooley, "starting with being out-coached" in "a distasteful [38–14] loss."

Led by quarterback Rockey Felker and running back Walter Packer, the host Bulldogs held a 24–0 advantage at halftime and cruised to an easy victory. Often unable to hear the signals called at the line of scrimmage because of the clamoring of cowbells, Georgia's offense struggled mightily. Clark, Georgia's starting quarterback, was benched at the end of the third quarter in favor of backups Robinson and Goff.

Although Georgia overall seemed to have underperformed through the season's first two games, Shag had played admirably, especially considering that he was slotted at a new position. His 66 receiving yards per game

ranked second in the SEC, while his 26.4 yards-per-reception average was tops in the conference. The *Atlanta Constitution* sent a reporter to campus to write an article on Shag. The story was about the former prep All-American quarterback who had been injured, followed by being suspended. Yet just as his future looked hopeless, he matured and turned into a first-rate wide receiver. The article was rather ironic considering what would occur just days after its printing.

On the Thursday night prior to Georgia's third game—a home contest against South Carolina—at least a couple dozen players attended a party. They all returned to McWhorter Hall just in time for bed check at 11:00 p.m. before most of them left the dormitory and headed back to the party. When Shag returned to his room that night around 2:30 a.m., he pulled back the covers to his bed ready to pass out when up jumped an unexpected visitor.

"I got ya'!" exclaimed Coach John Kasay, who had been hiding under the covers, waiting on the unsuspecting curfew violator. "I'll see you over at the coliseum at 6:30 in the morning for 'Sunrise Service,'" he added as he walked out of the room laughing. At that moment, Shag realized that more was likely in store for him than running steps and lifting weights a few hours later. Since the team was in season, perhaps also awaiting him was a suspension for a portion of the upcoming game.

Shag's punishment was much worse than he originally thought. For the nine players who were caught past curfew that Thursday night, Coach Dooley determined their sanctions on a case-by-case basis depending on the particular offense and the individual player's conduct record. For Shag, who didn't have the best record of conduct to say the least, that meant being benched for the entire South Carolina game.

With Robinson as the Bulldogs' starting quarterback, Georgia reverted to its run-oriented tendencies, rushing for over 500 yards while completing four of just six passes in a 52–14 victory over the Gamecocks. Three of the receptions were made by sophomore split end Mark Wilson, who had replaced Shag in the starting lineup.

To the chagrin of the few starters, like Shag, who had been caught after curfew prior to the South Carolina game, Coach Dooley announced the week of game four against Clemson that Georgia would feature the same lineup against the Tigers in regard to the players and positions affected by the disciplinary action.

At Clemson, Georgia led, 10–0, midway through the second quarter before four eventual lead changes resulted. Trailing 28–24, the Bulldogs

elected to punt from Clemson's 40-yard line with just under seven minutes left in the game. Georgia would never get the ball back, and its record dropped to 2-2.

Under the impression that he would resume his starting role after the Clemson game, Shag was informed otherwise by his position coach, "Baby Huey." Nicknamed for his likeness to the prominent cartoon character of the 1950s, Baby Huey had been a distinguished wideout at Georgia in the mid-1960s before playing professional football. A highly regarded assistant coach, he eventually would have a long coaching stint in the NFL after serving on Georgia's staff for most of the 1970s.

Baby Huey was an excellent coach, teaching a number of Bulldogs players, including Shag, much of what they learned to effectively play the wide receiver position. Notwithstanding, by the fifth game of the 1974 campaign, Shag had incurred what could be considered his third strike with Baby Huey. There was clearly a sense of indifference between coach and player.

It was an era when not necessarily all of the very best players started at their respective positions (for example, the second-best player at a particular position, if he was a scholar athlete, might start at the same position over a top player with below-average grades). Some assistant coaches tended to favor those players they had recruited. Baby Huey had not recruited Shag. In addition, aside from players with poor academics or those who loafed on the practice field, most coaches detested troublemakers, assuming they couldn't be relied upon on or off the field. And, by his third year at Georgia, Shag had indeed often been in trouble. Finally, if a player replaced another in the starting lineup, and the new starter was playing well, it was sometimes difficult for the old starter to get his job back, especially if the aforementioned two strikes were already against him. Against South Carolina and Clemson, Wilson had proved to be a good, steady receiver. It would be tough to get him to relinquish his role if handed a starting job.

Prior to the fifth game of the year, Baby Huey deemed both Shag and Wilson to be "co-starters" at split end for an indefinite period; the latter would actually start and play the first series. Shag would come in for the second offensive possession, and they'd alternate for the remainder of the contest. Subsequently, in consecutive home games against Ole Miss and Vanderbilt—both victories—Shag found his co-starting role to be more like a "hardly-thrown-to" role, as Georgia's offense increasingly became more run-oriented. After ranking second in the SEC in receiving, the "co-starter"

had caught just one pass for four yards in four games entering the Bulldogs' seventh contest at Kentucky.

Seeking its first victory on the road, Georgia traveled to Lexington in late October to face the Wildcats. Normally, when the Bulldogs flew out of Atlanta, players had the option of riding a team bus from Athens to the airport or driving over. Electing to drive before catching the team's chartered night flight, a dejected and careless Shag, along with Chambers and Donaldson, each chose to drink several beers during their eighty-five-mile trek to the Atlanta airport.

Once aboard the plane, the three players hastened to the back of the cabin for the bathroom, only to find a line had already formed for each of the two lavatories. After eventually relieving himself, Shag was stopped before reaching his seat by Coach Pace, who wanted to discuss a couple of new plays involving the receiver he had drawn up to use against Kentucky. Eventually settling in his seat, Shag had relaxed for about forty-five minutes, or about halfway into the flight, when, suddenly, the captain's voice unexpectedly came over the cabin speaker.

"Gentlemen, this is your captain speaking," he began. "It has been brought to this flight's attention that a bomb threat was written on one of the bathroom's mirrors. We are guessing, and hoping, this is only a prank. If you are responsible for this, please come forward and you won't get in nearly as much trouble than if you're eventually found out. Thank you."

The passengers sat in silence, most of them staring at one another—a stillness that essentially lasted the remainder of the flight. As the plane descended toward Lexington's Blue Grass Field, one player looking out his window remarked how the ground was "lit up like a Christmas tree." The runway was covered with as many as two dozen lighted emergency vehicles. Once the plane landed and came to a stop, it was soon surrounded by at least twenty-five FBI agents, plus a bomb squad and local authorities. After searching under the vessel, the FBI boarded the plane, telling the team members to sit in their seats and not move. The agents milled about the cabin, gravitating toward the bathroom where the threat had apparently been written.

With no one having professed to the bomb threat, the players were marched from the plane into a room inside the airport, where they sat while authorities waited for a confession. After more than an hour of sitting and waiting, some players grew weary and antsy, including a senior team leader, who snapped.

"Come on, God damnit!" the player yelled at no one in particular. "Whoever did it, confess already! We've got to get to the stadium and practice tonight!" he declared, referring to the thirty-minute mini-practice scheduled that night.

Following what had been about three hours since the plane had landed, all the FBI agents curiously left the room together. After being gone for no more than twenty minutes, they returned as a group, as if they had just held a meeting, and promptly circled the players, who sat in chairs. Instantly, one of them, who appeared to be the head agent, made a peculiar announcement.

"Whoever wrote the bomb threat was a real dumbass!" the head agent said. "He spelled airplane, 'a-i-r-p-l-a-i-n.'"

If the FBI agent was hoping to get some sort of reaction following his brash statement, he was very much misguided, as most of the players remained still, in absolute silence and utterly confused. Without incriminating evidence or anyone confessing to the prank, it was soon determined that the FBI had no choice but to let the entire team go.

As Shag was about to board one of the team buses, which would not transport the players to their hotel until almost midnight, an agitated Kojak, the dorm counselor, approached him.

"Shag, I've got who wrote the threat narrowed down to ten people," Kojak asserted, "and you're one of them!"

Shag was scared, and he had been for hours—and for good reason. He was the one who had written the threat.

A few hours before, as Shag had been waiting to use the plane's restroom, fellow receiver Dave Christianson got in line behind him. While using the bathroom, Shag recalled a scene from a movie he had recently seen, *The Parallax View*. In the film, character Joe Frady, played by actor Warren Beatty, while in an airplane's bathroom, grabbed a bar of soap and wrote on the mirror, "THERE IS A BOMB ON THIS PLANE." In an attempt to play a trick on Christianson, Shag used the bathroom's bar of soap to write on the mirror something similar: "THERE IS A BOMB ON THIS AIRCRAFT."

Still somewhat intoxicated as he exited the bathroom, coupled with being called over by Coach Pace, Shag did not notice that Christianson was no longer behind him in line, but instead had entered the other restroom when it became unoccupied. And, in talking with Coach Pace, Shag totally forgot his original intention of erasing the threat before the plane took off. Instead of Christianson seeing the threat, or it being erased before takeoff, "THERE IS A BOMB ON THIS AIRCRAFT" was not detected until roughly forty minutes into the flight by Coach

Bomb Threat On Georgia Plane a Hoax

LEXINGTON, Ky.—(AP)— Georgia defensive coach Erk Russell discovered a bomb threat warning as the Bulldogs theirLexington for their Saturday night encounter with the Kentucky Wildcats.

A message. scrawled in soap

The bomb threat—a hoax—written by a Georgia player on a plane en route to Lexington, Kentucky, in 1974 became nationwide news. Detroit Free Press.

Russell, who went from the bathroom straight to the cockpit to notify them of what he had spotted.

Any chance of Shag confessing to the prank dissipated when the captain indicated that the confessor, although supposedly sustaining a lighter penalty, would still be in trouble. Having been arrested, dismissed from the team for a season, suspended and losing his starting role—all in the course of just over a year—Shag couldn't afford to get into *any* trouble. If he confessed, he figured he would be dismissed from the program permanently and perhaps even kicked out of school. He kept his mouth shut.

It turned out that the reason the FBI agents had left the room in the airport, only to return shortly thereafter, was that they indeed had held a brief meeting, agreeing that there was likely only one way they would get a confession: mind tricks.

Figuring the culprit—a young, cocky football player—had likely told a teammate about his prank, the FBI decided to insult the player by claiming that the "dumbass" had spelled "airplane" incorrectly. In reality, since he hadn't even written the word "airplane," much less misspelled it, the culprit would surely react somehow right in front of the agents' watchful eyes, likely by maintaining to his teammate that he had actually scrawled "aircraft." But Shag had told no one of his prank and wouldn't for more than a year. The only reaction the agents perceived was one of silence and stillness.

The next night at Commonwealth Stadium, Shag was injured early in the game in what was perhaps poetic justice. He fractured his collarbone after several players—mostly his own teammates—fell on top of him as he attempted to block downfield on a running play. Shag would miss the next month of the season. As for the rest of the team, an exciting 24–20 victory over an adequate Kentucky squad was a continuation of one of the most inconsistent seasons in Georgia football history.

After a 5-2 start to their campaign, the Bulldogs were defeated at home by the Houston Cougars, but they bounced back the next week by beating sixth-ranked, Sugar Bowl–bound and significantly favored Florida. The upset victory was followed by losing a 17–13 heartbreaker on the road at

Auburn. Still, Georgia figured to end its regular season by dismantling chief rival Georgia Tech.

The Bulldogs' vaunted Veer, which had been productive for most of the season quarterbacked primarily by Robinson, struggled mightily on a muddy field in a cold sleet at Sanford Stadium. Defensively, Georgia was gashed by the Yellow Jackets' wishbone offense in a 34–14 loss—the Bulldogs' fourth defeat of the season in which they were favored to win.

Finishing with a 6-5 regular-season mark, Georgia surprisingly had one of the better offenses in the SEC for 1974. But its defense was inexplicably substandard, allowing a conference-worst twenty-four points and 360 total yards per game, including nearly 250 yards rushing.

In late November/early December, while still nursing his fractured collarbone, an anxious Shag took most of his handful of trips to the main library while a student in a period of less than two weeks. In nationwide newspaper accounts of the bomb threat, it had been reported that the FBI was "planning on interrogating every member of the Georgia football squad as well as the coaches," including conducting handwriting analysis and lie detector tests. Studying up on how to beat such tests, Shag prepared himself for the FBI's anticipated arrival in Athens.

With the idea of a possible invasion by the FBI, Shag and the rest of the team prepared for a December 21 date in Orlando's Tangerine Bowl against Miami of Ohio. The Redskins had achieved a 10-0-1 record and were riding a twenty-two-game unbeaten streak. Reportedly accepting the Tangerine Bowl's invitation prior to their loss to Georgia Tech (in the words of a Georgia official, "I'm very pleased the team voted to accept"), the Georgia players had actually voted *not* to accept. They were overridden by the athletic department.

Featuring a team that didn't want to be in Orlando, and three standouts, each eventual NFL draft selections, who literally didn't make the trip because they were ruled academically ineligible just days prior to the bowl—All-American Hertwig and defenders Spivey and Taylor—Georgia allowed Miami of Ohio three touchdowns in the game's first sixteen minutes before finally being defeated, 21–10.

Losing half of their games, the 6-6 Bulldogs were appropriately characterized by running back Horace King as playing most of the season "half-assed." There was plenty of individual talent on the team. Eight players earned All-SEC recognition—no Georgia squad had had more since the 1968 SEC championship team—including four whose final game as a Bulldog was unfortunately the loss in the Tangerine Bowl: King,

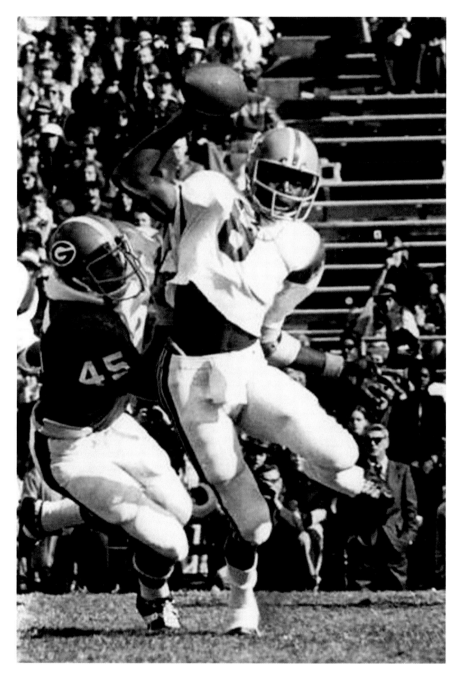

For a number of outstanding and hardworking Bulldog players, like linebacker Keith Harris (pictured), it was unfortunate that their Georgia careers had to end in such a disappointing fashion. *Donald Harris.*

Hertwig, Sylvester Boler and David McKnight. Three more players—all defenders—who also would not be returning in 1975, made all-conference honorable mention: Taylor, Chuck Kinnebrew and Keith Harris (who probably should have be recognized as first team All-SEC).

With the team losing an abundance of talent, the issue for most Georgia enthusiasts wasn't necessarily how good the team should have been in 1974, but how bad the Bulldogs would be in 1975.

Still, there were those who were incensed with what had resulted—namely, athletic director Joel Eaves. Likely swayed by the facts that the team had underachieved, had an undercurrent of organized crime and was embarrassed by the bomb threat incident, Eaves was overheard proclaiming that the 1974 Bulldogs were "the biggest bunch of thugs to ever come through the football program." He vowed to never recognize them for the rest of his life.

By mid-January and with winter quarter having started, it was apparent the FBI's claim that it would be converging on Athens to conduct handwriting analysis and lie detector tests was unfounded. Shag, who still hadn't told anyone that he had written the bomb threat, was extremely relieved—as was another Bulldog.

One night at a bar, Shag was approached by a teammate, and the two engaged in small talk before the friend inquired, "Shag, you remember the bomb threat on the plane, right?"

How could Shag have forgotten? He answered, "Yeah, what of it?"

"Well, I know who did it—who wrote the threat on the mirror," the teammate claimed in a near-whisper.

Nervously, Shag asked, "Who?"

"It was me, man! I was the one who did the bomb threat," he lied in a boasting manner. "Can you believe I was able to pull that over on the FBI?"

No, Shag couldn't believe it. Although the FBI's trickery had failed to catch the culprit, it appeared to have been effective enough for the innocent to take credit for the misdeed.

9

A Manipulator among Them

In January 1975, Shag was approached at McWhorter Hall by a departing senior player. The two teammates weren't close at all, so when the older player began the conversation, Shag immediately knew the senior probably wanted something from him.

"There's a guy in Atlanta that wants to meet you," the teammate said.

"A guy?" Shag asked.

"Yeah, he's an older guy who comes to the home games with binoculars, checks out players on the sidelines, saw you this past season, and wants to meet you," he answered.

"Is this guy gay?!?" Shag blurted with a chuckle.

At the time, Shag had been only minimally exposed to alternate sexualities. In fact, it had only been a year or so since he became aware of the prevalence of a homosexual lifestyle.

A week before Georgia opened its 1972 season, Shag and a few other freshmen players went to an Atlanta nightclub, Uncle Sam's, located on Peachtree Road at Bennett Street. Situated in a warehouse-like facility, the bar was a real happening place with lots of women.

About a year later, essentially the same group of players revisited Uncle Sam's but found that the bar's clientele had changed drastically since their initial visit. There were no women—just men. "I think that was the first time any of us had seen two guys kiss," recalled a teammate of Shag's and a member of the group. "I didn't know that lifestyle even existed, and certainly wasn't aware there could actually be a bar catering pretty much to just gay men."

At the time, although the city of Athens had a growing alternative scene and liberal disposition, homosexuality remained a foreign concept for most straight students at the university, especially those who were part of the football team. For many players, a homosexual was not merely a person with an alternative lifestyle, or even an individual who should be avoided. Gay and bisexual men—and there seemed to be a growing number of them in Athens in the 1970s—were objects of ridicule and scorn for most players. Some players went as far as taking advantage of them for their own amusement and gain, even if it meant at times performing acts they normally wouldn't even consider.

A particular teammate of Shag's occasionally spoke of a gay professor who was willing to give any football player an "A" in his class without having to attend a single lecture. "I just had to let him suck my dick one time," the teammate said rather nonchalantly. Shag thought the player was pulling his leg, but two other teammates informed him that they, too, had the same professor and had received an "A" for the very same trade-off.

A few older teammates of Shag's spoke of a bisexual man, "Louis," who evidently was also enamored with Georgia football players. A player could go over to Louis's home in Athens and be given oral sex by his wife in the middle of a room while Louis watched from the corner, masturbating. At the end of the session, Louis would emerge from the corner of the room and hand the player some money, usually twenty-five dollars.

One night, Shag and a teammate of his from south Georgia were riding around, contemplating what they were going to eat for a late-night meal and, more importantly, how they were going to pay for it. They pulled into a Krystal, a fast-food restaurant known for its hamburger sliders located on Baxter Street within walking distance of Sanford Stadium. As they began counting their coins, figuring out how many of the miniature burgers they could afford, they noticed a guy a little older than they were who had pulled up next to them and continued to look over into their car. Shag's teammate waved to the guy to come over, whereupon he obliged.

"What are you looking at?" the teammate asked the rather feminine man, who was peeking through the car's partly rolled-down window. "You wanna suck my dick?" the player added.

Much to Shag's surprise, and the teammate's as well, the man replied, "Yeah, I actually do. I *would* like to suck your dick."

After a long pause, the teammate finally commanded, "Okay, then go inside the Krystal and bring me and my friend back a few of those sliders."

The man went into the restaurant and, a few minutes later, appeared with a sack spilling over with burgers and fries under one arm and two sodas in the other. When he reached the car window, the friend grabbed the bag and the sodas, passed Shag's share over to him, and then instructed the man to wait until they finished their food. The man waited patiently in his car as each of the boys devoured several sliders, an order of fries and a large soda. When he finished his food, the teammate started the car, put it in reverse and peeled out of the Krystal parking lot while shouting out his window, "You ain't sucking this dick tonight, you faggot!"

As the players sped away from the man in his parked car, Shag stared at a face he has never forgotten—one filled with disappointment, yet anger and embarrassment, gawking out his driver's-side window.

Shag certainly never had anything against homosexuals. Growing up in a secluded part of Maryland, unaware that gays were just as much human beings with feelings and rights as everyone else, he, as a college student, was simply unfamiliar with the type of lifestyle. Regardless, for most straight twenty-year-old males in 1975 living in the Deep South, the idea of a much older homosexual man—one who lived more than an hour away—wanting to meet you could be somewhat disturbing.

After Shag had asked his much larger teammate if the man wanting to meet him was gay, he replied, "Yeah, he's gay. But, you don't have to do anything with him. Just go meet him at his condo in Atlanta, and he'll give both you and me some money."

Receiving money for just meeting with someone was enticing; however, Shag was skeptical, and it must have shown on his face.

"Look, I really need the money," the teammate persisted. "We will just go and meet with him, and he'll give you and me $100 each."

Shag couldn't resist. That was about as much money as he received in cleaning allowance for an entire year. Plus, the player was huge and intimidating—he was referred to as a "Big Bad Ass." For Shag's own well-being, he wasn't going to deny the player $100.

The teammate said he would drive Shag into downtown Atlanta and accompany him inside the man's condo. However, in the end, Shag was only given directions and reluctantly went there by himself. The man lived in the relatively new Colony Square condos in the Midtown section of Atlanta at the intersection of Fourteenth and Peachtree Streets. On Shag's arrival to the lobby of the luxury apartments, he was buzzed up by the doorman before riding an elevator to the seventh floor.

This photo of Jim Barnett, which appeared in the *Washington Post*, was taken in his living room at his Colony Square condo in Atlanta—the same room where he intermingled with and entertained Georgia football players. *Gittings Studio, Atlanta.*

The man, Jim Barnett, was somewhat small in stature and rather unattractive. He wore thick, unflattering glasses, had a flabby build and appeared as if he was a seventy-year-old accountant. In fact, he was actually about twenty years younger than that. Barnett also had on exactly what he would be wearing every time Shag and accompanying teammates would visit him over the next two and a half years: suit pants and an open-collared white shirt exposing garish gold necklaces across his chest.

Within a few minutes of greeting Shag at the door, Barnett had already given him a liquor drink and hinted that he worked as an executive with Barnett Bank—at the time, the largest commercial bank in Florida. He also indicated that he was gay and wanted to meet football players. Demonstrating an alluring, humorous and intellectual disposition, Barnett was quick with a quip, as well—particularly one he would repeat several times over the next couple of years: "Did you know I'm *bi*sexual? I love men *and* boys!" After Barnett's joke, Shag noticed a framed photo of his host standing with the governor of Georgia, Jimmy Carter, taken in that very room in the condo.

The home had a very odd layout—like two condos combined into one. To reach the main room, one would have to walk through several other rooms, including a couple of bedrooms. Once in the living room, Shag noticed a television tuned to what many Americans were watching at that very moment: Super Bowl IX matching the Pittsburgh Steelers and Minnesota Vikings.

Barnett was funny, evidently liked football and knew Jimmy Carter well enough for the governor to visit his home; plus, he gave away free liquor drinks. Just as Shag thought to himself, "Regardless of this guy's sexuality, he can't be all that bad," Barnett interrupted any comforting thoughts by asserting, "My boy, let me see how big your dick is."

While Shag frantically explained that his older teammate had claimed he didn't have to do anything if he didn't want to, Barnett looked curiously at Shag's chest and abruptly interrupted, "Oh, my boy, it looks like you have chest hair. And, well, that's the shits."

After Shag had removed his jacket, Barnett spotted hair protruding from his button-down shirt. It was evident that the host did not like a man with a hairy body. But Shag apparently could still be of service. Barnett suggested, "Maybe you can start introducing me to other players on the team."

Barnett described that it could work just like it had with the older teammate, who would soon be leaving school. Shag would receive a phone call at his room in McWhorter Hall from Barnett, who would request a player he wanted to meet. Then, the players—the requested teammate and Shag—would visit the condo and each receive $100. It was as simple as that.

Shag must have looked hesitant, because Barnett began to preach a rehearsed-sounding stance, including, "My boy, it's the '70s—homosexuality is the *in* thing!" He continued, "It's not a big deal. Even straight people are trying it!"

To get Shag to feel more comfortable with the idea, Barnett followed his speech with a fascinating story. He revealed that, for several years while living in Lexington, Kentucky, in the late 1950s and early '60s, he met football players from the University of Kentucky and others from smaller nearby colleges. While in Lexington, he also somehow met and became friends with the famous actor Rock Hudson. Like Barnett, Hudson was gay and wanted to meet local football players.

When Barnett claimed that Rock Hudson was gay, Shag was shocked and began wondering if his host was not only a man wanting to meet Georgia football players, but a liar, as well. Little did Shag know at the time, but he had been given information very few were aware of and the rest of the world would not become familiar with for another ten years.

Apparently, Barnett started setting Hudson up with local players he had met around Lexington. There was one player in particular—a wannabe actor who would serve as Barnett's limo driver—whom Hudson really liked. In fact, he fell in love with the player. Hudson wanted to see him on a regular basis, but could only travel to Kentucky so often because of his movie work in Hollywood. The actor asked Barnett to fly the player out to Hollywood after he graduated from college. From there, Hudson could find him work and eventually maybe some backup roles in movies and television.

Barnett ended his story by giving Shag the name of Hudson's one-time lover, who, by then, was twice married and one of the most well-known actors in Hollywood—a real macho type.

Barnett's attempt to make Shag feel comfortable with his "business idea" of teammates being delivered to his condo had succeeded with his story of the love affair between Rock Hudson and the other celebrated actor. In time,

as Barnett and Shag became "friends"—Shag guesses he would consider them as such at the time—Barnett also spoke of previous relationships he had had. These relationships included "flings," as Barnett called them, with two individuals whose names Shag recognized as an NFL coach and a well-known NFL referee at the time.

After their initial meeting, and for the next two-plus years, Barnett periodically phoned Shag's room at McWhorter Hall. A phone call from Barnett was normally a request for a new player he wanted to meet. The calls usually occurred during the off-season, when players weren't as busy with football-related duties and when curfew at McWhorter Hall was lax. If Shag was in need of money, he would approach Barnett's requested player. If not, an excuse would generally be given as to why he wouldn't be able to make it to Atlanta.

What transpired at the condo with each of Shag's visits became as predictable as Barnett greeting the players at his door wearing multiple gold necklaces and later addressing them as "my boys" or "my wonderful stars." He would first give the teammate(s) and Shag a drink, which could turn into several, and then they'd usually smoke a joint, although Barnett detested smoke. There were always magazines to read, and the television was turned on, but the flamboyant Barnett provided most of the entertainment with his animated gestures and sayings.

Without even ever having seen a particular player's penis, Barnett would often attach a penis-related nickname to him, like, "The Cock Supreme" or "The Big Dick Man." In addition, Barnett joked that if he was ever introduced to a particular Georgia player—a standout defender he *really* wanted to meet—he would "stuff lit newspapers in his ass and watch him do the 'Dance of the Flaming Ass Hole.'"

Barnett would ask a room of players in his condo—"my wonderful stars in my living room"—if there was "any news" or "any scoops." He often recognized something that was not good as "the shits!" Barnett once informed Shag that his "dream boy" was Donnie Osmond, whereas his "dream man" was Steve McQueen. And, as mentioned, there was his favorite, oft-repeated quip: "Did you know I'm *bi*sexual? I love men *and* boys!"

Barnett was evidently wealthy, and he loved to flaunt it. Each of his gold necklaces looked expensive, and he would wear as many as four or five at one time. He often spoke of his Rolls Royce and its driver that would take him to and from the condo. Once a teammate and Shag jokingly questioned whether Barnett actually owned a Rolls Royce. He instantly responded by taking the two down to the condo's parking garage and letting them drive the car.

For any new guy who had been brought to the condo and who Barnett was attracted to, the moment would inevitably arrive when the player was asked into a separate room. There, according to the few who eventually revealed what was discussed, Barnett asked if the player would be interested in earning even more money than what he would be given that night. If so, the two swapped phone numbers, and the player could return to the condo alone at a later date to have sex with Barnett—more specifically, Barnett would perform oral sex on the player.

After Barnett and the player had been in the separate room for five to ten minutes, they would reconvene with everyone else. After an hour or so at the condo, Barnett would always hand everybody their money—usually $100 each and always placed inside the player's front pocket of their jeans, shorts or shirt. The manner in which Barnett handed out money was the only time most players were ever physically touched by him, and even then, it was more of a graze than a touch. Usually, after receiving the money, the players simply left.

Most players who met Barnett thought he was a really funny guy. At their initial visit, the majority of them soon felt rather comfortable around him, especially after having drinks, smoking marijuana and, for most, becoming aware that either he was too hairy for Barnett's taste or had already turned down the offer to have sex with him. If Barnett had previously been turned down by a player, he would—to anyone's knowledge—never later pressure that same player to change his mind.

After leaving Barnett's place, Shag and his teammate(s) would generally either go out for a night on the town in Atlanta with lots of money at their disposal or return home to Athens. Either way, the player rarely brought up what Barnett had discussed, or offered, in the separate room. And Shag made sure to never ask questions. If the teammate wanted to return to Barnett's on his own accord, that was his business, not Shag's, who didn't want to know either way.

As described, a visit to Barnett's usually occurred following his desire to meet a new player. However, there were a few times when he called Shag simply wanting to hang out with a few teammates, even if he was well aware that none of the players coming over were interested in receiving money for sex. The players thought of this as an easy way to get their hands on a quick $100. In retrospect, Shag and others believe this was Barnett's way of keeping the players close to him and away from the possibility of anyone informing the authorities. Nevertheless, as long as money was being handed out by Jim Barnett, no one was telling a soul the details of what was going on inside his Atlanta condo.

Over time, Shag began to like Barnett and enjoyed being around him. Besides lots of money, the gracious host also occasionally gave Shag clothes and, once, a nice Rolex wristwatch. All the while, Barnett never came on to him. Although he could be overly eccentric and dramatic, the charming Barnett was someone to talk to about subjects beyond the normal college or football ones. Through their discussions, Barnett became familiar with Shag's family, his past and his intentions for the future, while totally earning his trust.

The two became so close that, when Barnett was invited to functions at the governor's mansion leading up to Jimmy Carter's presidency, he twice asked to "borrow" a friend of Shag's—a girl—for his date. Apparently, Barnett could not be as openly gay with those who hobnobbed with the soon-to-be U.S. president as he was with Georgia football players. At first, Shag's friend was leery. But, "at least you don't have to worry about him hitting up on you," Shag said in an attempt to ease her mind. The friend agreed both times to accompany Barnett and, on each occasion, she was bought a new dress and given money in return.

By all accounts, most of the football players who visited Barnett on at least a few occasions trusted him and enjoyed his company. The following account comes from a former Bulldog—one who wanted to remain anonymous for obvious reasons. He estimated that he made "probably five trips" to the Colony Square condo:

> *I thought of Barnett as an old and weak gay man who wanted to associate with macho football players. In return for just an hour or two each time I went over there, he gave me money, clothes and once a nice Seiko watch. Even after I graduated and was in the process of moving far from Georgia, Barnett once wired me $500 via Western Union after I simply called him requesting money. That was the last time I ever came in contact with him, and he probably knew at the time it would be the last time, but he still sent the money. While I was at UGA, there was only one person who ever gave me a significant amount of money: Jim Barnett.*
>
> *I could see how Barnett might have been very manipulative towards certain players, but he picked his battles. He never tried any "gay stuff" with me after I turned down his initial offer—never put me in a bad situation. He was nice to me. I think he liked my mind and enjoyed talking with me. We all knew we could make even more money if one of us was willing to have sex with him. And Barnett had so much money—it seemed unlimited. But, looking back, I'm not 100 percent sure if any Georgia player actually wound up having*

sex or any kind of relationship with Barnett. Although, at the time, I was
suspicious of one who did, and maybe as many as two or three.

For the vast majority of players taken to Barnett's, their initial visit was also likely their last. Most received their money and never returned. Others, like the quoted teammate, visited several times, received money or gifts with each visit but apparently never had sexual relations with their host. There was only one teammate whom Shag personally brought to the condo who seemingly later visited Barnett on his own accord, and on a number of occasions. Barnett later confided in Shag that he and this particular player were having a fling. At the start of the fling, the player instantly owned an "extravagant gift" (labeled such for reasons of anonymity)—a gift assuredly given to him by Barnett.

Shag eventually got a call from Barnett, who, for the first time, offered twice as much money as usual if a particular, good-looking younger Bulldog player was brought to Atlanta. Saying that he spotted the player with binoculars during the previous football season, Barnett said to Shag, "I think this one's a real challenge, my boy. He looked really straitlaced from the stands."

Ultimately, the "straitlaced" player turned down the invitation to "go make some easy money by just meeting an old guy in Atlanta," as Shag would normally phrase the offer. When Shag called back to explain that the requested teammate had turned down the invitation, Barnett first responded with "Well, that's the shits," but followed with another $200 challenge, requesting that Shag call a standout football player from another school—Georgia Tech.

"You know, my boy, I like my Yellow Jackets just as much as my Bulldogs," Barnett said.

Barnett proceeded to tell Shag about a relationship he recently had with a Georgia Tech basketball player, originally from Lexington, Kentucky, who had played with the Yellow Jackets approximately a decade

Although generous, humorous, intelligent and one who became friends with a few Georgia football players, Jim Barnett was manipulative, enticing athletes with money and gifts in exchange for sex.

before. From Barnett's description, there seemed much more to the one-time arrangement than a player repeatedly visiting for money. It was more like a "boyfriend" relationship. Nevertheless, Shag's phone call to the requested Yellow Jacket football player—a guy Shag had twice played against but never formally met—was quite awkward, to say the least. He, too, turned down the request, likely thinking the call was some sort of prank from a rival Georgia player.

Still, besides those two requests—for the straitlaced Georgia teammate and the Georgia Tech football player—from what Shag recollects, everyone else he asked to go over to the condo willingly did so, including a Bulldogs walk-on player who visited on two occasions. Although the second visit was with Shag, the walk-on initially was accompanied to Barnett's by another teammate, who most likely was originally approached by the same older player who had propositioned Shag:

> How it was presented to me was like, "Go over to this guy's place and he'll give you money." The player who told me was a good friend and obviously not gay—he had a girlfriend. Plus, he was on full scholarship, so he probably had a lot to lose if it was ever found out he was going over there. So, since my friend was already going over there, I felt fully comfortable also going over to Jim Barnett's place.
>
> [Barnett] must not have been attracted to me because I only got fifty dollars the two times I went over to his place [laughing]. Both times, it was the same thing: He gave me a drink, some weed and then I remember looking through some Playboy magazines as he talked with me and a couple of other players. I actually don't think Barnett ever got me alone, but we're talking about more than forty years ago, so it's hard to remember everything.
>
> I do remember the second time I was there with Shag, when I suddenly started spinning from the combination of the alcohol and the weed I was given. I started to feel sick. I got up to leave but Barnett wouldn't let me. He quickly put fifty in my pocket and insisted that I not go outside the condo. He actually wanted me to get sick inside his apartment. Looking back now, I think I realize why he didn't want me to leave sick. How would that have looked to a cop, running into a sick UGA football player who said he drank and smoked weed at Jim Barnett's place? Imagine the scene. The police would then arrive at Barnett's only to find a couple other Georgia players! And, the way Barnett quickly gave me that fifty dollars…in a way, I'm pretty sure that was "hush" money, so there would be no thought by me of turning him into law enforcement.

Notably, according to another teammate, the scholarship player who the walk-on referred to repeatedly drove from Athens to Barnett's without other players, but curiously, his girlfriend was in the car. She would stay in the automobile while her boyfriend went inside the condo. When he was done with Barnett, the player would return to the car, and he and his girlfriend would go out in Atlanta with the money he had just been given.

More than likely, the aforementioned teammates—the player given the extravagant gift by Barnett and the one who went inside the condo while his girlfriend waited in the car—both had sex with Barnett, and repeatedly, but they were in all likelihood not homosexual. Instead, they seemingly were young men Barnett figured he could manipulate and succeeded in doing so by preying upon their empty pockets. Still, the two players might have justified their actions by believing they were the ones doing the manipulating, taking a considerable amount of money from an "old and weak gay man" in exchange for a mere quick sexual act. But this is only a guess.

Again, hardly any of the Georgia players fully discussed what their intentions were with Jim Barnett or why they returned to his condo. And no one asked any questions.

10
Athletes to Men

After living in residential Reed Hall and before moving back into McWhorter Hall, Shag lived for a short time in a house located on Holman Avenue near Athens's Normaltown neighborhood. He and a friend, Woody, often partied at a nearby house located on connecting Sunset Drive, which attracted an assortment of people, including a young, attractive blonde, Cindy. The quiet Cindy Wilson would emerge from her shell, so to speak, within a few years as a vocalist of the new wave rock band the B-52s.

One morning after a night of partying, Shag and Woody were leaving the Sunset Drive home when a couple of young teenagers—a boy and a girl—were walking by. Still feeling loopy from the night before, in an attempt to get a laugh out of Woody, Shag crudely asked the young boy, "You just climb out of bed with her?"

A couple of weeks following the run-in, Shag and the teenagers encountered one another again—this time on Holman Avenue. Getting out of his car to enter his home, Shag exchanged no words with the kids, and he didn't think anything of spotting them a second time until about an hour later, when a policeman was knocking on his door.

"Is that your Gran Torino outside?" the policeman asked Shag while standing in his doorway.

"Yes," he responded. "Is there a problem?"

"Yes, there is a problem," the policeman answered. "You're under arrest for making a lewd comment to young children."

As Shag, in utter disbelief, was escorted outside to a police car, he spotted the two teenagers, apparently siblings, sitting inside another police car accompanied by their father. The kids had recalled witnessing Shag and his Gran Torino a couple of weeks before on Sunset Drive and had alerted their father that they had just observed the man who had previously made the comment to them entering a house on Holman Avenue.

For Shag, it had been the wrong time and place to make a suggestive remark. An unidentified man, nicknamed the "Sunset Rapist," was being sought by local authorities. The criminal was amid a three-year period of invading homes in the area of Sunset Drive and Holman and Prince Avenues, raping as many as six young women. The rapist, who was never caught, was said to be a Caucasian in his twenties.

Bewildered for being arrested for a lewd comment after all the things he had gotten away with, Shag was taken and locked up at the very same jail where he had been incarcerated less than a year before for his part in the spraying of the fire extinguisher. And, apparently like before, a phone call was placed to head coach Vince Dooley. Shag was released from prison after a few hours.

Extremely embarrassed about the incident, especially when informed that he would eventually have to go to court over the offense, Shag was certain that Coach Dooley was going to kick him off the team—this time, permanently. Consequently, one can imagine Shag's surprise when not only was he not kicked off the team, or even suspended, but Dooley provided the player with his personal attorney for the court proceedings.

Dooley had always seemed partial to the troubled Shag, but why? Not even the player himself could imagine. Perhaps it was associated with the first time the two truly interacted with one another. Following a victory by Georgia's freshman team at Auburn in 1972, the team bus, soon to return to Athens, was filled with elation because of the exciting 20–12 comeback win. But, one Bullpup was not celebrating.

Still wearing the full-length cast on his leg for the stretched knee ligaments he had suffered in fall camp, a dejected Shag sat quietly chatting with Coach Payne, a former Georgia standout end who was working on his law degree as a graduate assistant. Having just observed a victory by the future of Georgia's varsity program, Coach Dooley started walking from his seat up front to the back of the bus. As he passed by the onlooking players, most of whose expressions had turned from elated to somewhat intimidated, the head coach suddenly stopped next to Coach Payne and Shag.

"Steve, you know, you kind of remind me of myself back when I was in college," Dooley stated as he stood over Shag.

Coach Dooley explained that a little over twenty years before, he had received a football scholarship to Auburn University as a quarterback. Leading up to his freshman team's big game against Alabama, within the same week, Dooley lost his mother after a long illness and then broke his finger on his throwing hand, keeping him from playing. He said he was fully aware of how it was to have high expectations (during his freshman year at Auburn in 1950, Dooley's running style was compared by a longtime sportswriter to that of the legendary Jim Thorpe) yet not contribute to the team. Dooley added that there could very well be stumbling blocks down the road. He, for instance, had suffered a severe knee injury early in his junior year and missed more than half the season. But, according to him, everything should turn out okay. "You can tough it out," Dooley concluded. "Just hang in there."

As Coach Dooley walked back to the front of the bus, a supportive hand was placed on Shag's left shoulder. An accompanying voice echoed the head coach's encouragement: "Just hang in there," repeated Coach Payne, a real class act.

The inspiring words were those Payne likely had lived by and would certainly continue doing so. Coach Payne would eventually be recognized as the determined Billy Payne, the leading advocate for bringing the 1996 Olympic Games to Atlanta. He currently serves as the distinguished chairman of the Augusta National Golf Club.

As for Coach Dooley, after an auspicious start to his head-coaching career, they were words he, too, was having to live by as he faced adversity, turmoil and times of great adjustment.

Hired by UGA athletic director Joel Eaves, who had been his head basketball coach at Auburn, Dooley came to Athens as an inexperienced thirty-one-year-old whose previous position had been the head coach of Auburn's freshman team, which won only one game in 1963. Yet, over the next five years at Georgia, the undistinguished coach proceeded to capture two conference championships, winning at a rate that ranked among the top ten of major-college teams (second in the SEC only to Alabama). It was the best five-year run for Georgia football in nearly twenty years.

Dooley's Dogs then fell on hard times, recording non-winning seasons in 1969 (5-5-1) and 1970 (5-5), leaving some Georgia enthusiasts wondering what had suddenly gone wrong with the young, accomplished head coach and his program. A couple of disappointing campaigns was only the

beginning for Dooley regarding the hardships and challenges that loomed for him and his team.

In the spring of 1971, the program was devastated by the deaths of players Jim Florio and Ed Milo, both rising sophomores, who were in an automobile accident one night when their car collided with another on Baxter Street in Athens. Soon after, three players from the Georgia football team, an all-white squad at the time, were charged with repeated assault by two UGA African American students who claimed the attacks occurred one night in late January in the "Russell Hall [dormitory] parking lot and around the city [of Athens]." The case was eventually referred to state court, whereupon the two black students curiously didn't show up for the proceedings. "They didn't appear...they couldn't be found," according to the solicitor general for Athens and Clarke County. The case was dismissed.

Soon after the alleged attacks on the African American students, the initial group of black players joined the program as true freshmen along with, for the first time in more than a decade, multiple signees from outside the Southeast. Besides Dooley, highly respected assistant coach Mike Castronis was instrumental in the signing of the black and "Yankee" freshmen, which totaled a combined ten newcomers.

Dooley and his coaching staff certainly faced a challenge in terms of the makeup of the team of approximately one hundred players. Entering the summer of 1971, the team was not only all white (roughly two-thirds of them from in-state, a dozen from South Carolina, a half dozen from both Alabama and Florida, a couple from both Virginia and Tennessee and one from Oklahoma), but the majority of them had never in their lives even been teammates with an African American player or one from outside the South. Then, in an instant, the composition of the squad was altered in August when one-third of the Bulldogs' incoming class arrived at McWhorter Hall as complete foreigners to what had been the standard of Georgia football.

Around the same time, a sportswriter remarked to Dooley how the head coach continually appeared to be the epitome of calmness and composure. The coach, having encountered difficulties while managing a program that had been recently integrated both racially and geographically, fittingly replied, "But, sometimes you are not relaxed inside."

Whether Coach Dooley was relaxed or not, he continued to be a tenacious spirit over the next few years and slowly but steadily got closer with his players—without allowing a breakdown in discipline. He banned what the players of that time knew of as Rat Court sessions after a walk-on

player was hit in the face with a thrown egg, nearly causing him to lose the use of an eye. Still, although he never approved of the Seagrave's Initiation "because of the danger of it," he once said, the head coach realized that it was a Georgia football tradition. Also, after girls were forbidden at McWhorter Hall soon after the crab infestation, Coach Dooley eventually lifted the restriction when he deemed it appropriate; however, following a series of misconduct incidents by several resident players, women were once again not allowed in the dorm.

By 1973, Dooley had also demonstrated that he was becoming more innovative and creative with the program—he was thinking outside the box. That summer, he hosted an on-campus ladies football clinic—believed to be one of the first of its kind—sponsored by the Athens Area Chamber of Commerce. At the event, 250 women spent more than two days learning the ins and outs of Georgia football and the sport as a whole. It was around this time that the more approachable Dooley initiated small group and individual meetings and rap sessions with players, where they were encouraged to speak their minds, even if it was to criticize the head coach—once an unthinkable possibility.

Actually, Coach Dooley had been receiving criticism for a while from one member of the team—perhaps the last member one would ever imagine doing so. "Squab," an African American man, had been associated with UGA athletics since 1910, at the age of eight. He was officially a team trainer, but his role for the Bulldogs extended much further. Besides scalping tickets for the players, Squabby concocted for the team at practices and games his "Squab Juice"—a replenishing sports drink—years before Gatorade and other such products appeared on the sideline.

Squab was also an inspiration of sorts to most of Georgia's first African American players. He demonstrated a toughness and tenacity regardless of the racial makeup of the Bulldog team and did the same when visiting segregated and, at times, extremely bigoted venues in the Deep South. Whether black or white, players avoided getting on Squab's bad side, especially those who played a limited role on the field. It was evident that Squabby was partial to Georgia's standout players—those who perhaps had earned his respect.

"Man, Squab had a lot of clout," said a white player from the early to mid-1970s. "And, he treated me like shit before I became a starter. But, once I did, he suddenly was respectful to me."

Squab was not afraid to give anybody—even Dooley—frank and harsh comments and criticism. Such advice to the head coach heightened when

the program began to integrate, at which point Dooley actually started approaching Squab for advice.

After Georgia football had been integrated for a few years, the program's race relations not surprisingly were still somewhat strained on the whole. Against Houston in 1974, hindered by a couple of bad pitches that gave him credit for lost yardage, plus two other rushes in which he was essentially sacked attempting a halfback pass, the Bulldogs' black standout, Horace King, finished with -5 yards rushing on eight carries in defeat. Until his two-touchdown outing the next week in an upset over Florida, King's negative-rushing performance against the Cougars prompted a couple of his white teammates—jokingly, according to the pair when interviewed years later—to temporarily tag him, "Negative Niggers King." The two white players dared not mention the racist nickname to King's face—only safely and cowardly behind his back. Yet, just three years before, King and the four other African American newcomers had confronted teammates dressed in KKK attire and bowed before a "Grand Dragon" while a hangman's noose dangled above them.

By 1974, Coach Dooley was in charge of a program in which racial discomfort persisted. The situation was seemingly improving, and tensions were beginning to wane—if only slightly. After Georgia signed just four black recruits in 1972 and 1973 combined, seven African American newcomers became Bulldogs in 1974, including the program's first black quarterback signee, Anthony (Tony) Flanagan, and the first African American signee hailing from outside the Deep South, running back Kevin McLee. In 1975, Georgia signed a dozen African American prospects, or nearly half of its entire incoming class, including Mike Hart of LaGrange, Georgia, the Bulldogs' first black quarterback to see playing time, albeit at the junior varsity level.

As the 1975 football season loomed, Calvin Jones, who had been a highly successful basketball coach at a predominantly African American high school in Atlanta, became the university's first black coach when he was hired as a "Football and Basketball Assistant." Although Jones, who served primarily as an assistant coach for Georgia's basketball squad, had nothing to do with the on-field operations of the football team, he did play an integral part in assisting Dooley in recruiting.

Also assisting Coach Dooley in recruiting was Hank Aaron, who, at the time, was closing in on becoming the all-time home run leader in Major League Baseball history. Both hailing from Mobile, Alabama, Aaron and Dooley were close friends, and the head coach once in a while brought the

baseball legend to McWhorter Hall to mingle with the players. At least two black prospects-turned-signees from the mid-1970s claimed that they received a mailed letter from Aaron during their recruiting process enticing them to attend Georgia.

Mailed to Sylvester Boler when he was a senior in high school, one of those letters from Aaron was eventually read by Boler's mother and, with that, the more than one hundred other schools offering a scholarship to the six-foot, two-inch, 220-pound (and growing) linebacker from Augusta, Georgia, "might as well have forgotten about me coming there," according to Boler.

At a time when it was rare for a freshman to play on the varsity level, Sylvester Boler first saw the field in the eighth game of the 1973 campaign, at Tennessee. It actually would have been much earlier in his initial season if not for a thigh injury. The first African American true freshman to play varsity football for Georgia soon made his presence felt when he seemingly came out of nowhere to sack—or, more like, *truck*—Tennessee quarterback Condredge Holloway. For an instant, it appeared as if Holloway had been decapitated. Never before had Georgia players, nor their opposition, witnessed a linebacker with such ability: tremendous size, yet 4.5 40-yard speed, enabling him to pull down runners from behind.

"And we had to practice against him!" said a teammate of Boler's, an offensive player. "To try to block him, I'd fire into his legs, and he literally wouldn't budge. It was like firing into a tree trunk—but, at least, a tree trunk wouldn't hit back!"

He ended his freshman season with twenty tackles against Auburn and fifteen stops versus Georgia Tech, and as the recipient of the Most Outstanding Defensive Player Award against Maryland in the Peach Bowl—all Georgia victories. Boler had not only earned a number of nicknames in a short period—"Bolo," "The Black Blur," "The Sacker"—but, after having appeared in only five games, he was already being considered arguably the greatest linebacker in Georgia football history.

Having grown an inch and gained fifteen pounds by 1974, Boler totaled 134 tackles as a sophomore, earning him second team All-SEC honors, despite essentially being handicapped the entire season with an ankle injury, including missing the majority of three games. Not revealed until May 1975, Boler had sprained his ankle early in the season opener against Oregon State; however, instead of staying off the ankle, he played the rest of the game, and the injury got worse as calcium deposits formed. By the

Established in August 1975, Georgia's "Junkyard Dogs" defense was a diverse group, including linebacker Rusty Russell (*left*), who had been a two-year starter, and tackle Jeff Sanders (*right*), who had very little varsity experience. *Henck and Kelley collection.*

spring, the deposits remained on the ankle, and Coach Dooley was not very optimistic of a healthy return for Boler.

"We need Sylvester...without him we're a no-name defense," Dooley said at the conclusion of spring practice. "But I just don't know if he'll ever play again."

Granted, the head coach had a track record of being overly pessimistic—at least, when speaking to the media. Regardless, Georgia having "a no-name defense" in 1975 was an accurate assessment—with or without Boler. Seven of the unit's eleven starters from the year before had been seniors, while returning starter Mike "Moonpie" Wilson had moved from defensive to offensive line. The only returning starters were Boler, defensive back David Schwak and Rusty Russell, who had moved to linebacker after beginning at defensive end.

Others, like head trainer Warren Morris, were more encouraged about Boler's return. If the rising junior rested and didn't further irritate the injury, his body would absorb the calcium deposits over the summer and, therefore, there'd be "a good chance for full recovery," according to Morris. As for Boler, an unrelenting competitor, although he said that he would only play if he was "at full strength" (unlike in 1974), he projected, "Personally, I do think I'll be [out] there [for the 1975 season]."

Standing in front of McWhorter Hall are (*left to right*) cornerback Robert Hope, linebacker Ricky McBride, head trainer Warren Morris and running back Willie McClendon. *D.J. Pascale collection.*

It should be noted that Boler, who seemingly was determined to make it back on the field, was an excellent student, soft-spoken, often kept to himself and apparently had no problems with any of his teammates off the field. It was thus quite surprising how he conducted himself one evening at McWhorter Hall as the spring quarter of 1975 was nearing its close. Depicted in newspaper reports soon following the incident and recently accounted by former players, there have been several versions of the infamous event. What follows is seemingly the most common and accurate description of what occurred.

During the dining hall's dinner period, a handful of players were standing outside of Shag's room on the second-floor balcony of the dormitory, including two white running backs from the Midwest. One of these two players had somehow come into possession of a basket of oranges and, as groups of players were going across the breezeway below toward the dining hall, an orange or more was thrown by one or both of the players. The third or fourth group consisted of several African American players, including Boler. In an instant, an orange thrown at the group hit a railing, splattering

the fruit's juice and pulp all over Boler, who appeared not too happy. He demanded an apology from the player who had thrown the orange, but he did not receive one—or, at least, not one that he was satisfied with. Still, although outwardly upset, Boler seemed content and walked into the dining hall with the rest of the group.

Apparently, while eating in the dining hall, Boler simply snapped. He later indicated that his outburst was fueled because of the disappointing 1974 season he felt he experienced, plus the fact that it seemed like he would miss the 1975 campaign. "I guess my resistance was lower that day," he later admitted. "I just didn't feel like playing around with anybody."

The two running backs from the Midwest were in one of their rooms on the first floor when the player who had thrown the orange walked outside. He was instantly met by Boler wielding a handgun, which was unloaded. Boler pointed the gun at the player and backed him all the way down the balcony walkway before he ran into his room to safety.

After hearing what had occurred, Coach Dooley had no choice but to indefinitely suspend arguably his most talented player, leaving Boler's playing status for the 1975 season even more in doubt. The two orange-throwing teammates were placed on probation.

There was tremendous speculation in the media as to whether the incident was indicative of racial unrest on the Georgia team. According to Dooley, the player who threw the orange and Boler— who would promptly and courageously stand in front of the team in a meeting and apologize for his actions—the episode was not racially related whatsoever. However, the other running back, who had also hurled oranges, curiously claimed that the Georgia coaches were not treating the white and black players equally. "[The coaches] are letting the blacks get away with a lot of things," the player said from his home in the Midwest during the ensuing summer break. "But we went to the coaches about it and they denied it."

It was determined that Boler wasn't necessarily booted from the team. Similar to what Shag had experienced following the fire extinguisher incident two years before, Boler was given something akin to a one-year suspension; he would be redshirted. This outcome had essentially already been determined because of the calcium deposits on his ankle.

Although Dooley truly did not believe that the incident with Boler had anything to do with race—he went as far as claiming, "I sincerely believe we at Georgia have as good a black-white situation as any school in the country"—the head coach wanted to soothe any possible unrest. Not long after Boler spoke in front of the squad, Dooley called another meeting

of the entire team (minus Boler) in the form of the newly implemented rap session. Players were encouraged to speak their minds—and, did one player ever!

Dooley stood in front of the team for roughly fifteen minutes discussing how, any time 120 personalities were brought together, there were bound to be disagreements. And, although there was racial tension in every facet of life, he believed that Georgia's race relations had drastically improved over the last four years and was only going to get better. He concluded by asking if anyone had anything to say, regarding the Boler situation or anything else. After a pause, and just when it appeared as though no one would comment, a voice was heard among the crowd of players.

"Yes sir, coach. I've got something to say," said a rising junior, a Caucasian player, as he stood up from his seat. The teammate was known to be a really good guy, a friend to many. In fact, it was rather peculiar that he would have an outspoken opinion concerning the team's race relations—unless maybe it was a positive one.

"Coach Dooley, I don't like niggers—never have, never will," the player declared as surrounding teammates and coaches froze in shock. "Just don't like 'em—that's the way I was raised."

Players sat stunned in silence, including the ten or so African American players, likely none of whom had any inkling that a teammate of theirs felt so strongly about blacks. Dropping his head toward the floor, Coach Dooley was speechless. Coach Erk Russell's reaction wasn't immediately clear, as he instantly and briskly walked out of the meeting room with his head lowered. The player who had made the comment was also silent as he calmly sat back down in his chair. He would comment on the incident decades later, and rather ashamedly: "Yeah, it wasn't one of my finer moments during my athletic career."

Entering the 1975 season, Coach Dooley and the Bulldogs clearly faced a number of troublesome obstacles. There were the couple of hindrances most of the team was unaware of: Jim Barnett, who continued to lure players to his condo in Atlanta; and organized crime, primarily in the form of Señor Grande, who continued to hang out with a select few players on the team. And there were obstacles only recently revealed, at least to the head coach, who discovered that Georgia evidently did not have as good a black-white situation as any school in the country. Finally, there was the lingering problem of Dooley being on what now would be considered the proverbial "hot seat." Some influential alumni wanted him to go from the hot seat to the unemployment line.

Pictured just prior to the start of the season, Georgia's 1975 team was given virtually no chance to succeed. It was a consensus pick to finish in the bottom half of the ten-member Southeastern Conference. *Henck and Kelley collection.*

After a somewhat disappointing 7-4 season in 1972, Georgia had staggered to a substandard 3-3-1 start in its following campaign, including a tie versus Pittsburgh and losses to Vanderbilt and Kentucky—in all three games, the Bulldogs entered as at least two-touchdown favorites. It was after the setbacks to the Commodores and Wildcats, which occurred consecutively, that "Dump Dooley" bumper stickers began appearing on automobiles around Athens. By the summer of 1975, just after Georgia had slumped to an even 6-6 mark, including losses in its final three games, the slogan had spread to Atlanta and other parts of the state. There were even those in the local media who seemed to relish in "dumping" on Dooley.

In early July, Shag's father, Bob, had just returned home to Cambridge, Maryland, from a business trip, when he started to read back editions of Athens and Atlanta newspapers he subscribed to and had specially mailed to him. Bob was taken aback at some of the opinion pieces regarding Dooley's future as the Bulldogs' head coach. Some writers appeared to be deliberately attempting to fuel a public outcry of not renewing Dooley's contract, which expired at the end of the upcoming season.

Although Dooley was to enter his twelfth season as Georgia's head coach with a .668 career winning percentage—the thirteenth-highest among active college football coaches—the prevailing sentiment was "What have you done for me lately?" Critics—including allegedly the large and reputable Jacksonville Bulldog Club, according to a particular writer—pointed to Dooley's three consecutive disappointing seasons. And evidently, the worst

of all was looming: the 1975 campaign. The Bulldogs were a consensus preseason pick to finish in the bottom half of the ten-member league. One media outlet predicted a next-to-last finish for UGA.

If Vince Dooley could achieve only a subpar record five of the previous six seasons with what were supposed to be good teams, what would be the outcome in 1975, with what was supposed to be a second-rate squad? The season's prospects did not look good—even Dooley had admitted as much—prompting some Georgia enthusiasts to assume that their head coach's status was not necessarily *if* his contract would eventually be extended beyond the ensuing campaign, but exactly *when* his contract would be terminated.

After finishing the newspapers, Bob sat down and typed out a lengthy letter to the school's athletic director, Joel Eaves. The letter would trigger a wave of more letters and phone calls between Bob and the athletic department—a month and a half of correspondence completely unbeknownst to Shag until roughly thirty-five years later.

"Unfortunately, the 'win-loss record' is the media's only gauge of the accomplishments of a program," Bob wrote to Eaves. "But I hasten to write this letter to state that there are other important aspects in measuring success."

In his first three years on campus, Shag had tested the tolerance of Georgia's athletic department. And, according to Bob, "his escapades and ensuing troubles have caused considerable embarrassment for everyone concerned." Yet, through it all, Coach Dooley knew and understood the troubled player and, more so, hadn't given up on him. And, finally, Bob, his family and even some of their friends had noticed a "remarkable change" in Shag and improved behavior while he was home for the summer—a maturing process primarily owed to the Georgia football program and, chiefly, Dooley.

"Coach Dooley has already achieved the status of a fine coach—the public acknowledges his ability to take a young man and make him an athlete," Bob concluded. "It is unfortunate that the media has not recognized his success at taking an athlete and making him a man."

Within a week of writing the letter, Bob received a response from Eaves, who, according to the athletic director, appreciated the correspondence, which was "especially welcomed in light of the very negative attitude of almost all the news media."

A week later, Bob received a second letter from Eaves, indicating that he had taken the liberty of passing the original letter to Fred Davison, the

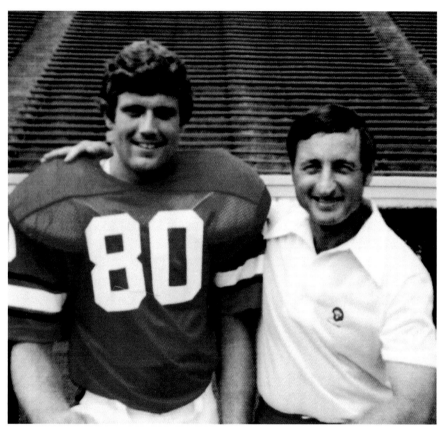

Above: By the 1975 season, the once-troubled Shag Davis (80) had undergone a remarkable change, due in large part to head coach Vince Dooley (*right*). *Helen Castronis collection.*

Right: Athletic director Joel Eaves's correspondence to Bob Davis, asking him for permission to share his initial letter with members of Georgia's athletic board. *Bob Davis collection.*

department of athletics the university of georgia
 athens, georgia 30602

July 22, 1975

Mr. Robert B. Davis
Jenkins Creek
Cambridge, Md. 21613

I took the liberty, Mr. Davis . . .

. . . of letting our president, Dr. Davison, read your letter.
He was so impressed that he asked me to obtain your permission
to share the letter with members of our Athletic Board. Will
you please let me know on this?

Sincerely,

Joel Eaves
Joel Eaves
Athletic Director

JE:cb

president of the University of Georgia. According to Eaves, "He [Davison] was so impressed that he asked me to obtain your permission to share the letter with members of our Athletic Board. Will you please let me know on this?"

Knowing that the school's athletic board, which consisted of approximately twenty members including Eaves and Davison, would have the primary say in whether Coach Dooley's contract would be extended, Bob was thrilled and in absolute favor of his letter being shared with additional board members. But, before he even had a chance to write Eaves back, the athletic director called Bob, reiterating that he would like to share the letter to other board members. Bob wholeheartedly complied.

By mid-August, Bob had received a few additional letters from athletic board members thanking him for supporting Coach Dooley, including from Reid Parker, the faculty chairman of athletics. Parker claimed that Dooley knew Shag well and was aware of his "problems" but never gave up on him and knew he would eventually exhibit an "improved attitude and a desire to contribute to the team." In closing, Parker said, "In particular, Coach Dooley is man of integrity and character. He does know the players and understands their strengths and weaknesses and I am grateful he is our Head Football Coach."

Seemingly, most of the athletic board echoed Parker's sentiments, because on August 27, nine days after the start of fall camp and nine days before Georgia was to kick off its season against Pittsburgh, Coach Dooley was uncommonly granted a new contract prior to the start of a season and long before the old contract expired. The move, according to a sportswriter, "rates as a first in this sometimes cold world of sports" in a country with a "win-at-any-cost society."

Made jointly by Eaves and Davison, the announcement of the new contract began, "In today's society where winning at any cost has been detrimental to the lives of some individuals and institutions, we feel that coach Dooley has served as the university's head coach with a deep personal interest in his athletes and with a high regard for the university standards and its administrative standards."

This leads to the question of whether Bob Davis's letter to Joel Eaves had any bearing for, not necessarily Dooley getting a new contract, but the head coach receiving a new contract so early. The new contract came just before his last contracted season, not right afterward, which was more common. Who knows? It may have been mere coincidence. Still, it is worthy of mention that, following the conclusions of separate sessions during fall camp

in 1975, Eaves, followed by Davison a few practices later, joined the team huddle. Each man stood along the edge of the group and directly behind Shag. Each time the huddle broke to end the day's session, Eaves—then, at a later practice, Davison—put his arm around Shag and asked him how he was doing. After Eaves greeted Shag, he followed by curiously asking Shag, "And, how's your dad?"

For more than three decades, Shag often wondered why two distinguished men of the university—those he had never spoken to before—separately greeted him after practice. He was the only player they acknowledged. And one of them went as far as asking how his father was. After Bob Davis showed his son the corresponding letters, Shag had a good idea why.

But a new contract did nothing to solve the problems Dooley was expected to endure on the field. Only two players were selected by the media as preseason first team All-SEC, including junior placekicker Allan Leavitt. The other, senior Randy Johnson, was part of what was believed to be Georgia's strongest unit—the offensive line. However, early in fall camp, the Bulldogs received a jolt when the projected starting center, Will Legg, was forced to give up football after sustaining his second serious head injury in a matter of months. Defensively, as mentioned, it was certainly a no-name group. Besides returning starters Russell and Schwak, five defenders who would start against Pittsburgh had been second-string players in 1974 (end Lawrence Craft, tackle Brad Thompson, linebacker Ben Zambiasi and defensive backs Chip Miller and Rod Johnson); two had been freshmen on the junior varsity squad (tackle Ronnie Swoopes and safety Johnny Henderson); starting linebacker Jeff Lewis had missed the previous season with an injury; and the other starting end, Dicky Clark, had begun the year before as the Bulldogs' starting quarterback.

Around the time the announcement was made regarding Coach Dooley's new contract, it was also announced that Coach Russell, as "a ploy to instill pride," according to the defensive coordinator, nicknamed Georgia's reviled defense the "Junkyard Dogs."

"There isn't anything meaner than a junkyard dog," Russell said, "and that's the way we hope our defensive men will play this year." Taking it a step further, the coach asked Georgia's Redcoat Band to play the song "Bad, Bad Leroy Brown" by the late Jim Croce when the defense took the field during the upcoming season. According to the song, Leroy Brown was "badder than old King Kong, meaner than a junkyard dog."

The week of the season opener, Coach Dooley was confident in Georgia's offense. Despite losing a few key linemen, the Bulldogs returned

nearly all of their skilled players from one of the most explosive Georgia offenses in decades. On the contrary, defensively, when a writer mentioned Pittsburgh's Tony Dorsett to Coach Russell, instead of Junkyard Dogs, he said his group of defenders was more like the "Much Maligned Mongrels from McWhorter (Hall)."

According to the Pittsburgh coaches, just days before the game, the Panthers had issues of their own. Featuring only five seniors of its twenty-two starters, the Pittsburgh team was inexperienced—what team it apparently could field. The Panthers had supposedly been hit so hard by injuries that Johnny Majors had to cut back practices. Also noted was the expected game-time temperature in Athens of nearly ninety degrees—heat the Pittsburgh squad was not accustomed to. Regardless of Dorsett, Georgia's deplorable defense, injuries or even the heat, the Bulldogs were established as a slight favorite, based primarily on where the game was being played.

Early on, Georgia appeared not just slightly better than Pittsburgh, but downright dominant. However, the Bulldogs led at halftime by a score of just 7–0 on a short touchdown run by sophomore running back Kevin McLee, appearing in his first varsity game. It could have just as easily been 17–0, but Ray Goff lost a fumble from Pittsburgh's 4-yard line, and a 54-yard field goal attempt by Allan Leavitt fell just short of the crossbar.

It was a game of two halves, as the Junkyard Dogs had a hard time stopping Dorsett in the second half and the Georgia offense became stationary. Trailing 7–6 early in the fourth quarter, Pittsburgh quarterback and Georgia native Robert Haygood led the Panthers to a touchdown and a 12–7 advantage. The Bulldogs soon caught a break by scoring a safety. However, after receiving the free kick near midfield and trailing just 12–9 with 9:21 remaining, the Bulldog offense suffered another three-and-out and was forced to punt. Pittsburgh drove 74 yards in fourteen plays for a touchdown and a 19–9 victory.

Following a week off and riding a four-game losing streak from the year before, Georgia hosted a Mississippi State squad that had throttled the Red and Black the previous season. The visiting Bulldogs' offensive line outweighed the home team's defensive line by an average of a hefty 30 pounds per man (245 to 215). More so, only a few days before, Mississippi State had been placed on probation by the NCAA for what was believed to be "more than one year," the result of recruiting violations. According to Coach Dooley at the time, "what really concerns me is historically it's (probation) been a help [incentive] to teams."

Dooley seemed to be onto something through two quarters as Georgia trailed Mississippi State, 6–0, at halftime. As was the case with virtually the entire Pittsburgh game, the Junkyard Dogs surprisingly played relatively well but, like the second half against the Panthers, the Bulldogs' offense was sluggish.

Finally, to open the second half, Goff guided Georgia to a touchdown. After trading punts, Mississippi State drove to the Bulldogs' 24-yard line, where it faced third down and 3 yards to go. That's when the turning point of the game and, what was believed at the time, perhaps of the young season, occurred.

Oddly, State head coach Bob Tyler replaced starting quarterback Bruce Threadgill with backup Norman Joseph, who had yet to attempt a pass that season through nearly two games. Joseph rolled out, and his pass was batted in the air by sophomore defensive tackle Ronnie Swoopes and then corralled by the unlikeliest of the Junkyard Dogs, end Dicky Clark, who had been benched the year before against Mississippi State. Clark raced 71 yards for a touchdown, giving Georgia a 14–6 lead in what was an eventual 28–6 victory.

The following week on the road, Georgia defeated South Carolina, 28–20, in a game that wasn't actually as close as the score indicated. In their first true offensive outburst of the season, the Bulldogs rushed for over 400 yards, including 160 yards by Glynn Harrison, 131 by McLee and 84 by Andy Reid.

On Homecoming in early October, Georgia jumped out to a 28–7 halftime lead on Clemson—a team that had defeated the Bulldogs the previous year—before cruising to a 35–7 win. For the second straight game, Harrison and McLee each rushed for over 100 yards; the latter also rushed for four touchdowns—all scored in the first two and a half quarters of play—tying a modern single-game school record.

Considering they were supposed to be more like Maligned Mongrels, the Junkyard Dogs had been extraordinary through four games. Maybe most impressive was the fact that, despite featuring no true standouts—except maybe linebacker Zambiasi—the unit was exceptionally deep, filled with many small and inexperienced but aggressive players who displayed a lot of heart. Besides those who started the opening game, early on, the Junkyard Dogs also included linemen Jim Baker, Jeff Sanders and Tom Saunders, linebacker Jim Griffith and defensive backs Bill Krug and Mark Mitchell. The defense's bend-but-don't-break style had allowed nearly 300 yards of total offense per game, including about 175 yards on the ground, but the

Tackle Jim Baker (*left*) and linebacker Ben Zambiasi (*right*) were two of seventeen or more defenders who were vital contributors to Georgia's "Junkyard Dogs" defensive unit of 1975. *Henck and Kelley collection.*

feisty group was yielding only thirteen points per game while forcing at least two turnovers in every contest. Around this time, "Happy" Howard Williamson, the Bulldogs' radio network's first-year color analyst, was so astonished by the unit's surprising play that he sat down one day and began writing a song about the Junkyard Dogs.

Game five featured Georgia's first-ever trip to Oxford, Mississippi, to face Ole Miss. The Rebels, who had been routed by the Bulldogs, 49–0, the year before in Athens, were absolutely dismal on offense, averaging only 220 total yards and less than nine points per game through five contests. Seemingly, the Junkyard Dogs were to encounter its easiest test to that point of the season. And early on, it appeared that way; Georgia led, 7–0, and was about to reach the end zone again at the end of the first quarter. But the Bulldogs' offense bogged down, whereby the Rebels experienced what could be considered their turning point of not only the game, but their season—a campaign in which they won five of their last six games following a 1-4 start.

Totally swinging the momentum in the Rebels' favor, Leavitt's 31-yard field goal try early in the second quarter was blocked by free safety Rickye Hicks. From there, over the next two quarters, Ole Miss scored four consecutive touchdowns to hold a 28–7 shocking advantage.

Shag, who had entered the season with a new attitude of dedicating himself to being the best he could be on and off the field, found himself in the same old routine as a "co-starter," switching possessions off and on with Mark Wilson. He also found himself without a catch for the season until just over nine minutes remaining in the game, when he hauled in a nine-yard touchdown pass from quarterback Matt Robinson, making the final score somewhat respectable at 28–13.

Perhaps more detrimental than the Junkyard Dogs yielding 333 yards in rushing alone, or the Georgia offense committing six turnovers, or perhaps even how the Ole Miss crowd occasionally spat on Georgia players when they went for Squab Juice situated behind the sideline where the stands began, were the number of injuries suffered by the Bulldogs in their setback to the Rebels. It was believed that Harrison, the team's leading rusher, would miss at least the next game at Vanderbilt with an injured shoulder. Goff, who was second behind Harrison in total offense, was day-by-day with a hurt elbow. Leavitt, the only Georgia player to have attempted a placekick for three seasons, was said to be out for at least three games with a pulled groin.

Probably the most disturbing injury suffered by the Bulldogs in Oxford was a leg ailment causing the indefinite loss of Joel "Cowboy" Parrish, who had been shaping up to be one of the best blocking guards in the SEC. Replacing Cowboy was a junior reserve who, although likely the player on the squad who most strained his potential, would be making his first career collegiate start at Vanderbilt. His timing couldn't have been better. Or worse. Georgia needed a victory in the worst possible way.

The Ultimate Teammate

D on't mess with the linemen" was an unspoken protocol of the Georgia football program, or more like precautionary advice. It was known before the early to mid-1970s, possibly ever since then, but definitely during the era. It was then that the linemen, especially on offense, were big and strong, but very few of them could be considered "fat" or even overweight. On the whole, they were physical, athletic, quick for their size—a "Big Bad Ass," as some were called—and, you dare not cross most of them unless you were willing to deal with the repercussions. Although nearly all of them associated with players at other positions, most of the linemen seemingly belonged to their own quasi-fraternity of sorts—maybe, Beta Beta Alpha, for "Big Bad Asses."

Upholding what was like a gangster or outlaw mystique, a number of linemen often played cards, a handful chewed tobacco, at least a couple continued to associate with Señor Grande well into the 1975 season and there were a few, and thankfully only a few, who—how to say this?—were fanatical about feces, proud of their poop. They would give their feces a name, take photos of it and, every once in a while, "drop" it in the communal shower (although toilets were a mere five-second walk away) for some poor soul to have to clean up. *It* once was dropped and left by an offensive lineman on a couch in a sorority house during a party. After catching wind (no pun intended) of the offense, an incensed Vince Dooley called an emergency meeting of the entire team. Of course, there were a number of linemen who were exceptions to such questionable

and unpolished behavior, including the biggest exception of them all—Hugh Hendrix.

As wild as some of his teammates were, Hugh was as tame. Yet, he was well liked by seemingly everyone and got along and mingled with all cliques of players. About the only thing Hugh had in common with many linemen was that he often wore flip-flops.

Born in Savannah, Georgia, before eventually moving to Decatur, Hugh was the only child of Harvey and Carolyn Hendrix. The parents still find humor in the fact that when their astute son was in grade school, a career aptitude test revealed that he would be best suited as a farmer. Harvey, a 1950 graduate of the University of Georgia and an executive with General Electric, wanted

Fellow Georgia players thought of Hugh Hendrix as friendly, intelligent, a mentor and a player who always gave his best effort—the ultimate teammate. *Henck and Kelley collection.*

his son to follow in daddy's footsteps and become a businessman—maybe an accountant, or even a lawyer. But Hugh had no interest in such work. Indeed, he wanted to follow in his dad's path, only by attending Georgia, where he wanted to play football.

A sparingly used lineman entering his junior year at Shamrock High School, Hugh's desire to play major-college football seemed far-fetched. But he was confident he could succeed if only given "a chance—that's all I want," he would say. He finally got that chance with the arrival of a new head coach, Jim Cates. Suddenly, Hugh blossomed and flourished at the prep level.

Like every sixteen-year-old boy, Hugh longed for his own car. Harvey promised him an automobile when he graduated from high school, but only if he had earned a football scholarship, knowing full well the chances of that were, at best, very minimal. However, if given a chance, Hugh was capable of accomplishing just about anything.

Having grown to six feet, four inches tall and weighing around 220 pounds, Hugh was recognized as one of the top thirty players in the state entering the 1972 campaign—a senior season in which he became the first from Shamrock to be named first team all-state. Considerably

intelligent with excellent grades, he had been steadily recruited by a number of programs, primarily schools known more for their academics: Rice University, Vanderbilt, the University of Pennsylvania and Harvard. Because of the education Hugh would receive, Harvey emphasized these schools, but the son had his sights on one particular university—and one alone. "I want to go to Georgia," Hugh repeatedly said. "If I want an education, I can get an education at *any* school."

Soon, Georgia assistant coach Pat Hodgson started to recruit Hugh. Projected to play on the defensive line, Hugh began receiving brief letters in the mail from defensive coordinator Erk Russell. Further sold on becoming a Bulldog, Hugh signed a four-year scholarship with Georgia in mid-December 1972 with little fanfare as his parents and assistant coach Barry Wilson observed. Subsequently, Harvey made good on his promise and took his son car shopping, whereby a mustard gold 1972 Cutlass Supreme was purchased for $3,200.

On his arrival to Georgia, although unaccustomed to an environment of wild behavior, rigorous practices and freshman hazing, Hugh was seemingly unfazed by it all. "Hugh couldn't be run off," his mother said when informed that a number of players left the program when faced with such obstacles. "He was just so thrilled to be at Georgia, and playing football—like he had died and gone to heaven."

Recognized by a handful of players as "the ultimate teammate," Hugh was a mentor to many of the boys off the field. He often helped several with their classwork. There was an instance in which a fellow lineman arrived at McWhorter Hall from home literally not fully understanding how to adequately brush his teeth. In private so that no one would become aware of the lineman's shortcoming, Hugh taught him how. After some time, Carolyn questioned her son as to why he was asking for a little more allowance money than what had been his typical amount. When she was told that he had been giving the extra to a few needy teammates, Carolyn became upset, proclaiming that they did not have enough money to be giving any away. Hugh replied, "But Mama, we might not have enough, but we got so much more than a lot of those boys over there."

Beginning with Hugh's freshman season, a few good friends from high school, three girls—Janice, Kathy and Gayle—would drive over from Decatur for every Saturday home game and pay for a room at the old Downtowner Inn, which was located where Milledge Avenue and Lumpkin Street meet at the Five Points area of town. The girls were granted room 116, supposedly "the best room in the house," the manager always claimed, because it was

near the pool and had a great view. The girls agreed with the manager that the room did not have to be cleaned until after their late-morning arrival. Room 116 remained reserved for the girls every time they came into Athens. Each time they first entered the room, it smelled of cigar smoke while the bed was covered with sections of that morning's newspaper. The smoke and newspaper were left by the same individual who was given room 116 every

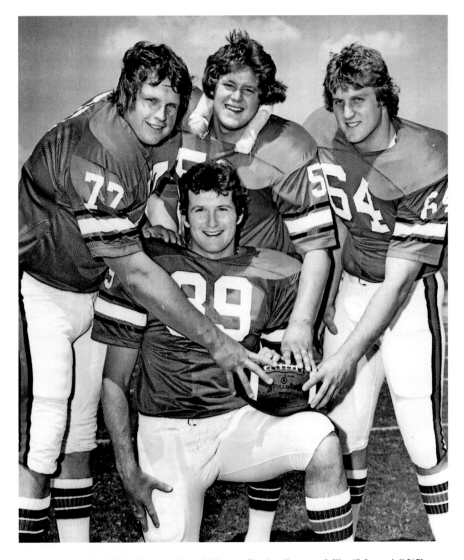

Pictured with Hugh Hendrix (*standing, right*) are offensive linemen Mike "Moonpie" Wilson (*standing, left*) and Ken Helms (*standing, center*), and tight end Mike Striplin (*kneeling*). *Henck and Kelley collection.*

Friday evening before home games—Larry Munson, Georgia's legendary radio play-by-play man, who was living in Nashville, Tennessee, at the time.

After they had fulfilled any postgame responsibilities, some players—sometimes as many as a couple dozen—proceeded to 116, which, filled with iced-down cases of beer, had been transformed into the best "party room" in the house. Hugh was there every time, but he would have maybe only one beer. If he consumed two, he was regarded by the partygoers as having done something "crazy." Hugh wasn't there to drink and party. He was there to watch over his three friends from high school—girls he considered sisters—as they partied with a throng of testosterone-filled football players. And he was there to continue what some players had left on the field at Sanford Stadium hours before: the pleasing and gratifying sensation Hugh experienced for simply being part of a team.

On the field, Hugh worked his way up to be the starting defensive tackle on the 1973 junior varsity squad. However, he just didn't quite fit the role of a college defender, so he was moved to the offensive line to begin his sophomore season. For the entire 1974 campaign and into 1975, Hugh primarily backed up Randy Johnson at right guard before standout Joel Parrish was injured against Ole Miss. The injury was an unfortunate mishap for the Bulldogs, but it provided all that Hugh could desire—a chance.

With a 3-2 record—Georgia's same mark through five contests the disappointing year before—the Bulldogs' meeting with Vanderbilt in Nashville was what Coach Dooley regarded as a "crossroads football game."

During the previous couple of seasons or so, the team's receivers sometimes joking referred to their position as "Downfield Blocking Specialist," because of Georgia's tendency to primarily run the ball and, at times, pass infrequently. The Bulldogs' game plan versus the Commodores was to do just that, but run the ball even more, although star running back Glynn Harrison was out with an injury. Having attempted just two passes, completing none, Georgia led, 7–3, with about five minutes remaining until halftime. The Bulldogs faced second down and eight from Vanderbilt's 36-yard line. Having noticed that the Commodores' defenders often held hands when huddling and while paying little attention to the opposing offense, the Bulldogs called for some razzle-dazzle—the "Shoestring Play."

Quarterback Ray Goff, who had not fully recovered from a ruptured bursal sac in his throwing elbow, approached the football, which was spotted on the right hash mark. As Vanderbilt's defense huddled, Goff knelt in front of the ball pretending to tie his shoe as the other ten Bulldogs nonchalantly gathered at the left hash mark on the wide side of the field. Instantly, Goff

flipped the ball to flanker Gene Washington, who began racing down the left sideline with a convoy of blockers. Only Reggie Calvin had the remote possibility of reaching Washington, but the Vanderbilt defensive back was quickly blocked out of the play by "Downfield Blocking Specialist" Shag Davis and finished off by starting left guard Hugh Hendrix.

Washington's 36-yard, shoestring touchdown incited Georgia to a 47–3 rout of the Commodores in a game that had been forecasted to be a close affair. Playing only because of the injuries the Bulldogs had endured, walk-on running back Hilton Young, who entered the game having carried the ball just twice during his career, rushed for two touchdowns. Backup placekicker Cary Long, who had never attempted a placekick as a member of the varsity squad, made five extra points and two field goals.

Next was a home game against Kentucky, which was led by heralded running back Sonny Collins. Collins, who had been named the SEC's Player of the Year two years before as a mere sophomore, had been a real thorn in Georgia's side, rushing for around 150 yards in each of his last two games against the Bulldogs. At first, his final game against Georgia appeared to be no different, as he repeatedly gained yardage in moderate chunks while leading the Wildcats to three first-half scores.

Although Georgia's offense became more run-oriented the last half of the 1975 season, offensive coordinator Bill Pace (*left*) and head coach Vince Dooley (*right*) implemented a number of innovative trick plays. *D.J. Pascale collection.*

After trailing 13–7 at halftime, Georgia's offense stepped up in the second half, scoring two touchdowns, including a head's-up fumble recovery for a score gathered by tackle "Moonpie" Wilson after Goff had fumbled into the end zone. In the final two quarters, the Junkyard Dogs bottled up Collins and the rest of the Kentucky offense until the final minutes of the game. Trailing 21–13, the Wildcats moved from their 20-yard line to Georgia's 18 in ten plays. Then, the Bulldogs' defenders stiffened with Kentucky looking to salvage a tie. End Dicky Clark and tackle Ronnie Swoopes sacked Cliff Hite for a deep loss, followed by the Wildcats' quarterback throwing an incomplete pass and finally passing for only a short gain as the game ended.

The week after the Kentucky game, the song about Georgia's surprising defensive unit of 1975 by "Happy" Howard Williamson was revealed on October 29 with a press conference at Atlanta's International Hotel. Sung and recorded by the "Godfather of Soul," James Brown, who was in his early forties at the time, "Dooley's Junkyard Dogs" was released on approximately 100,000 records. Regarded as the first rock 'n' roll song about a college sports team, "Dooley's Junkyard Dogs" became so prominent, according to *The Red and Black*, the tune would replace "'Dixie' as the most popular song of the football season."

Whether it was the notoriety going to their heads or the unit looking ahead to the following week's game against Florida, the Junkyard Dogs were lifeless in the first half against the lower-tiered Richmond Spiders. In what was supposed to be a breather, the visitors had scored seventeen points by halftime. Matt Robinson, who was to begin the season as Georgia's starting quarterback before suffering an injury, started under center after relieving Goff the first two months of the campaign. Robinson's command of the offense kept the Bulldogs in the game and then gave them a 28–24 lead with just under ten minutes remaining following a 14-yard touchdown run by Kevin McLee. The Junkyard Dogs came up big when it counted the most, forcing Richmond's offense to go three-and-out on its final three possessions.

Back when appearing on television was really something special—so much so, some players admitted it actually gave them extra incentive to perform well—Jacksonville's Georgia-Florida game, also known as the "World's Largest Outdoor Cocktail Party," was being broadcast nationally for the first time after being regionally shown for years.

On display against the eleventh-ranked and heavily favored Gators was a Georgia offense that came into the game running the ball more than 85 percent of the time. Still, since the Bulldogs' gifted receiving corps consisted of athletic, highly capable football players, it had been decided that the

roles of several "Downfield Blocking Specialists" be expanded beyond blocking and getting thrown to every once in a while. By the time the 1975 season was nearing its close, receiver Butch Box had demonstrated an uncanny ability to cover kickoffs and punts. Mark Wilson punted on occasion. Washington and tight end Richard Appleby had each been used several times on end arounds. As for Shag, it was determined the split end could finally exhibit his prep All-American, completely healed throwing arm against Florida.

After it had rained the entire morning, the Bulldogs and Gators kicked off in a slight drizzle. Florida scored a touchdown on its first offensive possession, and the score remained 7–0 as halftime neared. With about six minutes left in the second quarter, Georgia faced third and long on Florida's 31-yard line—the first time the Bulldogs had reached inside the Gators' 40-yard line the entire game. A play was called in which Shag, lined up on the right side at tight end, would come off the line, run an end around from right to left, receive the football from the quarterback, stop and then throw a pass into the Florida end zone to a receiver whom Georgia coaches were positive would be open. Just like it had been drawn up, Shag was handed the football running from his right to left, and just as he spotted his receiver drifting open and began positioning himself to throw long, he suddenly stopped—and slipped on the wet surface, collapsing to the Gator Bowl field.

Shag's "pass" play not only did not result in a Georgia touchdown, but it also lost yardage, to where a field-goal attempt was seemingly just beyond the reach of Allan Leavitt. Nonetheless, on the Bulldogs' next possession, the Georgia placekicker made a 21-yarder to pull the team to within four points at halftime, 7–3.

The Bulldogs did not threaten to score the entire second half until 3:24 remained in the game. Possessing the ball at its own 20-yard line, while a third loss on the year appeared certain, Georgia called the same end-around pass play as before, except instead of Shag coming off the line, moving right to left and throwing long, Appleby did the same, moving from his left to right. Aided by Hugh, the pulling guard who blocked an oncoming Florida defender, Appleby received the handoff from Robinson, stopped, planted his feet and threw the ball more than 50 yards in the air to a wide-open Washington, who caught it on the Gators' 35-yard line and dashed into the end zone for an 80-yard touchdown.

"Appleby-to-Washington" and the "Shoestring Play"—both resulting in Gene Washington touchdowns, and occurring in a span of three weeks—remain two of the greatest plays in the history of Georgia football.

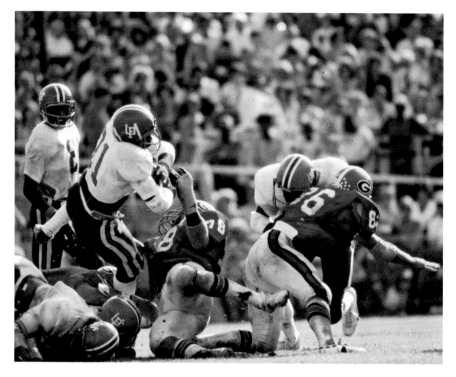

Leading 10–7 in the final minutes of their 1975 meeting, Georgia's defense halted Florida on its final two possessions to capture an upset win. *dr. jteeee collection.*

While the 80-yard end-around touchdown pass might have defeated Florida, it was the Junkyard Dogs defense that clinched a 10–7 victory. The Gators still had time to possess the ball two more times, reaching Georgia's 35-yard line and its 21-yard line. But the Bulldogs' defense forced a lost fumble and a missed field goal, respectively.

Against Auburn in Athens, Harrison and McLee—the Bulldogs' top two rushers on the season—were lost to injuries in the first half. Reserves Andy Reid and Al Pollard filled in admirably, rushing for 112 and 91 yards, respectively, in a 28–13 Georgia win. That night, the Bulldogs hoped to receive an invitation from the Gator Bowl; however, the invite from the Jacksonville bowl game went to Florida, although Georgia had beaten the Gators the week before and the two had identical records (8-2 overall, 5-1 in the conference). Yet the agitated Bulldogs made out even better the following evening, when they were extended a bid from the Cotton Bowl. The postseason affair in Dallas originally wanted Notre Dame or Southern California to play the Southwest Conference champion. However, when

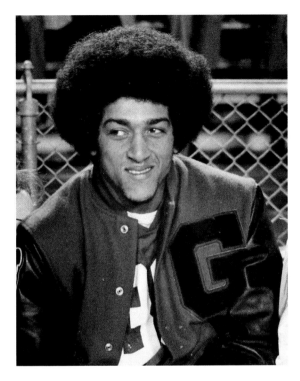

Nursing an injured ankle on the sideline at Georgia Tech in 1975, sophomore running back Kevin McLee led the SEC in touchdowns scored (ten) that year, despite essentially missing the final two games of the regular season. *Helen Castronis collection.*

the Fighting Irish and Trojans were upset by Pittsburgh and Washington, respectively, dropping both teams' records to 7-3 and out of the national rankings, Georgia was invited, instead.

At that point, with twelve days until the following game and a berth in a major bowl already secured, some teams might have neglected their next opponent. But not this Georgia team—a true "team" in every sense of the word and one that had been embarrassed at home by its next opponent the year before, 34–14.

On Thanksgiving night on national television, the Bulldogs led Georgia Tech, 7–0, with just under ten minutes remaining until halftime when Georgia opened the floodgates, so to speak. Beginning with a 78-yard touchdown jaunt by Harrison, the Bulldogs scored five touchdowns in a span of only about a quarter and a half to take a 42–0 lead late in the third quarter. The play of Georgia's offensive line was phenomenal. Guard Randy Johnson displayed why selectors had started recognizing him as a first team All-American just a few days before. Junior Ken Helms, who was making just his third start at center after replacing injured Joe Tereshinski, would be named the game's top offensive player by ABC-TV. The defensive

In a 42–26 victory over Georgia Tech in 1975, split end Mark Wilson (*left*) caught a touchdown pass—one of only five thrown by Georgia that season—and center Ken Helms (*right*) was named the offensive player of the game by ABC-TV. *Henck and Kelley collection.*

player of the game was junior end Lawrence Craft, who totaled a team-high six tackles, including one for a loss, and recovered a midair fumble that he returned for a touchdown. Then there was senior Joey Butler, who may have tallied just one tackle, but it resulted in one of the highlights (or lowlights) of the game.

During the third quarter, in bracing himself to tackle halfback Adrian Rucker for a short gain, while apparently suffering from an upset stomach, Butler, ironically a lineman, defecated on himself. With his pristine white football pants clearly soiled in the back, and a national viewing audience numbering in the millions, he quickly took a break from the action to clean up and change on the sideline.

In the rivalry that would soon be nicknamed "Clean, Old-Fashioned Hate," Shag also discovered the Georgia–Georgia Tech game to be "dirty." After Tech scored a third consecutive touchdown to cut its deficit to 42–20 with under three minutes left, he was inserted into the game along with the rest of Georgia's "hand's team," fully expecting an onside kick. Indeed, the Jackets' E.O. Whealler's kickoff was skidded on the turf, where Shag fielded

it on a hop and fell to the ground. While he clutched the ball under a pile of players, it was reiterated why being a member of the hand's team could be the worst role in football. Shag was poked, punched and grabbed by opposing players—anything so he'd let go of the football. Then, a Georgia Tech player near him in the pile said, "The doctor's in the house! So, when I grab your nuts, I want you to *cough...* up the football." Consequently, Shag's testicles were grabbed by the player with such force that he had no choice but to "cough up" the football, whereupon it was recovered by the Yellow Jackets. Fortunately for Shag, an offside penalty on Georgia Tech nullified the play. Unfortunately, his privates ached until after Georgia's 42–26 victory was completed.

The next day, during the team's review of the game film, for perhaps the first time several players could recall, Dooley demonstrated a quick-witted sense of humor representing the closeness for what he felt was a very special team. During the stoppage of the film to highlight notable plays, he paused on Butler's tackle just prior to the ensuing mishap in his pants.

"Now, Joey, tell us *exactly* what happened on this play," Dooley said. The room roared with laughter. The head coach followed up his request by adding that, considering Butler's upset stomach while playing against Georgia's biggest rival, "I should've had you line up backwards the entire game!"

While Georgia prepared in Dallas to face Arkansas in the Cotton Bowl on January 1, the media repeated the theme that the two teams were much alike. The Bulldogs and Razorbacks had identical records (9-2); featured run-oriented offenses exhibiting large offensive lines; had high-risk, big-reward passing games; utilized smallish but very aggressive defenses and had exceptionally sound kicking games. Still, although Georgia was decidedly ranked higher in the Associated Press national poll (twelfth to Arkansas's eighteenth), the Bulldogs were seemingly disrespected as nearly a touchdown underdog. On the other hand, the Hogs demonstrated the entire week of the game that they certainly did not lack in confidence.

For Georgia's final workout the day before the game, Dooley brought in a special guest, perhaps to maintain morale. "I want to introduce you to a friend of mine who just signed a multi-million dollar recording contract," the head coach declared as James Brown suddenly walked into the middle of the team huddle. "James, give the team a little motivational speech."

Although the famous singer had been seen a couple of times hanging around Dooley and the program since the release of "Dooley's Junkyard Dogs," it was an honor for him to actually travel to Dallas and represent

Georgia. The team anxiously gathered around Brown for the final pep talk before the day of the game, only to hear a "talk" that, by most accounts, was hardly understandable—a two or three-minute speech that was incoherent except when he clearly mentioned "Junkyard Dogs" a couple of times.

Although muddled, the pep talk conceivably did the trick, as the Bulldogs jumped out to an early 3–0 lead before driving toward the Razorbacks' goal line early in the second quarter. Around midfield, Georgia surprisingly turned to its passing game. Robinson completed a pass to Shag to Arkansas's 35-yard line when Alex Hawkins, CBS-TV's animated color analyst and former NFL player, announced that the catch was the first reception made in all of organized football in the country's 200th year. Three plays later, Shag made another catch, earning even more praise from the broadcaster.

It turned out that Hawkins had been made aware prior to the game of the similarities between himself and Shag: wide receivers who had been hell-raisers; the younger player was from Cambridge and an avid fan of the Baltimore Colts, and the other often hunted near Cambridge and had primarily played for the Colts. On the next play, Shag made his third reception—the third in a span of only five plays, and the same number he had the entire regular season. Hawkins interjected again, claiming Shag was "the first athlete from Dorchester County to go to college."

As was the case by mentioning the first catch of America's bicentennial year (actually, Georgia's Pollard had made the first reception of the game a couple of plays before), perhaps the color analyst made an innocent mistake, meaning Shag was the first from Dorchester County to play major-college football. But to some television viewers, particularly those in Dorchester County, the remark was more like a joke, poking fun at the people from an area Hawkins was familiar with. Nevertheless, Robinson soon passed to Washington for a touchdown, giving Georgia a 10–0 lead. Soon after that, Shag's father received a phone call from the head of the board of education of the county, a friend, venting about the multiple calls he had received regarding Hawkins's comment.

There would be no more remarks made the rest of the game regarding the Dorchester County native, as Shag did not see the field from the midway point of the second quarter through the end of the contest. After alternating series with Wilson for most of two seasons, Shag was curiously, and without explanation, removed from the game following Georgia's touchdown drive and never reinserted by receivers coach Baby Huey.

Late in the second quarter, Arkansas got on the scoreboard with a field goal following a Robinson fumble. On the ensuing possession, Georgia had

the ball on its own 22-yard line with only thirty-five seconds until halftime. Instead of running out the clock, Dooley called for a trick play, believing the Razorbacks had, by scoring, stole the game's momentum. But in an attempt to retake the momentum, what was called was no ordinary trick play at all.

If the "Shoestring Play" had been used at Vanderbilt, what could be characterized as a "triple-knotted shoestring" would be attempted in the Cotton Bowl. As before, Goff was to kneel near the ball, pretending to tie his shoe, and then flip the ball to Washington. The twist was that the Bulldogs actually hoped Arkansas, which surely was aware of Georgia's trickery at Vanderbilt, would recognize the shoestring formation. With Washington expected to run, he would instead flip the ball to Appleby, who would be coming around on a reverse and then have the option to run the ball or pass it back to Goff. Unfortunately, the twist never occurred. Once Washington received the flipped ball, he collided with Pollard and fumbled. Arkansas recovered the fumble and, two plays later, tied the game with a touchdown. The play intended to retake the momentum actually wound up providing even more for the Razorbacks, as they scored an additional three unanswered touchdowns in the second half to prevail, 31–10.

For some Bulldogs, their Cotton Bowl experience gradually became an even worse ordeal beyond the game itself. After partying the entire night and into the next morning in Dallas, a handful of players lost track of time. Instead of missing the flight back to Atlanta, they settled on flying home empty-handed, leaving behind their luggage and belongings. In addition, some sort of flu bug infected a few players, especially Shag. On the flight home, he got progressively more sick.

"Shag, you're in no condition to drive back to Athens," Hugh said when the team landed in Atlanta. "Let me drive your car, and tonight you and I will stay at my parents' house, which is kind of on the way."

In two years of playing football together at Georgia, the two boys had become close acquaintances, but nothing more. However, in deciding that he needed to straighten out his act and associate with better influences, Shag found himself gravitating toward Hugh. Prior to that evening, he had never met Hugh's parents; regardless, they treated him as if he was their own son. For nearly the entire night, Carolyn attended to bedridden Shag, bringing him buckets to vomit in.

Back then, teams from the National Football League often contacted, via a mailed questionnaire or similar means, college players they might be interested in eventually drafting. En route to Athens the next day, the two players discussed the few NFL teams that had corresponded with them.

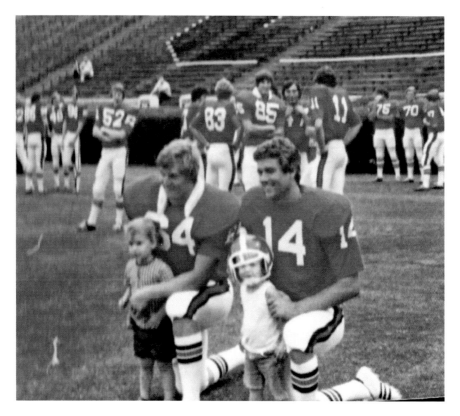

Hugh Hendrix (64) and Shag (14) pose with two young Bulldogs fans at a Georgia Picture Day. *Henck and Kelley collection.*

One of only twenty-six players in the entire conference to be voted a few weeks before to the SEC's All-Academic team, Hugh seemed especially encouraged about a particular pro scout, who indicated that although he lacked speed, his intelligence and footwork gave him a good shot to play in the pros. "I think I can make it, Shag," Hugh said of playing in the NFL. "A chance—that's all I want."

But first things first. Georgia was scheduled to begin spring practice less than three months later, on March 25. Returning eighteen of twenty-four starters from a major-bowl team, the Bulldogs appeared as if they could be very special in 1976. Also returning would be linebacker Sylvester Boler, who would bolster the Junkyard Dogs defensive unit after having to sit out the 1975 campaign.

"We have a great chance to be a really good team in '76," Hugh said that spring. "We've had the talent. But now, we've got our heads right-thinking

about the *team*, more so than ourselves." Similarly, according to M primary difference between the 1975 and 1976 squads compared to ones just prior was that "the coaches and players care more for each other."

To cap spring practice, in order to create new interest in G-Day, Coach Dooley implemented some changes for the intrasquad game. For one, whereas in the past the assistant coaches attempted to split the team into even Red and Black squads, a draft was held. Two local sportswriters drafted the teams—when each selected a starter, the other automatically received the backup at that position. For instance, when Wilson, who ended the spring listed as Georgia's number-one split end, was selected by the writer choosing for the Black, the Red automatically got the number-two split end, Shag. Also, the teams were headed by sportswriters from the Atlanta and Macon newspapers as "honorary head coaches," although they were literally coached by the Bulldogs' two coordinators. For Shag, although G-Day was yet another reminder that he was a second-stringer—and evidently would be for his senior year—he found some solace in the fact that he had the opportunity to be coached by Erk Russell.

The tenacious, motivational and inspirational Coach Russell was believed to be probably the only defensive coordinator in all of college football to have touched the lives of not only the defenders he coached, but everyone else belonging to the teams he was a part of: the quarterbacks, the kickers, the walk-ons, the trainers—everyone. Russell's Red team was considered by both Dooley and sports information director Dan Magill as the underdog, primarily because the Black featured the team's starting quarterback (Goff), placekicker (Leavitt) and punter (Bucky Dilts). However, as a member of the Red team said after the game, "Coach Russell got us so fired up beforehand, there was no way we were going to lose that damn spring game!"

A highlight of a Red upset victory over the Black was the performance of Tony Flanagan. Georgia's number-three quarterback and the starter for the Red, Flanagan hadn't played football in two-and-a-half years, since his senior season of high school, after concentrating solely on playing basketball for the Bulldogs. The quick and lanky rising sophomore led all players in total offense and fired a touchdown pass to Shag to give his team a decided halftime lead. In the second half, the Blacks finally scored a touchdown on a drive where "every play [was] a running play," a game recap reported. "And, most of those [were] behind the right side of the line, behind seniors Mike 'Moonpie' Wilson and guard Hugh Hendrix." After Hugh started the final seven games of the previous year at left guard, with the return of Joel Parrish, he was to be Georgia's starting right guard in 1976.

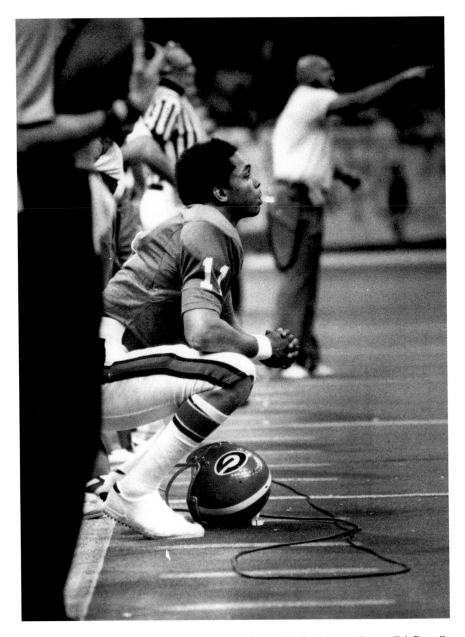

Shown here are quarterback Tony Flanagan (*kneeling*) and defensive coordinator Erk Russell (*background, pointing*). *Historic Images.*

The Black's lone touchdown would make the score close, but in the end, the underdog Reds won, 19–13. As reported by multiple media outlets, perhaps the main highlight of the spring game wasn't on the field, but on the stadium—literally. Nobody knew where it came from or by whom, but posted near the top of Sanford Stadium was a stand-alone sign warning the head coach of Alabama that Georgia would be primed in 1976 to possibly halt his SEC title streak of five seasons and go to the Sugar Bowl: "BEWARE BEAR—DOGS WANT SUGAR IN '76."

Obviously, it was the entire Georgia squad's desire to capture the SEC championship in the upcoming season, but maybe for the first time in years, many of the players were confident they could actually do so. A good portion of the team, especially of the upcoming senior class, stayed on campus during the summer, taking classes, but primarily focused on the looming season by diligently working out. Most of these players hardly partied for the entire month of June and into July. One particular player didn't party at all and was especially working out, getting ready for his final, senior season of 1976.

"[Hugh] Hendrix is really working," observed a teammate in early July. "Man, he's really serious about it."

After a workout in early July by a group of six—Hugh, Shag, three other players and a former player—one of the boys invited the rest of them to the house he was staying at during the summer. That afternoon, while at the house located out in the country surrounded by cow pastures, the host suggested that the entire group deserved to cut loose for the first time in a while. He informed them that a nearby pasture was filled with hallucinogenic-producing mushrooms—or "shrooms"—and that the six of them should go pick some and eventually eat them to get really high. Two of the players practically knocked the other four down as they darted to the front door for the cow pasture; two others, including Shag, were somewhat hesitant. And then there was Hugh Hendrix, who said that there was no way he was eating the shrooms. But he didn't see anything wrong with going along to pick them.

Shrooms was just about the only drug Shag Davis hadn't tried, and he was not planning to do so at any time in the foreseeable future. For one, he had worked too hard toward his fifth-year senior season—one in which he was planning to take back his starting position at split end—to blow it by getting in any trouble. And, maybe more so, Shag didn't know much about shrooms, but he was aware that they primarily grew out of cow stool.

"How the hell are we going to get caught?" a player asked Shag. "We're out in the middle of fucking nowhere!"

"Maybe I can go," Shag replied. "But, I'm not eating any. I know they come straight from cow shit!"

"Look, when we get back, I'll fry them up with some butter," the player said. "You'll never know where they came from, and I guarantee you'll actually like the taste."

"Well, after you eat them, how do you know when you're high?" Shag asked.

"Oh, you'll know," the player responded.

The response must have satisfied Shag, since he went as far as agreeing to eventually eating the shrooms, as did the other player who had been hesitant.

Little remains not forgotten from that afternoon when the six Georgia players ventured into the cow pasture. Combined, the group picked approximately two to three dozen small mushrooms. Hugh was seen holding some of those he picked up to his nose and smelling them out of curiosity. Also, he was definitely wearing flip-flops, because a player recalled hearing the distinct popping noise of the shoes.

The players returned to the house, and the shrooms were eventually cooked and then eaten by everyone except Hugh. In fact, nobody really even tried to pressure Hugh into trying the shrooms, because they knew they would only be wasting their breath. Of those who consumed them, nobody actually "liked" the taste of the shrooms—as had been guaranteed—but everyone definitely knew when they were high! To cap the evening, some of the players stayed at the house mostly listening to music, whereas others attended the professional wrestling matches held most Thursday nights at a huge indoor-outdoor facility, the J&J Flea Market, located on the outskirts of Athens.

Only a handful of days following the picking of the shrooms, on an afternoon in mid-July 1976, a teammate pulled his car up to Shag while he stood outside the house he was renting that summer.

"Hey, man, did you hear what happened to Hugh?!?" the teammate hollered to Shag, who only responded with a blank stare.

"Hugh's sick, man—*really* sick!"

12

Spirit of '76

It was explained to some Georgia football players that their friend Hugh Hendrix had left Athens not feeling well for his Decatur home on Saturday, July 10. According to a teammate, "I was running and lifting weights with him [on July 8]. He was running real good." Yet, the next day, Friday, he turned down an invitation to play tennis with some friends over the weekend because he felt like he had the flu.

On Saturday, when Harvey Hendrix arrived home, his wife, Carolyn, said, "Hugh's come home for the weekend, but he's sick." He was running a fever and had been vomiting, and his flu-like symptoms were beginning to worsen. The next day, Hugh was in such bad shape, a doctor made a house call to examine him. Based on the youth and great physical condition of the six-foot, four-inch, 230-pound twenty-one-year-old, the physician seemed confident. "But, if he's not better by tomorrow," the doctor said, "bring him to the office." Hugh would become progressively sicker.

Transported to DeKalb General Hospital, Hugh was ravaged, pathetic and hardly recognizable by Tuesday. Much of his body was inflated, including his feet, which were also extremely cold. Hugh was confused, repeatedly saying that the Georgia team was "down in Florida, so I got to get to Florida!" Yet, he was oriented enough to seem to understand his fate. When Carolyn tried to reassure him that the doctors were going to make him well, Hugh always responded, "They're going to take me out of here feet first."

With doctors unaware of what was wrong with Hugh, he was transported to nearby Emory University Hospital the morning of Wednesday, July 14.

There, the staff held out hope for his survival, citing, as before, his youth and health. But they were afraid that whatever he had contracted likely would be lethal if it got in his bloodstream.

After being at Emory for only an hour or so, Hugh was pronounced dead by cardiac arrest. The death was believed to have been caused by a rare, acute bloodstream infection. The infection was said to be normally caused by consuming contaminated food or water. Its symptoms generally became visible after anywhere from four to fourteen days, but there had been some extreme cases of visibility after only a day or so. The blood disease usually responded to antibiotics, but not in Hugh's case.

That night, Georgia's football coordinators, Bill Pace and Erk Russell, consoled Harvey and Carolyn at their home for the loss of their only child. Assistant coach Pat Hodgson, who had recruited Hugh, visited and comforted the parents for days. Two days after passing away, he was buried about sixty miles from his home in Carrollton, Georgia, where both Harvey and Carolyn were originally from. For his funeral, Hugh was fittingly escorted by his teammates, while Ray Goff, one of his best friends, spoke at the ceremony. As was the case with the other attending players, Shag stood at the funeral heartbroken for losing his good friend. Along with his grief, he was confused. The question remained: what had caused the blood infection in the first place? Rumors were swirling that perhaps it was something Hugh ate or drank. Also, he had been seeing a girl who attended college elsewhere in the state, and it was said that he might have gone swimming with her in a pond. Maybe Hugh contracted what killed him while swimming.

With his head swirling, Shag was suddenly approached by Harvey. Not having seen one another since the morning after Shag had gotten sick at his house, Harvey mentioned that his son was fond of Shag and even had a photo of him in his bedroom. For whatever reason, Shag felt compelled to inform Harvey about the incident from more than a week before, when he, Hugh and four others picked mushrooms in the pasture. Maybe that had something to do with his death. But he restrained himself. For one thing, the idea that picking shrooms possibly caused someone's death seemed ridiculous. For another, although Hugh was the only one of the six not to eat any, Shag thought it might be best not to inform a father that his straitlaced son, who had just passed away, had fairly recently been picking illegal hallucinogenic mushrooms.

When fall camp began on August 23, the Bulldogs had to come to the realization that Hugh was no longer a member of the team. "I think about Hugh every day. He was a good football player," said senior offensive lineman

Ken Helms. "But it will make us all work a little bit harder, whe how quickly something like this can happen."

Hugh's passing left a void to fill at Georgia's starting left guard spot. After a week of practice, another void was left with the departure of Sylvester Boler. After starring for the Bulldogs in 1973 and 1974, the talented linebacker had quit the squad after having to sit out the 1975 season. There were those in the media quick to point to Boler's orange-throwing episode from more than a year before as fueling his departure. It was assumed that he had never fully gotten over the incident. But, according to a particular sportswriter, Boler actually left "for no apparent reason....Many theories have been introduced as to why...but nobody seems to know the real reason."

Apparently, Boler's departure was yet another example of a lesson learned by many Georgia players of the era: the media often doesn't know the entire story. Even if they do, they might not reveal it all in order to fit their agenda. In reality, it was widely known why Boler decided not to play in 1976: simply put, he probably wouldn't have been able to play. On top of his lingering ankle injury, he had permanently injured his arm in a motorcycle accident in early August. "I was out there practicing when I realized that I wasn't going to be able to play ball like that [being injured]," Boler said. "Not only was I not going to be a starter [in 1976], I wasn't even going to be the team's water boy. That's why I left summer practice."

During summer practice nine days prior to the season opener, as the team took the field, it was observed that more than twenty players had completely shaved their heads. To the contrary, completely bald coach Erk Russell jokingly wore a wig. It appeared that a good portion of the team had emulated the acclaimed defensive coordinator or, according to Goff, it was "just one of those crazy things you sometimes do in college."

It turned out that Helms had recently received a six-dollar haircut from an Athens barber (not a cheap price in 1976). After the senior lineman purchased a hair dryer, Helms' new hairdo was criticized by teammate "Moonpie" Wilson. Accordingly, Helms promptly shaved off all of his hair, as did Wilson on a dare, followed by others. Within a few hours, the total of bald Bulldogs had reached about two dozen, which would climb to twenty-nine, including fourteen starters, by the start of the season. Included was Goff, who hailed from Moultrie in south Georgia. He remarked that even "the black dudes" shaved their heads, and "you can tell which ones of us are from South Georgia. Our heads ain't smooth like those city slickers from Atlanta. We got scars all over our heads."

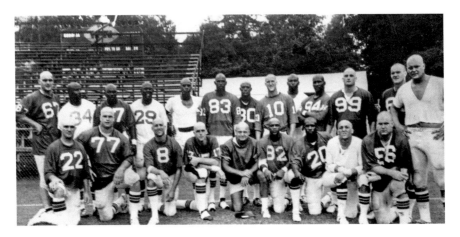

Within hours one day during fall camp of 1976, about two dozen Georgia players shaved their heads, joining the clean-shaven defensive coordinator Erk Russell (*center, kneeling*). *Butch Box.*

While the shaving of their heads gave the players more of a sense of team unity during fall camp, at the same time, Hugh Hendrix's presence was felt by the team in an intangible, spiritual sense. After one summer session, a senior starter stated, "Man, it's hot out there. They're really working us. I was about to pass out, felt my legs going, then I thought about Hugh! When I remembered him, I forgot about my complaint. I just grabbed my second wind, sucked it in, and kept at it." For the looming season, a decal featuring Hugh's jersey number 64 was placed in his memory on the back of each player's helmet, signifying the first time in Georgia football history that the Bulldogs had altered their uniform celebrating or in memory of a teammate.

As for Hugh's parents, their son's passing was still inconceivable. "I still can't believe it at times," Harvey said about Hugh's death just prior to the season-opening game. "I find myself thinking about coming over for the games and seeing him there."

After serving a co-starter role at split end for nearly two entire seasons, Shag had been approached by Coach Pace, Georgia's offensive coordinator, who indicated he couldn't promote the senior receiver to starting split end. Mark Wilson had performed too well over the previous two seasons, and Gene Washington was well established at flanker, the team's other position at receiver. Still, according to Pace, "We're going to have you starting somewhere if we have to create a position for you."

In the end, Shag was slotted as Georgia's starting tight end, and he wasn't the only Bulldog playing a new role when sixteenth-ranked Georgia hosted

 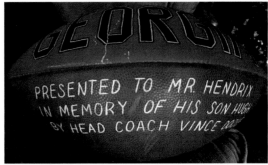

Left: The back of Shag's helmet from the 1976 season. The white stars recognized individual extra efforts and team accomplishments, and a black star was given to the "Top Dog" on offense, defense and special teams for each game. The black "64" was in honor of Hugh Hendrix. *Bob Davis collection.*

Right: Presented to Harvey Hendrix in memory of his son Hugh, from head coach Vince Dooley is the game ball versus California in 1976. *Henck and Kelley collection.*

California on September 11. Wanting the "Junkyard Dogs" nickname to not solely be associated with the defensive unit, Coach Dooley broadened the moniker to include the entire team. In turn, Coach Russell renamed the 1976 defense "Ronnie and the Runts," since 245-pound lineman Ronnie Swoopes was the only starting defender not considered moderate in size.

California, similar to Pittsburgh in 1973 and 1975, had been scheduled years before as an intriguing, intersectional season-opening opponent, yet a foreseeable victory at home. However, also like the Panthers, the fifteenth-ranked Bears weren't the same team as old. Quarterbacked by Joe Roth, who was considered likely the best passer in college football, California started off in Sanford Stadium even better than advertised, building a 24–12 lead early in the third quarter. Nevertheless, after being picked apart by Roth for two and a half quarters, the "Runts" (Swoopes missed the game with an injured leg) intercepted the Bear quarterback three times in a span of just six possessions. Meanwhile, the Georgia offense scored twenty-four unanswered points for a 36-24 win.

The Tuesday following the California game, eight Georgia players, including three starters, were demoted because of their involvement in a barroom brawl that had occurred within the previous two days. Taking place at Cooper's—the same country bar discovered to have a revolving door to a gambling house—details of the fight, including exactly when it occurred and who was responsible weren't disclosed. The demotion of the three starters gave opportunities to sophomores offensive tackle Mack

Guest and defensive guard Louis Freedman to make their first collegiate start that Saturday at Clemson, televised regionally by ABC-TV.

Also given an opportunity—an old one— against the Tigers was Shag, as Wilson, who was involved in the fight by association, "had the most serious punishment," according to the *Athens Banner-Herald*. "It was his demotion that elevated Davis to the starting split end spot. It is ironic that Davis first lost his starting spot to Wilson when as a soph [in 1974] he was disciplined for a dorm violation."

Starting at his old position for the first time in two years, Shag had the best game of his collegiate career, making four receptions for 66 yards and two touchdowns—both thrown by Matt Robinson. Still, the leading highlights of the Bulldogs' 41–0 win over the Tigers might have started when Tony Flanagan, Georgia's third-string quarterback, was inserted into the game with 11:41 remaining and the team leading, 34–0. Becoming the school's first African American quarterback to see varsity action, Flanagan promptly led the team on a twelve-play, 66-yard drive ending in a touchdown. Finally, in completing six of nine passes for 166 yards and three touchdowns,

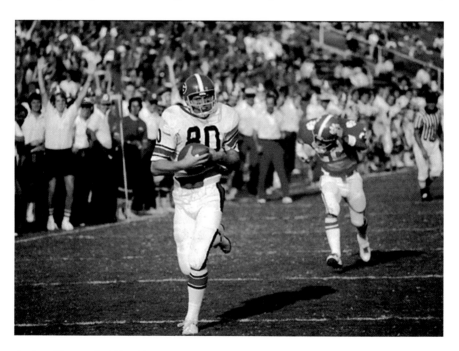

Against Clemson in 1976, Shag catches a 36-yard touchdown pass from Matt Robinson during a 41–0 Georgia win. *Bob Davis collection.*

Robinson was named the recipient of the Chevrolet Offensive Player of the Game Award. However, when a member of the ABC-TV broadcast team informed the quarterback of the honor, he refused it, asking if the award could instead be dedicated in memory of Hugh Hendrix.

Against South Carolina in Athens the following week, Georgia trailed, 12–7, with approximately five minutes remaining in the third quarter. With the Bulldogs possessing the ball on their own 41-yard line facing second down and eight, Robinson lofted a long, looping pass toward Shag, who had been lined up at tight end before racing down the sideline. The pass appeared clearly overthrown and would seemingly fall incomplete. Yet Shag lunged for the pass with both arms fully extended, and his fingertips barely came in contact with the back nose of the ball. Using only the tips of a few of his fingers, Shag flicked the ball toward himself, grabbing the back half of the football with both hands. Pulling the ball in, he stumbled down to South Carolina's 9-yard line for a 50-yard gain.

The next day, Shag's reception was recognized by a newspaper writer as "likely the greatest catch in the history of Sanford Stadium." But, more so, the *Athens Banner-Herald* deemed it "The Big Play!" as the reception was "responsible for the University of Georgia football team's unbeaten status." Three plays following the 50-yard gain, Robinson passed to Al Pollard for a touchdown. With just under four minutes left to play, Kevin McLee rushed for a touchdown on fourth down and goal to go from the 1-yard line. On the ensuing drive, trailing by eight points, South Carolina reached the Bulldogs' 6-yard line. Nevertheless, the Gamecocks fumbled on a bad pitch, which was recovered by Georgia's Bobby Thompson, securing a 20–12 victory.

Apparently, if the Bulldogs were going to defeat perennial power Alabama, a touchdown favorite, in their next game in Athens, they would need all the help they could get. And they indeed got it from their "Track Fans," a crowd of supporters numbering in the thousands who would start gathering on railroad tracks just outside of Sanford Stadium the morning of games. However, in facing the tenth-ranked Crimson Tide coached by the legendary Paul "Bear" Bryant, the Track Fans started arriving even earlier, like twenty-four hours before kickoff, already cheering on the team as it conducted its routine forty-five-minute workout the day before the game.

In what was said to be the most jubilant Georgia crowd in the history of its stadium, Ronnie and the Runts put on what remains maybe the greatest defensive performance by a Bulldogs' team at home considering the opponent. Entering the game averaging 300 rushing yards per contest for the year, Alabama was limited to 49 yards on the ground. In a 21–0

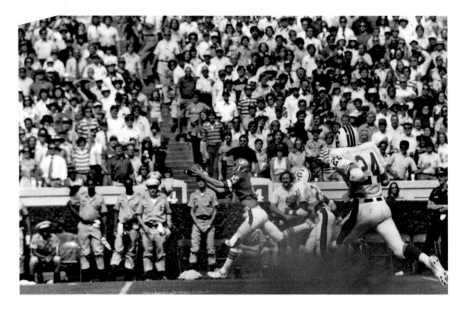

Pictured is Shag's miraculous 50-yard reception against South Carolina in 1976, recognized as "likely the greatest catch in the history of Sanford Stadium." *Bob Davis collection.*

defeat, the Crimson Tide also committed three turnovers. The Georgia defense featured a cast of standouts, but Bill Krug might have stood out the most. The junior rover back intercepted a pass inside the Bulldogs' 25-yard line and later appeared to have scored a touchdown after stripping a ball carrier around midfield, but the ball was ruled dead. Krug also registered a sack, one of seven by Georgia—remarkably, all seven occurred in the fourth quarter. Offensively, the Bulldogs were led by outstanding line play that pushed around Alabama's vaunted defensive line for most of the game. Especially impressive was "Moonpie" Wilson, who physically dominated All-American defensive tackle Bob Baumhower.

If the Georgia enthusiasts could be described as raucous before and during the Alabama game, their actions following the contest were virtually indescribable in what was considered "the wildest night" the city of Athens had ever experienced. The primary party covered an area of at least five blocks on Milledge Avenue and in the Five Points area. Partygoers were not only literally dancing in the streets but even on top of running cars belonging to people they didn't even know. The celebration caused the police to completely close Milledge from Broad Street to Five Points, a distance of more than a mile.

It was almost as if some Bulldog players didn't want the Alabama victory and the joyous sentiments that surrounded it to end, as they relaxed or became content. A week later, playing Ole Miss in Oxford, Shag and two other teammates were walking through their hotel to board the bus bound for the stadium when they caught a familiar smell in the air. It was clearly marijuana, and it was coming from the room of a standout player, recognizable by his cough. Two or three years before, one if not all three of the players possibly would have found it almost humorous that a teammate was smoking marijuana prior to a game. But, having matured and being seniors on a team that could contend for not only the SEC championship, but also for a national title, the trio was completely incensed.

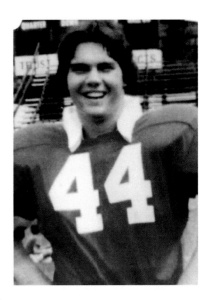

Including linebacker Ben Zambiasi—the Bulldogs' leading tackler both seasons—eight of the eleven starters for Georgia's "Junkyard Dogs" defense of 1975 also started for the "Ronnie and the Runts" unit of 1976. *Henck and Kelley collection.*

Despite, perhaps, the reaction time of at least one Bulldog being slowed, fourth-ranked and undefeated Georgia started off fast, building a 14–3 lead early in the second quarter. However, as was the case the year before in Oxford, the Bulldogs faltered after their quick start, and a significantly favored Georgia team was eventually upset by the Rebels, 21–17.

Also, as in 1975 after losing to Ole Miss, the Bulldogs' offense became more run-oriented, thus its receivers were more so "Downfield Blocking Specialists" and the team flourished following defeat. After Vanderbilt and Kentucky were subsequently routed by a combined score of 76–7, Georgia hosted Cincinnati. Only several years removed from having participated in the lower-tiered Missouri Valley Conference, the twentieth-ranked Bearcats were one of the biggest surprises of the season. The Bulldogs' 24–3 lead after three quarters was quickly narrowed to 24–17 with roughly eleven minutes left in the game. Cincinnati had legitimate opportunities to at least tie the contest until Georgia's Henderson, followed by linebacker Jim Griffith, intercepted Bearcat passes to halt the threats. With less than four minutes remaining, a short touchdown run by Pollard secured a 31–17 Bulldog win.

During all the excitement of the Cincinnati game, a couple of familiar faces were spotted on the sidelines of Sanford Stadium. Señor Grande, who stood along the Bulldogs' sideline for at least most of the second half, continued to associate with as few as a couple to maybe as many as several Georgia players. And on the Bearcats' sideline was an individual who once stood along the opposite side of the field: Chuck Farris, whose brother had duped the Bulldogs into signing the northern running back prospect three and a half years before. Farris, who saw some playing time that afternoon against his former team, had evidently transferred to Cincinnati, where he was a linebacker, after being run out of the Georgia program.

Against Florida in Jacksonville, the Bulldogs spotted the Gators a 27–13 halftime lead; however, the ever-pessimistic Dooley seemed surprisingly confident. So much so, after a senior player approached the head coach just prior to the start of the third quarter and said, "Don't worry, Coach. We'll kick their ass in the second half!" Dooley responded, "I know."

With about four minutes elapsed in the third quarter, Shag made what would be his final reception of the regular season, but it was a critical one. With Georgia still trailing by two touchdowns and facing third down and four to go on its own 25-yard line, Goff took a short drop and fired a high

Photographed from the Bulldogs' section of Jacksonville's Gator Bowl is the 1976 Georgia-Florida game. *Henck and Kelley collection.*

pass that was nearly intercepted by Alvin Cowans. Instead, Shag leaped high and essentially took the ball from the Florida safety, gaining 10 yards and a first down. Four plays later, the Bulldogs scored a touchdown. On the ensuing possession, after the Gators gained 9 yards in three plays, they encountered fourth down and one to go from their own 29-yard line. In what a Jacksonville newspaper dubbed the next day "Fourth and Dumb," Florida head coach Doug Dickey elected to go for the first down. Fullback Earl Carr took a pitch outside to his left. Reading the play perfectly, Georgia's Henderson dropped him for no gain. Six plays later, the Bulldogs had tied the game, 27–27.

Ending in a 41–27 Bulldogs' victory, Georgia's defense was spectacular in the second half. McLee finished with 198 rushing yards, while Goff rushed for 124 yards, completed all five of his passes and was responsible for five touchdowns. In being named ABC-TV's Chevrolet Offensive Player of the Game, Goff refused the honor, as fellow quarterback Robinson had done seven games before, and requested that it instead be dedicated to Hugh Hendrix.

"I'd like to give [the honor] to Hugh Hendrix, a guy that meant a lot to us who passed away at the first of the year," Goff said to sideline reporter Jim Lampley. "I'd like to give it to [him], and ask for you to put it in his name because he was the one who inspired us all."

With the SEC championship on the line the next week at Auburn, McLee rushed for 203 yards and Pollard added 158 yards on the ground in a 28–0 victory. As the final seconds ticked down, the most unusual reaction by Georgia fans took place (for a road game, no less)—at least, unusual as it would pertain to today.

In celebrating the Bulldogs' first conference championship and Sugar Bowl appearance in eight years, yet also indicative of how truly beloved the 1976 Georgia football team was by the student body, a few thousand Bulldog enthusiasts—primarily students—climbed out of the stands and began filling an end zone. Afraid the fans would tear down either of the two, or both, goal posts at Jordan-Hare Stadium, about ten policemen maneuvered into each end zone, only to witness the entire throng flood Georgia's sideline.

"Literally thousands of Georgia students over there jammed all around the bench, intermingling with the players....They're all over the team on the bench!" Larry Munson, Georgia's radio play-by-play man, proclaimed. "And, the 'Junkyard' is an SEC undisputed, all-by-themselves champion!"

Possibly looking ahead to the Sugar Bowl and Pittsburgh, which had completed its perfect regular season the day before with a win over Penn

State, Georgia barely escaped defeat or a draw with a thrilling 13–10 victory over rival Georgia Tech. With the game tied at 10–10 with just over three minutes remaining, the Bulldogs were moving into field-goal range when Goff lost a fumble, which was recovered by the Yellow Jackets at their 31-yard line. However, on the ensuing play, Tech's Adrian Rucker also fumbled, which was recovered by Georgia's Lawrence Craft at the opposing 34-yard line. After seven plays, Leavitt made a game-winning, 33-yard field goal with only five seconds left to relieve the Bulldogs of what would have been a sour note heading into the Sugar Bowl.

Georgia's win over Georgia Tech also assured that Dooley, like many of his players and assistants, would follow suit in becoming a bald Bulldog. Earlier in the season, after the dozens of players had shaved their heads, as well as a number of assistant coaches following victories, the head coach promised the team that if it won the SEC title and then defeated the Yellow Jackets, he, too, would shave his head. Accordingly, at a team function on December 15, celebrating the conference championship, the normally conservative Dooley ripped off a wig, revealing a completely shaven head in front of several hundred attendees, including the governor of Georgia, the SEC commissioner and the Sugar Bowl–bound team.

The day of the Sugar Bowl, on January 1, while Georgia players began dressing in the Superdome locker room before taking the field to warm up, Blue desperately looked for a ticket by asking anyone and everyone if they had an extra. But to no avail. Seeing that his hometown friend would actually be kept from seeing the Bulldogs for the very first time, Shag gave him the key to their room at the Hyatt Regency, where he could at least watch the game on television.

Not even an hour later, as Shag stood around midfield, he spotted two Georgia trainers pulling a large cart of towels under the goal posts. Just before the cart passed by a couple of security guards, the trainer positioned in the front suddenly whipped around to where he was pulling the cart with his back leading. But, on reaching the Georgia sideline, he turned back around to where he was facing the front again. When the trainer turned around, Shag realized that, although Blue was without a ticket or a sideline pass, he would still be able to see his Bulldogs in person, after all. Dressed as a trainer, he had gotten past security while pulling the cart by turning around at an opportune time to hide the fact he didn't have a sideline pass attached to the front of his waist. In no time, Blue had abandoned the cart and began roaming the sideline until he met and evidently became fast friends with Jim Lampley. Blue and the sideline reporter chitchatted about

The field of New Orleans's Superdome just prior to the start of the 1977 Sugar Bowl between Georgia and Pittsburgh. *Henck and Kelley collection.*

the possibility of Georgia winning the national championship. According to Lampley, with a Bulldogs' victory over Pittsburgh, the winner of the Rose Bowl between Michigan and Southern California would be chosen number one. Not everyone agreed.

Visiting the Georgia locker room not long before kickoff, a writer for *Sports Illustrated* indicated that if the Bulldogs did indeed defeat the Panthers, the magazine, which featured a reputable set of college football rankings at the time, would name them national champions—no matter the outcome of the Rose Bowl. Alas, as it turned out, it wouldn't matter what happened in the Rose Bowl after Georgia's nightmare in New Orleans.

After limiting Pittsburgh to a single score in its first five possessions, the Bulldogs allowed touchdowns on back-to-back drives just prior to halftime. The Panthers' offense, which was expected to run Tony Dorsett the majority of its plays, featured quarterback Matt Cavanaugh throwing

for 185 yards—in the first half alone. At the same time, the Bulldogs' normally efficient offense was extremely stagnant, scoring no points and gaining only 68 total yards in the first two quarters. During what was an especially substandard performance by Georgia's offensive line—a unit that had arguably been the best in the country during the regular season— the Pittsburgh defenders routinely got past blockers into the Bulldog backfield, making tackles for losses, hurrying Georgia's quarterbacks and forcing turnovers. When Goff and Robinson did have time to throw, it usually didn't end well. During a disastrous second quarter, the two Bulldog quarterbacks combined to throw four interceptions in a span of just twelve pass attempts after being intercepted an average of just once every sixteen attempts during the regular season.

During the Sugar Bowl, linebacker Jeff Lewis (61) looks away while cornerback Bobby Thompson (41) looks on in dismay. *Historic Images.*

With Georgia trailing 21–0 at halftime, it was evident in‍ locker room that frustrations had boiled over when a approached another, accusing him of "not trying hard." In add in the third quarter, two Georgia players in the offensive huddle got into a shoving match and had to be separated. Meanwhile, Dorsett shined in the second half and would finish with a Sugar Bowl–record 202 rushing yards. The Bulldogs managed a third-quarter field goal, but it would be their only points of the contest.

Early in the fourth quarter, with Georgia trailing, 24–3, and attempting to at least make it a ballgame, the Bulldogs reached into their bag of tricks. Shag was handed the ball on an end around, whereby he stopped and flung a long bomb downfield. The pass was "right on the money," according to ABC-TV play-by-play man Keith Jackson, but it was dropped by a wide-open teammate. The play, ironically an incomplete pass at that, would be Shag's final one at Georgia, as he was permanently removed from the game by Baby Huey and replaced with Mark Wilson.

A couple hours after an embarrassing 27–3 loss to Pittsburgh, a saddened and disappointed Shag was riding up an escalator at the Hyatt Regency with his consoling dad. Suddenly, coming down the opposite end alone was Baby Huey, looking away from the father-son pair. Shag began to reflect on his final three seasons at Georgia with Huey as his position coach—a period in which Shag believed he was underused for two seasons as a "co-starter" not because of ability, but because he had been suspended. Shag recalled getting permanently removed by Huey for unexplained reasons early in the Cotton Bowl the year before following a drive in which he had made three receptions. That postseason appearance was followed by Shag getting benched during his final game after an incomplete pass that was no fault of his own. An overreacting and immature Shag instantly snapped.

Shag verbally blasted a startled Baby Huey with a string of profanity-laced insults. Impulsively and obviously not thinking clearly, he also reared back with a fist high in the air aimed at the coach before he was restrained by his father. As Baby Huey continued riding the escalator in the opposite direction, Shag was instantly ashamed of himself, realizing his poor decision of assaulting the coach. However, at the same time, he was cognizant and relieved that he would never have to concern himself with Huey again—or, so he thought.

Four months later, Shag was selected by the Houston Oilers with the 198th overall pick of the NFL draft, becoming the third of eventually seven Georgia players chosen, behind Leavitt (90th) and "Moonpie" Wilson (103rd).

But he actually wasn't aware of his selection until the day after the draft, and only when Helms (220th) called to congratulate him. The Oilers, who had traded a player with Seattle for the pick the year before, had neglected to notify Shag that they had drafted him. It should have been an omen; he was cut by Houston after one preseason game.

Shag later signed with sports agent King Corcoran, a former semipro football star known for his extravagant dress and playboy lifestyle who eventually landed Shag a contract with the New York Giants. Once in Giants camp, Shag was running late for his first position meeting when he finally reached a room full of wide receivers. Standing among them was their position coach, who was beginning his first year as an assistant with the Giants after coaching receivers at the college level—none other than Baby Huey. Perhaps needless to say, Shag was cut by New York, as well, during the preseason.

Shag's post-Georgia football career, although brief and "entirely forgettable," according to the June 1980 issue of *Football Digest*, was actually rather event-filled. For one, considered one of the worst transactions in NFL history, Seattle's draft pick, which would be used to select Shag, was traded to Houston for an eventual hall-of-fame wide receiver, Steve Largent. The transaction was so one-sided in favor of the Seahawks, it was featured as a question in the 1980s trivia board game *Trivial Pursuit*. Also, Shag is maybe the only player in the history of football whose position coach in college reduced his playing time, his position coach in the NFL was part of him getting cut and the position coach in both instances was the *same* coach.

If You Go Down to Athens, G-A

Joe Hollingsworth was a Georgia player who was part of the program's 1972 incoming class. Like a number of the newcomers that season, he often partied—that is, until enduring a bad drug "trip" at an Allman Brothers concert in Macon, Georgia, during that school year. Abruptly leaving the concert in a crazed state, he started to walk the thirty miles back to his home. At one point, Hollingsworth hitched a ride, but he was literally thrown out of the automobile after attempting, for no apparent reason, to choke the driver. Toward the end of his journey, according to Hollingsworth, God spoke to him, telling him to change his ways. The event—an experience he credits today to changing his life—inspired Hollingsworth to eventually become a reputable and award-winning man of the ministry.

Whether an individual was once part of the wildness, like Hollingsworth, or not, it's intriguing to note what subsequently transpired with those exposed to the untamed environment surrounding the Georgia football program of the early to mid-1970s.

Following the 1976 season, Blue could still be spotted along the Georgia sideline during home games in 1977 and 1978—and always, like before, without a sideline pass. By 1979, although he had moved back to Maryland, he still simply wanted to feel part of a team. As a result, Blue could be spotted that season associating with the Baltimore Colts—the pro team his friend, Bucky Dilts, Georgia's punter from 1974 to 1976, played for at the time.

Although he had moved on from the Georgia program, Blue certainly left an indelible mark in Athens that has continued to persevere. By the late 1970s, his unique alternate spelling of Georgia's nickname—"Dawgs"—had started to catch on. Today, I believe most Bulldog enthusiasts would attest to the fact that "Dawgs" is even more popular than the original, "Dogs."

As far as those who somehow dealt with the wild bunch of Bulldog players, it was also in 1979 when Joel Eaves retired as Georgia's athletic director. As he had vowed five years before, he never fully recognized the 1974 team—"a bunch of thugs," as he characterized it—and wouldn't, as he declared, for the rest of his life. Even since Eaves's passing in 1991, that particular Georgia team, in a way, still goes unnoticed. If you ever get a chance to visit the Letterman's Club at Sanford Stadium, you can see for yourself. Along one of the walls, each annual photograph of the Georgia football team for the past several decades is displayed. Most of the team photos are in color, including those taken long ago, when a color photograph was a rarity. However, among a sea of colored team photos is one, and only one, displayed in black and white: the 1974 Bulldogs.

Arriving at Georgia in 1972 or 1973, the Bulldogs' 1976 seniors overcame a number of obstacles to develop into a spirit-filled, dedicated and unified championship team. *Helen Castronis collection.*

In 1980, or four years after the Junkyard Dogs of 1976 came up empty-handed, coach Vince Dooley captured the national championship in the same game as before, the Sugar Bowl, and at the same venue, New Orleans' Superdome. At the time, it was a wonder how many of those Georgia fans still yearned, as they had five to seven years before, to "dump" Dooley.

After a few years of Shag wondering whatever became of Jim Barnett, it was also in 1980 when he spotted his one-time friend's familiar name in a newspaper. Barnett had been nominated to the prestigious National Council on the Arts by President Jimmy Carter. "Mr. Barnett's art expertise?" the newspaper article read. "He is...the director of Georgia Championship Wrestling."

In May 1977, the final time he visited the Colony Square condo in Atlanta, Shag informed who appeared to be a new doorman that he was there to see Jim Barnett.

"Are you a wrestler?" the doorman asked.

After receiving what must have been a puzzled look by Shag, the doorman said, "Yeah, Mr. Barnett is the commissioner of Georgia Wrestling."

Until then, Shag had always thought Barnett worked for Barnett Bank in Florida. In reality, he was an owner of Georgia Championship Wrestling and, prior to that, a promoter of Australia's World Championship Wrestling. In fact, Barnett had been recognized as the founder of television studio wrestling and considered the "godfather" of professional wrestling. Soon, he would be an integral part of the World Wrestling Federation's expansion in the mid-1980s under Vince McMahon. He was a close confidant to media mogul Ted Turner during the sport's heyday. Yet, as long as Shag had known him, the word "wrestling" never came out of Barnett's mouth during their countless conversations.

Regardless of the kind of work Barnett was in, Shag needed money. Although he had recently been drafted by the Houston Oilers and was to receive a signing bonus of $8,000, the check had yet to arrive in the mail. Like always, Barnett knew why Shag had come over and promptly gave him $100. Besides money, he soon gave Shag the impression that he was fully aware that the two might not interact again.

Barnett asked Shag if he was familiar with a particular Georgia football player. Shag said he was. The player was three or four years younger than Shag and had been a member of the Bulldogs' scout team during the 1976 season. During practice, Georgia's first team often lined up against the scout team, and Shag remembered the player—a rather good-looking guy—lining up opposite him on defense for some drills. Since Shag would

soon be either earning a spot on Houston's roster or, if that didn't work out, finally graduating from Georgia and hopefully getting a "real job," he informed Barnett that his days of bringing requested teammates to the condo had ended.

"Oh, my boy, not only have I already met him [the player]," Barnett retorted, "but he and I have been in a relationship for months!"

The only question Shag would have was if the "relationship" was a money-for-sex arrangement or something more. However, when it concerned Jim Barnett and his relationships/flings, Shag never asked *anyone* any questions.

Still, more surprising than the thought of Barnett actually having a relationship with a teammate was that Shag had not introduced the Georgia player to Barnett nor received a request from Barnett to meet the player. However, he assuredly had to contact *somebody* for the introduction. In other words, Barnett had evidently moved on from Shag to another Georgia player to bring over teammates. Or, most likely, there had been others besides Shag all along who took Barnett's requests and brought over teammates to make some quick cash while not minding to ask teammates if they wanted to do the same.

At that very moment, standing in front of Barnett while he described how wonderful of a relationship he had with the teammate, Shag realized exactly what he had been a part of: one of multiple football players delivering teammates to a man who preyed upon them by utilizing the enticement of money and gifts.

If there was another question to be asked, it would be if Barnett's scheme only involved Bulldog players, or if Georgia had been part of a much larger money-for-sex network.

A few more familiar names that had associated with Bulldogs' football in some form or another were detected by a startled Shag while watching television on January 17, 1983. Broadcast by PBS was the first airing of *Frontline*, titled "An Unauthorized History of the NFL," a documentary of organized crime's involvement with, among several other gambling-related issues, game fixing. Georgia football greats Jake Scott, whom Shag had met years before, and Craig Hertwig, whom Shag had played with in 1974, were alleged to have been closely associated with none other than Señor Grande. Until then, Shag hadn't seen Señor Grande since he stood along the Georgia sideline during the 1976 Cincinnati game. He hadn't even heard of anything concerning Señor Grande since about a month following the Cincinnati game, when he and a twenty-four-year-old former Georgia football player were two of four individuals arrested for running a parlay football gambling operation.

Reportedly, Señor Grande's Athens residence had been raided by GBI agents on December 18, 1978, for suspicion of being a bookmaking operation. Scott, sitting on a couch, and Hertwig, in a chair, were present at the home when it was raided. Both had been members of NFL teams—Scott with the Washington Redskins, Hertwig with the Buffalo Bills—which had just concluded their regular seasons within the previous two days. Although Hertwig hadn't appeared in the Bills' season finale, Scott had started at free safety for the Redskins in a 14–10 upset loss to the Chicago Bears on December 16. Señor Grande, a close friend of Scott's, reportedly won $1,700 by betting on the Bears, a four-and-a-half-point underdog and the opponent of his "lifelong friend." Señor Grande, who was said to be running a $500,000-a-year bookmaking ring, was arrested along with two other accomplices, although Scott and Hertwig were not charged. In fact, the mere mention of their being present at the raid was not publicized until a newspaper report nearly four years later in August 1982.

Scott and Hertwig were reported to the NFL by the GBI for associating with a convicted gambler, and *Frontline* alleged that the players were forced into early retirement just prior to the 1979 season because of pressure by the league. However, the episode would come under some fire, including from NFL commissioner Pete Rozelle and from an article in *Sports Illustrated*—"Unfounded Findings: What PBS's NFL exposé exposed was the network's poor journalism"—which claimed that "*Frontline* provided no substantiation" regarding game-fixing allegations.

It is also important to note that neither Scott nor Herwig were charged during the raid of Señor Grande's home or ever admitted to any wrongdoing. In addition, Señor Grande denied running a gambling operation out of his home. As he stated, he ran his gambling business "somewhere else." The bookie also denied ever receiving any inside information from either Scott or Hertwig, claimed he didn't remember wagering on the Chicago-Washington game of 1978 and declared the two players were simply visiting his home during the time of the raid.

During a Georgia players' reunion in 2006, or six years before he would pass away in 2012, Hertwig was bluntly asked by his friend and former teammate Shag, "whatever came of" the 1978 raid on Señor Grande's house, where he and Scott were present. Hertwig paused, looked directly into the eyes of Shag and said with all seriousness, "I have no idea of what you're talking about." Similarly, when Scott was once asked about the raid, he responded, "We're just simple people who like to have fun."

As far as the idea of Scott possibly having a hand in "fixing" the 1978 Redskins-Bears game by lying down or giving little effort, Shag thought the notion was somewhat ridiculous. As Hertwig said in 1982 when asked about the raid and his close relationship with bookmaker Señor Grande, "What could an offensive lineman do, anyway?" Likewise, Shag questioned what a free safety, a linebacker, a noseguard, etcetera, could do, anyway? How feasible was it that a player at a position that has very little contact with the football was capable of "fixing" a game?

What Shag hardly questioned at the time was his belief that Jim Barnett's sexual manipulation extended beyond and prior to the Georgia football program during the mid-1970s.

A year prior to Barnett's death in 2004 after a battle with cancer, *Chokehold*, by former professional wrestler Jim Wilson and sociologist Weldon T. Johnson, was published. Wilson, ironically a Georgia football player in the 1960s, alleged in his whistle-blowing book about wrestling's unfair labor practices that Barnett had made sexual advances toward him. When Wilson turned down the advances in the 1970s, he was "blacklisted" by Barnett, who ordered his wrestling booker to arrange for Wilson to lose matches.

Several years later, another book, *The Thin Thirty* by Shannon Ragland, was published. It prominently featured Barnett. Evidently, for approximately four years in the late 1950s and early 1960s and while living in Lexington, Kentucky, Barnett took advantage of University of Kentucky football players in an eerily similar fashion to how he later manipulated Georgia Bulldog players. He lured Wildcat players to his home with money, clothes and alcohol in exchange for sex. If a Kentucky player was not willing to have sex, but had vulnerable followers, the gifts given collectively from Barnett to all players were "a small price to pay indeed," according to the author. In addition, however any lured Georgia players considered it, Kentucky players "looked upon [exchanging sex for gifts] as a game...that the players were somehow gaming the system, getting free money for nothing."

According to Ragland, and as Shag was informed, Barnett became associated with actor Rock Hudson while in Lexington. Allegedly, Hudson engaged in sexual relationships with Wildcat players as Barnett acted in a solicitor-like role in their prostitution. Interestingly, also claimed is that Kentucky players threw a game during the 1962 season for gambling purposes and, because of his influence over members of the team, Barnett was possibly the actual "fixer" of the suspected game.

In 1963, Kentucky head football coach Charlie Bradshaw learned of his team's sex and game-fixing scandals and took appropriate actions to "clean

up the mess" and "do it as quietly as possible." Soon afterward, Barnett fled from Lexington to Australia, where he worked in wrestling until returning to the United States and Atlanta. Wrestler Jim Wilson stated that Barnett moved into the city's Colony Square condos in November 1973.

As Shag experienced himself, the accounts of the Kentucky football players, and Wilson to a certain degree, are consistent by portraying Barnett as a manipulator who was compelled to charm athletes. Notably, also referenced is Barnett's relationship with a boyfriend—the same Georgia Tech basketball player originally from Lexington he described to Shag. However, unlike Shag's experiences, the two other narratives both include a male companion, or a sidekick of Barnett's.

Apparently, companion Lonnie Winters had lived with Barnett for a long time, including in Lexington from 1959 to 1963, whereby Lonnie was "a secondary figure who acted as a public face for Barnett's solicitations." When Barnett left the country for Australia, Lonnie was with him; however, "his story after 1963 is mysterious" and his whereabouts "are not known." As indicated, Shag never encountered Lonnie, but if Barnett had had his way in 1977, it apparently would have been a much different story.

While in training camp with the Houston Oilers in Nacogdoches, Texas, Shag received an unexpected phone call in his dorm room on the campus of Stephen F. Austin State University from a very familiar voice.

"Oh, my boy," the caller replied when Shag answered the phone.

Remarkably, Barnett somehow knew where, and how, to reach Shag at his dorm room.

"If you want me to ask [Oilers quarterback] Dan Pastorini if he would like to make some quick cash in Atlanta, he already has plenty of money," Shag quickly quipped. "Regardless, I think Pastorini is hairy, anyway."

During their brief chat, Shag mentioned the likelihood of him soon being cut by the Oilers. In response, Barnett insisted that as soon as he was released, Shag should immediately call him. As expected, a few days after the phone conversation, Shag was cut by Houston.

Prior to the start of training camp, Shag had started seeing a girl living in the Houston area. After being released, instead of driving back to Athens, or home to Maryland, he first decided to drive the 150 miles south to Houston to stay with her for a few days. While staying with the girl at her apartment, Shag remembered he had told Barnett he would call him upon his release. He phoned the Atlanta condo.

Again, Barnett seemed to have kept better track of Shag than he did with himself, almost scolding Shag for not calling *immediately* after being released,

but waiting a few days instead. He then asked how far Shag was from Houston. After Shag mentioned that he was actually in the city, a delighted Barnett inquired if he had access to an automobile.

"I want you to go visit a friend of mine who lives in Houston," Barnett said. "Just go visit him at his home, and he'll give you some money."

Barnett gave his friend's address to Shag, instructing him to write it down, and then asked for him to repeat it back. Still somewhat under Barnett's manipulative control, Shag indeed jotted down the friend's address and repeated it back. Finally, for what would turn out to be the final words ever said between the two, Barnett closed the conversation by adding, "And, by the way, my friend's name is Lonnie."

Shag admits that, if he needed money at the time, he most likely would have done exactly what Barnett had said and visited his friend Lonnie. However, for perhaps the first time since he could remember, Shag actually had *plenty* of money. At the time, he had hardly spent any of his signing bonus, and he had received roughly $750 a week while in training camp. Visiting Lonnie was unnecessary for Shag, so he stayed with the girl for a few more days before driving back home.

More than thirty years later, Shag finally became aware of exactly whom Barnett had insisted he visit in Houston: undoubtedly, his onetime companion and fellow manipulator, Lonnie Winters. And Shag became aware that Lonnie's whereabouts were not necessarily mysterious after 1963, at least not during the summer of 1977, when he apparently was living in Houston. Worse, Shag came to the realization that Jim Barnett's money-for-sex manipulation involved much more than the Georgia football program of the mid-1970s, but Kentucky's before that and, apparently, extending to Houston and God knows where else, when and involving how many vulnerable young men.

Notably, at a fairly recent Georgia football lettermen's tailgate, Shag was approached by a former teammate of his, an offensive lineman. Eventually, the 1973 G-Day game came up—the spring game in which Shag struggled mightily as quarterback of the Red squad. Evidently, there was a reason why, on that afternoon, a beat writer noted, "It appears as if part of the Red's offensive line is simply just going through the motions on some plays." Shag was shocked to hear the former teammate out of the blue, without being prompted, and while laughing, admit that, prior to the game, a couple of linemen playing for the Red team agreed to hardly block for Shag. Apparently, according to the former teammate, the linemen wanted "to see if the pretty-boy Yankee was tough." I can attest

that those were the former teammate's exact words, as I was at the tailgate as a guest of Shag's.

While the former teammate provided even more evidence of geographic prejudice on the Georgia football team at the time, he also supported a notion that I personally would've thought was inconceivable.

"Because the position doesn't have any contact with the football," I said to Shag after we finished speaking with his former teammate, "I would have never thought an offensive lineman, even a couple of them, could essentially 'fix' a game."

It was early in the week leading up to the lettermen's tailgate when Shag, two of the women who had been good friends with Hugh Hendrix—Janice and Kathy—and I traveled to Carrollton, Georgia, to visit with Hugh's parents, Harvey and Carolyn.

Since Hugh's passing, the cause of his death had been considered "a medical mystery." Officials seemed to believe the cause of the rare blood infection was from food and/or water contamination. But it was never pinpointed when Hugh could have been exposed to such contamination. Also, a rumor had developed that he possibly was infected while swimming in a pond. But Hugh could not swim. Curiously, although a number of Hugh's hometown friends were interviewed by officials after his death, at least to everyone's knowledge who can recall, none of his teammates—the players he had been hanging around and working out with during the summer leading up to his passing—were interviewed.

For decades, Shag was only aware that Hugh died from "heart failure from a blood infection" until he discovered in April 2012 that the rare infection was specifically leptospirosis—a disease most commonly found in

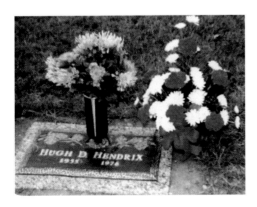

Taken soon after Hugh Hendrix's passing, this photograph shows his grave site at Carroll Memorial Gardens in Carrollton, Georgia. *Henck and Kelley collection.*

rats and cattle and spread by their urine, which is often in proximity if not covering its stool. The disease is commonly acquired through nasal and eye membranes or through open cuts in the hands, feet or other parts of the body. Instantly, Shag wondered if Hugh had contracted leptospirosis during the afternoon in early July 1976 when he and five teammates, including Shag, ventured into the cow pasture outside of Athens.

It was impossible for Shag to know what actions unquestionably killed Hugh Hendrix. Still, this much was realized: a perfectly healthy twenty-one-year-old man who had been working out all summer suddenly became extremely ill, contracting a disease transmitted from cow urine only a handful of days after he had been in a cow pasture, picking mushrooms out of cow stool. He was seen lifting the mushrooms up to his face to smell them, while the tops of his feet were exposed. Again, leptospirosis can be contracted through nasal membranes and cuts in the hands or feet. Shag obviously couldn't be 100 percent positive what resulted the afternoon in the cow pasture caused the death of Hugh, but he at least found it necessary to inform his friend's parents what he knew. Therefore, if they were still alive, Shag was going to tell them as soon as he could—like that fall during the week of a team reunion.

At Hugh's parents' home, among other things, Carolyn mentioned how she and Harvey had kept themselves preoccupied over the decades from dwelling on the thought of their only child's mysterious death. This included their immediately taking up the sport of golf. They had remained avid golfers ever since. A lasting memory of Hugh they had kept sacred over the years was his Oldsmobile Cutlass Supreme, which essentially remained in the exact mint condition it was in when Hugh died.

Hugh Hendrix's 1972 Cutlass Supreme in 1974 and, still in the same near-mint condition more than forty years later, in 2016. *Henck and Kelley collection.*

The front page of the July 15, 1976 edition of *The Red and Black*. There is irony in the announcement of Hugh Hendrix's passing just above an article discussing the "readily available" shrooms grown in the Athens area that summer. *The Red and Black*.

The parents were asked if it was ever indicated how Hugh contracted leptospirosis. According to Carolyn, "No clue." Then, uncomfortably and with some hesitation, Shag revealed how he believed their son was stricken with the disease, detailing the night in the cow pasture. Subsequently, the disease's incubation period was detailed, as well as its causes and effects. Shag's information was cross-referenced with the parents' timeframe of Hugh's illness.

"I bet you anything [the cow pasture] is where and how he got sick," Carolyn concluded. She then added that she believed Shag's theory was "100 percent accurate."

Toward the end of the visit, I began looking on a shelf in the family room at a football, which originally had been used in Georgia's season opener of 1976. The ball had been dedicated in Hugh's honor and then given to the parents following the Bulldogs' comeback victory over California. Suddenly, Carolyn walked in front of me carrying a plaque-like award.

"Do you know if the team still gives this out?" she asked me. "It's an award named after our Hugh."

Although I had never seen it, I immediately knew what I was looking at: the Hugh Hendrix Memorial Award, once annually given to the Bulldog player who most strained his potential. I was also aware that the honor hadn't been awarded in about twenty years. However, taken aback and not having the heart to be upfront with Carolyn, I was at a loss for words.

"You know, I'm not really sure," I mumbled, perhaps somewhat cowardly. Yet, at that instant, I felt suddenly compelled to begin a pursuit—albeit, an unconventional one.

"Man, I don't know what—if anything—I can do," I said to Shag in a near whisper while we were alone looking at the award. "But I'm going to do whatever I can to get Hugh's award reinstated."

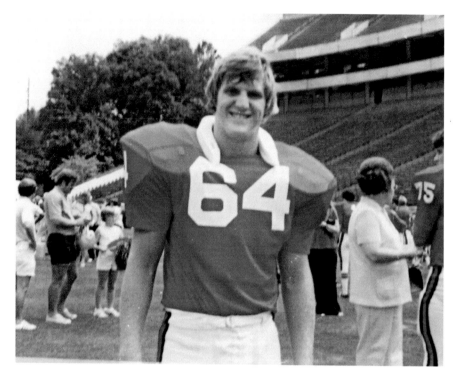

More than anything else, this book is a tribute to the Georgia football teams of the mid-1970s, especially Hugh Hendrix, may he always rest in peace. *Henck and Kelley collection.*

As Shag, Janice, Kathy and I were preparing to visit Hugh's nearby grave site, it seemed evident to all four of us that Harvey and Carolyn finally appeared to have some degree of closure—even if only the slightest—concerning what exactly had caused the death of their Hugh.

As the four of us were leaving the home—Janice and Kathy walking together in front of us—Shag and I were suddenly stopped. Harvey, who had spoken very little during the visitation, thanked us for coming. Walking us out the door, he then referred to the activity that for years had kept him occupied and prevented him from dwelling on his son's curious death, concluding, "I believe now I don't have to play as much golf as I have been."

Sources

Athens Banner-Herald (1973–76).

Atlanta Constitution (1964–84).

Bortstein, Larry. "Family Weekly's 6th Annual All-America College Football Team." *Family Weekly* (August 22, 1976): 4–6.

Butt, Jason. "Breaking Barriers." *Red & Black* (February 28, 2007). http://www.redandblack.com/news/breaking-barriers/article_f7dd0be9-fe22-55f0-8897-8c401f91076d.html.

Cambridge Daily Banner (1969–77).

Clarion-Ledger (October 26, 1980).

Coach & Athlete. "1971 Prep All-America Football Squad." (January 1972): 18–22.

Garbin, Patrick. *The Georgia Bulldogs Playbook: Inside the Huddle for the Greatest Plays in Bulldogs History*. Chicago: Triumph Books, 2015.

"Georgia at Auburn, November 13, 1976." Georgia Bulldogs Radio Network. 1976.

"Georgia versus Pittsburgh, January 1, 1977." ABC-TV. 1977.

Inabinett, Mark. "Why Does Kentucky Struggle in Football? Former Wildcats Coach Has Two Reasons." AL.com. November 12, 2013. http://www.al.com/sports/index.ssf/2013/11/why_does_kentucky_struggle_in.html.

Kaplan, Jim. "And Beasts Will Be Beasts." *Sports Illustrated* (August 11, 1980): 15.

Kirby, James. *Fumble: Bear Bryant, Wally Butts and the Great College Football Scandal*. New York: Harcourt, 1986.

Moldea, Dan E. *Interference: How Organized Crime Influences Professional Football*. New York: William Morrow and Company Inc., 1989.

New Orleans Times-Picayune. "Pitt, Georgia Want No. 1." December 28, 1976.

Palm Beach Post. "Frosh Rule Stirs Skeptics." January 10, 1972.

Ragland, Shannon. *The Thin Thirty: The Untold Story of Brutality, Scandal and Redemption for Charlie Bradshaw's 1962 Kentucky Football Team*. Louisville, KY: Set Shot Press, 2007.

The Red and Black (1971–77).

Rudman, Steve. "Steve Largent: He's Quietly Been Sensational." *Football Digest* (June 1980): 42–44.

Underwood, John. "The Setting Was Ripe for Scandal." *Sports Illustrated* (December 8, 1975): 36–45.

University of Georgia Football Media Guide (1969–77).

University of Pittsburgh Football Media Guide (1973–77).

Wilson, Jim, and Weldon T. Johnson. *Chokehold: Pro Wrestling's Real Mayhem Outside the Ring*. Xlibris Corporation, 2003.

Index

Y

Yale University 16
Young, Hilton 171

Z

Zambiasi, Ben 26, 27, 28, 29, 32,
 34, 38, 39, 161, 163